"The art of editing is little und[...]mation. This illuminating book explains how Pixar completely reshaped the role of the film editor, with clear examples and video links to boot. I hope other producers follow Pixar's lead; the results speak for themselves."
Leonard Maltin (Author, *Of Mice and Magic: A History of American Animated Cartoons*)

"As a live action editor, imagine my surprise when I discovered that animation editing shares the same dramatic values of live action: story structure, characterization, performance, pace, and emotional impact. From the first drawing through endless iterations with dialogue, sound, and music, anything and everything is possible, with the editor at the core of the collaborative, creative process. Filmmakers will treasure this artful book about animation storytelling from the inside out."
Carol Littleton (Editor, *E.T. the Extra-Terrestrial, Body Heat, The Big Chill*)

"Bill Kinder's and Bobbie O'Steen's wonderful book reveals that editing is at the heart of Pixar's digital animation process. It sheds light on how editors are involved with a production from the earliest stages of concept and design, through background and layout, and into the complex and extended phase of post-production. This book will change your understanding of how digital animation is made."
Lea Jacobs (University of Wisconsin-Madison)

"The full History of Editing cannot be understood without the contribution of this book. An insightful, in-depth look at the editor's contribution to both the story-telling success at Pixar and the evolution of digital filmmaking technology."
Phillip Linson (Chapman University)

"*Making the Cut at Pixar* is not only chock full of important and thought-provoking information about the history of computer animation, it's a fun read. Written by insiders in a way that will engage readers in and out of the industry!"
Michael Miller (Editor, *Miller's Crossing, Armageddon*)

"This book may primarily address the editor's role in animation production, but in doing so, it provides marvelous insight into the range of skills needed to make a Pixar-quality film. A must-read for both animation and live-action professionals, a fun read for any film enthusiast."
Atia Newman (Rochester Institute of Technology)

Making the Cut at Pixar

Join industry insiders Bill Kinder and Bobbie O'Steen as they guide readers on a journey through every stage of production on an animated film, from storyboards to virtual cameras and final animation.

With unprecedented access to the Pixar edit suite, this authoritative project highlights the central role film editors play in some of the most critically acclaimed and commercially successful movies of all time. Exclusive interviews with animation editors and other creative leads are supported by footage from deep inside Pixar's vault. Nearly 90 minutes of video segments include never-before-seen works in progress, deleted scenes, and demonstrations to shed light on how these beloved stories are crafted. The challenges and essential contributions of editors in animation have never been examined in such depth and detail.

In addition to exploring method and craft, this book provides important context for the editor in film history, the evolution of technology, and Pixar's uniquely collaborative studio culture. A must-read for students of digital filmmaking methods, filmmakers in all aspects of production, and fans of Pixar movies, this uniquely educational, historical, and entertaining book sheds light on how beloved stories are crafted from the perspective of crucial members of the filmmaking team.

Co-authors **Bill Kinder** and **Bobbie O'Steen** are experts in the field. Kinder was the founding Director of Editorial and Post Production at Pixar from 1996–2014. O'Steen is a teacher and film historian, specializing in editing, and author of *The Invisible Cut* and *Cut to the Chase*.

Making the Cut at Pixar

The Art of Editing Animation

BILL KINDER AND BOBBIE O'STEEN

Routledge
Taylor & Francis Group

NEW YORK AND LONDON

First published 2022
by Routledge
605 Third Avenue, New York, NY 10158

and by Routledge
2 Park Square, Milton Park, Abingdon, Oxon, OX14 4RN

Routledge is an imprint of the Taylor & Francis Group, an informa business

© 2022 Bill Kinder & Bobbie O'Steen

The right of Bill Kinder & Bobbie O'Steen to be identified as authors of this work has been asserted in accordance with sections 77 and 78 of the Copyright, Designs and Patents Act 1988.

All rights reserved. No part of this book may be reprinted or reproduced or utilised in any form or by any electronic, mechanical, or other means, now known or hereafter invented, including photocopying and recording, or in any information storage or retrieval system, without permission in writing from the publishers.

Trademark notice: Product or corporate names may be trademarks or registered trademarks, and are used only for identification and explanation without intent to infringe.

Library of Congress Cataloging-in-Publication Data
Names: Kinder, Bill (Film editor), author. | O'Steen, Bobbie, 1952- author.
Title: Making the cut at Pixar : the art of editing animation / Bill Kinder and Bobbie O'Steen.
Description: New York, NY : Routledge, 2022. | Includes index. |
Identifiers: LCCN 2021053414 (print) | LCCN 2021053415 (ebook) |
 ISBN 9780367766580 (hardback) | ISBN 9780367766146 (paperback) |
 ISBN 9781003167945 (ebook)
Subjects: LCSH: Pixar (Firm) | Computer animation. | Motion pictures–Editing. |
 Animated films–Production and direction.
Classification: LCC TR897.7 .K55 2022 (print) | LCC TR897.7 (ebook) | DDC
 777/.7–dc23/eng/20211209
LC record available at https://lccn.loc.gov/2021053414
LC ebook record available at https://lccn.loc.gov/2021053415

ISBN: 9780367766580 (hbk)
ISBN: 9780367766146 (pbk)
ISBN: 9781003167945 (ebk)

DOI: 10.4324/9781003167945

Typeset in Dante and Avenir
by KnowledgeWorks Global Ltd.

Access the companion website: www.routledge.com/cw/Kinder

Contents

Acknowledgments

This book is in your hands thanks to the participation of many generous, experienced, and insightful film minds. We are indebted to the creative leadership at Pixar, who together shaped and defined a new role for film editors. Lee Unkrich has been the rock on which this project stands. Ed Catmull, thank you for your earliest encouragements to write—and to publish. Darla K. Anderson, Jim Morris, Kori Rae, Jonas Rivera, and all the producers at Pixar: we are ever grateful for your broad support. Jim Kennedy, your patience has been saintly through this trans-media thicket.

We deeply appreciate all the talented editors who participated in this discussion and gave their time for interviews and follow up discussions. We hope this book will stand as a lasting reflection of your best contributions to a new golden age of animated filmmaking.

There are larger communities that support an enterprise like this: Jenni McCormick and American Cinema Editors have been stalwart. And our film teaching community: Norman Hollyn, Phillip Linson, Marie Regan, Lea Jacobs and, as always, Jim Hosney and Carol Littleton.

Writing is another kind of "invisible art": it demands a great deal of patience and faith from families that something worthy will eventually come from the sanctuary they have carefully helped sustain. Jenny, Henry, Jackson, Phoebe, Molly, Danielle and yes, Sam: know that we felt that support daily in surprising and wondrous ways.

–Bobbie O'Steen and Bill Kinder

A Note on the Text

Throughout the book, videos illustrate important concepts and case studies. References to this supporting video will appear in the text in boxes, with the video's number, the title of the video segment, and (running time). For example, this video appears at end of the first chapter:

VIDEO 1.3 "What Exactly Do You Do?"	(3:05)

The Video Material on the Companion Website is password-protected. Gain access to the material through www.routledge.com. (Web connection required.) Search there for *Making the Cut at Pixar*, and scroll down to "Support Material" for detailed instructions. The Companion Website has a "Video Materials" tab that lists links for all of the videos in the book.

If you have an eBook copy, once you have entered the password, clicking on the video's underlined link will take you to the Companion Website where you can navigate to the video through the "Video Materials" tab, organized by chapter.

Introduction
Reframing the Editor

The advent of computer-generated imagery (CGI) represented a change to narrative cinema as seismic as the introduction of synchronized sound. *Toy Story* (1995) is widely recognized as a landmark moment in Hollywood history for being the original example of a CGI movie. But what has not been well understood, nor thoughtfully addressed, is the role of the editor in these changes. *Making the Cut at Pixar: The Art of Editing Animation* places the editor in the center of the frame in its discussion of digital filmmaking for the 21st century.

The animation editor has long been just out of frame—often uncredited, mistaken as a clerk with scissors. Live-action editors have been credited, and some prized, but even they were widely misunderstood. *How* editors draw an audience into a story and keep them "there" is designed to go unnoticed. Before the paradigm shift traced here, the full potential of what an editor has to offer had been limited by both tradition and technology.

Building on an introductory, contextual history of animation, the book launches into the editor's dynamic new role, starting at the beginning of pre-production through three novel areas—none traditionally claimed by editors in either animation or live-action: story development, performance, and cinematography. Rejecting the customary, linear "pipeline" of pre-production, production, and post production, Pixar instead conjured a wheel. Spokes include story, acting, layout, sound, animation, and more. As each stage advances, this wheel spins round and round a hub—in the true center of which we find the editor.

DOI: 10.4324/9781003167945-1

While the live-action editor has been described as crafting the "last rewrite," this book shows how editors can be just as influential at the first draft. Numerous never-before-seen work-in-progress clips from celebrated Pixar films demonstrate how the editors' cinematic imagination brings to life a series of sketchy storyboards and temporary dialogue. Dramatic and comedic beats land, and the emotional moments play only after many failed attempts—in such close collaboration with story artists, they know this relationship as "Edi-storial."

Sound is the cornerstone in the editor's edifice and rare archival examples illustrate the editors' strategies and techniques. The book delves into the unprecedented freedom and challenges editors face filling the virtual void to construct an entire sonic world. They build performances on a microscopic level, with an unprecedented degree of control over every syllable and breath. In their collaboration with sound designers, editors discuss why they find believability, not to be mistaken for realism, so essential in the otherworldly CGI universe.

Later, as a CGI production (and this book) move to the layout stage, the editor remains central to the planning of character staging and camera composition. Further interviews and video examples illustrate how the editor works with the cinematographer and director to problem-solve for continuity and clarity, as two-dimensional storyboards change to three-dimensional sets, populated with robotic figures before they become fully animated.

Over the course of years-long productions, massive quantities of minute media elements pour in and out of the editor's room. With endurance and patience, these editors balance the scope of this massive enterprise with the human quality of empathy. For this, they have been called "Warrior People."

Finally, *Making the Cut: The Art of Editing Animation* takes measure of the impact cinema's technical evolution has had on the editor's creative gains, while inviting the reader to see ongoing technical change through the editor's perspective, in ways that extend far beyond animated films.

The visionary seed for the first computer-animated film was planted far from the heart of the film industry. Rather, the idea took root in Northern California, where an independent filmmaking culture helped nurture it, free from studio rules and hierarchies. The technical obstacles fell to a mindset cultivated nearby in an emerging computer industry. Founder Steve Jobs, looking back on Pixar's success, observed, "It blended the creative culture of Hollywood with the high-tech culture

of Silicon Valley… The Pixar culture, which respects both, treats both as equals."[1] This fusion is exemplified by the editor, who has always been both artist and technician—and whose role here fills the frame from the center out.

Note

1. Paik, K. 2007. *To Infinity and Beyond! The Story of Pixar Animation Studios.* Chronicle Books. p. 295.

The Hub of the Wheel

The Setup

> *Toy Story* came out and it just blew the world wide open. It's very, very exciting because after seventy or eighty years of making films in largely the same way, suddenly there's technology existing and people making films that are raising the bar, pushing the boundaries. You feel like you're living in a pioneering filmmaking time again.[1]
>
> —Peter Jackson, Director (*The Lord of the Rings, King Kong*)

Wild, Wild West

After driving through an industrial landscape pocked with oil refining tanks, a fresh-faced Lee Unkrich arrived at a nondescript office park in the so-called "Hidden City" of Point Richmond, in the Northern California Bay Area. It was the spring of 1994. The recent graduate of the University of Southern California School of Cinematic Arts was at the beginning of a career track aimed toward directing live-action films—perhaps in the manner of his hero, Stanley Kubrick. But this day's visit to the outskirts of the San Francisco Bay was a novel detour from that path—a

Photo 1.1 "Tin Toy" (1988).

© Pixar.

DOI: 10.4324/9781003167945-2

job interview for the position of film editor, with a small production company doing business as "Hi Tech Toons."

Soon to be known around the world as Pixar, the enterprise was then comprised of about 150 engineers, artists, and production staff packed into the leased building. Unkrich toured the long hallways, which commonly hosted scooter races, and saw the employees—for many of whom it was a first job—working in a warren of cubicles or playing arcade video games in the animators' "Bullpen." "Nobody talked about it. It was literally out of nowhere, and nobody really knew what they were doing. They were all making it up as they went. It was the Wild, Wild West," remembers Torbin Bullock, an early, local hire in the editorial department.

These recruits had been brought together by the man many consider "the godfather of 3D animation,"[2] Edwin Catmull, who had a hand in creating one of the earliest filmed examples of computer-generated imagery (CGI), back in 1972. (Literally, he scanned a mold of his own hand and animated it.) He then spent the better part of two decades steering toward his vision for a film rendered entirely with computers.

GALLERY: A Start-Up Studio in "Hidden City"

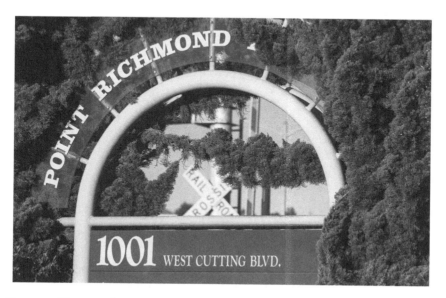

Photo 1.2 Home of *Toy Story*: an unassuming industrial park on Cutting Boulevard, of all places.

Photo by Bill Kinder.

Photo 1.3 Low-cost industrial park real estate.

Photo by Bill Kinder.

Photo 1.4 Other tenants of the complex included a bank, which was prone to being held up.

Photo by Bill Kinder.

Photo 1.5 Point Richmond also had its share of toxic spills from the nearby oil refinery. Evacuations were not uncommon.

Photo by Bill Kinder.

Photo 1.6 Point Richmond had its early-20th-century charms. The quaint town was known as "Hidden City."

Photo by Bill Kinder.

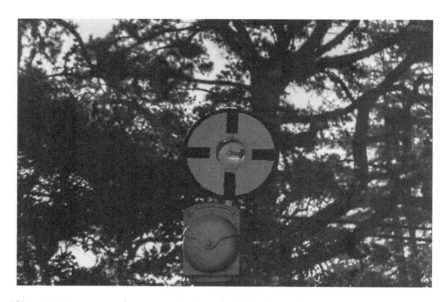

Photo 1.7 But to get there, one had to wait for the train to cross.

Photo by Bill Kinder.

Photo 1.8 The view from Point Richmond to Marin County, home to Lucasfilm in the 1990s.

Photo by Bill Kinder.

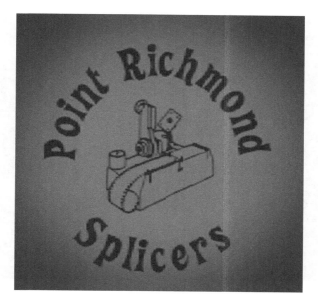

Photo 1.9 Editorial crew T-shirt.

Courtesy Torbin Bullock.

Like almost everyone else in April 1994, Unkrich knew very little about this animation studio by the bay. But as a self-avowed film nerd, he had seen all of its short films—and found them "intoxicating." He pulled into the unmarked industrial development as a fan, "just hoping to get a little glimpse of what they did because it was so magical to me." This chance meeting would arguably alter the course of numerous, notable films—and influence the way movies are made.

It may have appeared inauspicious, but Unkrich was merging with an effort founded on the wish to make not only a movie animated with computers, but also to make a movie with a global, cultural impact. Catmull had convinced Apple co-founder Steve Jobs to purchase the computer division from filmmaker George Lucas's company. Jobs bankrolled seven years of quiet trials to build the tools and confidence of a team of animators and computer scientists. They found customers for medical imaging and other industries before cutting their filmmaking teeth on television commercials and short films. But they had set their sights on making a bigger impression.

"Who do you know that hasn't seen *Snow White* [*and the Seven Dwarfs* (1937)]?," Jobs asked once. "I don't think I know one person who hasn't seen *Snow White*. So, the ability for these things to live for sixty, or even a

Photo 1.10 Meet your shiny new "Random-Access, Non-Linear" digital editing
 system.

Courtesy Tom Ohanian.

Photo 1.11 "Disk 2 of 13" (18.2 megabytes total).

Courtesy authors.

hundred years is amazing. And that's very different than the technology world that I come from. We're not competing against Microsoft or another company. We're competing against, 'can we make a great film that people love.'"[3]

By the time Unkrich was in his job interview, Pixar had built a relationship with The Walt Disney Studios, the birthplace of *Snow White and the Seven Dwarfs*. First it was to render the elder studio's animation cels for the digital future (via the Computer Animation Production System [CAPS]). Soon after, it was to deliver the first computer-animated feature film: *Toy Story*.

Though long-held, that "first" was still an audacious vision, and any evidence that it could be realized was not obvious from the outside. Among Disney projects, *Toy Story* at that point was known as "the fringe of the fringe."[4] This also worked to its advantage—Pixar was neither bound by traditional divisions of labor nor deeply rooted Hollywood hierarchies. The privately held amoeba was largely formless, inventing itself in response to the new demands of a feature film. Unkrich was introduced to people with titles such as "Story Lead," "Devil's Advocate," "Music Wrestler," and "Art Czar." In that fluid state, gathering the right collection of talent, experience, and energy for making "a great film that people love" was not automatic. "It wasn't like live-action filmmaking in Hollywood, where you're just going to hire twenty more people," explained *Toy Story* producer Ralph Guggenheim. "You needed to find people who can use Pixar's proprietary animation software that nobody else in the world uses."[5]

Editorial faced the same challenge. The studio had committed to a new, digital editing system, Avid Media Composer, which had recently become common in commercial and short-form television work. When Pixar had initially hired editors to travel up from Hollywood, some of them had a hard time adjusting their craft from trim bins and splicers to a computer interface. "It was a heady time of the intersection between traditional editorial on mag [magnetic sound film stock] and film, and digital editorial tools," recalls the editorial manager, Julie McDonald—whose own background as both choreographer and NASA scientist embodied the multi-modal mindset cultivated by that time and place.

"There just weren't a lot of people who knew how to use them," remembers McDonald. "It was hard to entice people up to Northern California…it was hard to find Avid editors. Very hard." There were those who claimed to be proficient when they were not, as was the case of one editor who was discovered furtively studying the heavy, bound instruction manual behind closed doors (there was no online search or

video tutorial to be found on the internet). "It was not uncommon that you would find people doing that sneaking," recounts McDonald.

There was some turnover in the position before Unkrich arrived. Perhaps Pixar was not completely sure what it needed in an editor, but it was clear they needed someone who could command the machinery. What are the odds that Pixar's Avid representative would choose to look at their "expert" list in reverse-alphabetical order—bringing "Unkrich" to the top for this referral? That is how he got the first call for this unpromising, remote assignment—to help out, temporarily. Unkrich fulfilled the requirement for technical expertise—and improbably he also offered a perspective the studio did not know it needed. "I loved filmmaking," Unkrich says.

"But I also was a huge computer geek, so when the first Avid Media Composer showed up in a lab at USC, I did everything I could to spend every waking moment in that lab learning it. That ended up not only getting me my first few jobs when I left grad school, but it also put me on Avid's radar."

Unlike all of the previous editors Pixar had tried out, McDonald recalls that Unkrich was "what we call now digitally native:" he was fluent in digital processes at the start of his career. He was "very, very, very fast" on the system, and could quickly present multiple creative options. But he was more than a proficient operator. "He was up and coming," reflects McDonald. "He was very, very excited, and he could work those incredibly long hours. He was really young. He was living for it. It was a great fit." Also, "He was a film aficionado."

The line of questioning in the interview indicated that, although his technical chops got Unkrich in the door, they were not the priority. "I stressed that I had a strong computer background, and while they were happy to know that I had those skills, they kept coming back to story and structure." He got the job.

His new collaborators studied—and revered—The Walt Disney Studios' animation legacy. Many of them also got their first experience and training under its banner. Director John Lasseter had shown early promise at Walt Disney Feature Animation in Burbank, as had lead story artist Joe Ranft. Still others in Pixar's story and animation departments were graduates of The California Institute of the Arts (CalArts), the university established with Walt Disney's support to develop talent—envisioned by some as a "a feeder school for the industry."[6] (Decades later, Lasseter would resign from Pixar amid claims by former and current employees that Pixar's working environment under his leadership had become toxic.)

Meanwhile, Unkrich had earned his advanced film school degree with an emphasis on editing, filling a gap—at CalArts, in line with standard industry practice of the time, editing was not featured in an animation curriculum. Luckily for him, *Toy Story*'s creative leadership welcomed collaboration with talent and skill sets different from its own. In this loose, collaborative environment, the editor's job description was open to possibilities.

Unkrich felt "a rhythm and sense of collaboration that I had never experienced in either film school or professionally," he remembers. "We would sit around a table and it was like a creative feeding frenzy. Because you're involved at such an early stage, you help to shape not just the structure of the movie but its tone and pacing."

An active role in these meetings throughout the remainder of *Toy Story*'s production earned Unkrich membership in the Braintrust, an informal group that spontaneously melded together while delivering the film from its unpredictable, embryonic state to a commercial and critical landmark. Catmull writes, "The Braintrust developed organically out of the rare working relationship among the five men who led and edited the production of *Toy Story*—John Lasseter, Andrew Stanton, Pete Docter, Lee Unkrich, and Joe Ranft. From Pixar's earliest days, this quintet gave us a solid model of a highly functional working group. They were funny, focused, smart, and relentlessly candid when arguing with each other."[7] While Unkrich was appreciated for his storytelling sensibilities, he quickly discovered there was no roadmap for editing computer-animated films. "We were trying to fuse this world of computers and this world of Disney style of cutting storyboards," reflects Bullock. "We were very, very much pushing the envelope."

This adventurous endeavor drew courage from its deep knowledge of animation traditions, and now combined in this environment with a faith in its new technology. This optimism contributed to early, unrealistic assessments of the challenge at hand. The enthusiastic group severely underestimated the resources demanded by the large-scale effort—in several key areas. Making a feature was not simply multiplying the length of a short or a commercial to equal 75 or 80 minutes of running time. It was going to be much more complicated than that.

An early *Toy Story* production planning meeting contemplated: about a dozen animators (34 were credited on the final film), and one layout artist (11 were credited). No editorial department. (Fifteen were eventually credited there.) Between a historical model of cel animation that minimized editing and all that new digital image-making ability, there were many reasons to overlook the upside of adding a film editor to their

production planning, since everyone knew they would only assemble what was animated. The animation was not done in multiple takes, with coverage—what would an editor cut? Also, none of Pixar's short films had needed an editor—and they did pretty well.

Photo 1.12 A tableau from *Luxo Jr.* (1986): no editor, and no edits.

© Pixar.

How did this discipline, editing—considered by so many live-action filmmakers to be the essential aspect of the medium—go from irrelevant to the center of Pixar's process? Before jumping to the artistic, social, and technical conditions that had so ripened by the day of Unkrich's job interview, it will be helpful to survey the way animation editing had, and had not, evolved since the earliest days.

Rewind

At the root of any misapprehension of editing as unessential to animation lie decades of creative precedents and technological constraints, all of which changed at Pixar. A deeper understanding of what changed in film editing—and why—derives from understanding how, well into the 1990s, the industry's animation production process was not just a status quo, but a time-honored tradition, with the momentum of many years of success behind it.

For most of the 20th century, the animated feature films that captured the public's imagination were understood as products of a studio. Whether from Disney, Fox, Universal, or Warner Bros., the directors of so-called "cartoons" were not widely known. And even among diehard fans, the editors were unheard of. It is also true that they had a limited set of technically oriented assignments and were not, in the industry parlance, called editors, but simply "cutters."

(In tracing the broad strokes of the editor's role in animation, Disney makes a fitting case to focus on here—not only because of the studio's heritage, which would eventually inspire Pixar, but also because Disney's methods largely stood for standard practice elsewhere. After all, many of the animators and artists that went on to other studios [e.g., Warner Bros., Fleischer, Mintz-Winkler, Harman & Ising, et. al.] got their starts with Disney.)

The first popular animated sound film, Walt Disney's *Steamboat Willie* (1928), established how it was done: pre-timed action was planned to be easily conformed to the rhythm of music. Starting with a fixed beat per minute, the visual "beats" in the animation would line up, when complete, with the music's rhythm. It was a very mechanical process, like clockwork; some of the visual gags from early animated sound films had the quality of a cuckoo bird appearing at the top of the mechanism's movement.

"We know how fast film will run—ninety feet a minute. All we've got to do is figure how fast the beat of the music is, and we can break it down

into frames."[8] So discovered Wilfred Jackson, who played harmonica to that metronome while Disney himself whistled for Mickey Mouse, in character as Steamboat Willie.

While quite inventive, there was no role for an editor in the creation of this landmark. As a renowned "Golden Age" of animated feature films dawned with *Snow White and the Seven Dwarfs* (1937), the role of determining shots and pace stayed with the director. Marc Davis, one of "Disney's Nine Old Men"—a Golden Age artist and animator—confirms this. "The cutting was done, pretty much, in the director's room. In other words, the director sat down with the animator and you discussed a scene, how to do this and so on. This was automatically cut, because to animate a whole lot of stuff, and then say, 'Let's clip it up,' was too expensive, and pretty ridiculous. Actually, the film was kind of pre-cut in storyboard."[9] In fact, every stage of production, storyboard, layout, and animation was all supervised by the director, and although they collaborated with the animator, storyboard, and layout artists, there was no editor in the creative process.

Describing the stages of production in cel animation from the 1930s will highlight what changed with the arrival of CGI. The terms for these stages would persist—and their meanings evolve—between the so-called Golden Age and a "CGI Age."

1. **Story Pitch:** The pitch entailed the "storyman," as story artists were called in the Golden Age, giving a live performance of all the roles, and pointing to a series of pencil-drawn sketches and storyboards, pinned around the room, illustrating key moments of plot and character.

 On approval, actors would sing live with musicians playing or perform dialogue together, much like a radio play; the sound was not to be edited. "Bar sheets" were created to bridge musical notation to film frame counts (i.e., a march in 4:4 time at two beats per second would be a beat every 12 frames). "You do the cutting on paper, in effect, and if your bar sheets are accurate, the assistant director doesn't have to spend time in the Cutting Room. The cutter just does what's on the bar sheets!"[10]

2. **Story Reel:** Once the tracks and the drawings seemed to work together in an effective way, the picture timings were counted out so a camera operator could expose each storyboard for the number of frames estimated for the moment. Hence, "pre-cut."

 Predictions were rarely perfect, so timing adjustments to the storyboards as shot by the camera were made as needed—to work

with the fixed timing of the audio. These changes were tracked on sheets of paper with lines indicating each frame of film on the track. These "x-sheets" ("x" for exposure) became the master ledger. The cutter was tasked with maintaining that document as it evolved, "recording each shift, each change, each cut, replacement, switch, addition—every whim of the director and animator."[11] Lab runs for printing and processing took hours at best. Physically, film editing was destructive. Undoing splices to change the cuts damaged the film, so the more preplanning the better. The cutter would be notified of changes and proceeded with the task of translating notes on a paper grid to actual frame counts on a reel of film. A typical reel might be close to ten minutes, comprising 14,400 frames. If any one of them slipped behind or ahead of the locked sound, the illusion of sync was broken for the rest of the reel. For that cutter, "there is no more desolate feeling, cooped up in the cutting room with the film all over the floor with nothing in sync anymore."[12]

3. **Layout:** Layout artists designed and colored sets and backgrounds to create perspective and a sense of depth for characters to "live" in. Working with the director on staging, they built on visual ideas in the storyboards by suggesting the pattern of action for the animator, and the "cutting that will tell the story in the most effective way." Those creative decisions were made by the director and layout artist, and did not include the cutter.

4. **Animation:** The animators finalized character drawings and prepared a "pencil test" for animation. Then came the "ink and paint" process: drawings were transferred to "cels," (clear sheets of celluloid) by outlining those characters in ink, and filling them in with predetermined paint colors. Those cels were laid on top of the background, and each frame of that composite was filmed, one exposure at a time.

Throughout these stages, the cutter kept record of every frame of picture and sound. After all the replacements and additions, their paperwork would be so patched and tattered it was almost unintelligible. Their contribution was that of "librarian...keeping, marking, and storing all of the film and, second, with keeping the all-important sync" of picture to sound, with "none of the latitude of his live-action counterpart to determine lengths of scenes or choose which shots shall be used."[13]

Directors from this early period showed subtle powers of imagination in their predictive editing decisions. Davis describes a scene from *Bambi* (1942), exemplary in terms of cinematic effects available through

film editing: "When the mother is shot and so on, god, here you're on this little deer and you see this happen but they don't cut to Mama. You know they stay [on Bambi]. That was not to cut to this thing being hit, or crashing. This was again very good judgment on the part of the story people. Or maybe it was what Walt asked for...."[14] But it certainly was not an editor—that tool was not available to these filmmakers, and they compensated with a host of strategies. Davis famously said that animation is the ultimate art form, involving drawing, acting, music, dancing, and painting, all combined into one medium.[15] "Editing" is here, but hiding—not in the list of arts, but in the verb "combined," bringing all the disciplines together, in time. It would take decades of crossover from live-action, plus the advent of digital tools, for the editor to become part of the "combining" process in animation.

The success of subsequent films helped enshrine this approach to production at the studio—and the cutter's role as well. In the 1980s, new corporate leadership arrived with the express aim to revitalize the animation division (only five new animated films were begun after Walt Disney's death in 1966). "We are here to operate this company like Walt Disney laid it down decades ago,"[16] explained Frank G. Wells, the new co-chairman of the studios, to employees.

Meanwhile, live-action cinema had developed its own history, styles, techniques, and cultural impact. These changes had seen the editor grow in creative influence. Jeffrey Katzenberg, the head of Walt Disney Feature Animation in the new regime, had come from those live-action traditions; he had no previous animation experience. Early on in his new job, he attended a color "WIP" work-in-progress screening of the project that was nearing release, *The Black Cauldron* (1985).

The nearly finished film was seen as too dark and menacing. Katzenberg proposed a solution based on what he knew: re-cut the film. He was told that was too expensive, and simply, "We can't edit the picture. It's seamless. It's been made from storyboard to Story Reel to finished animation, and the seams simply go from one part to another. It's not as if you have coverage that allows you to jump from one place in a movie to another and skip over." Katzenberg persevered. "Bring the film into an editing room and I will edit it."[17] And edit he did, cutting out two to three minutes in the name of brightening the brand. Animators were mortified by the editing. They had toiled on these scenes for weeks and were duly disappointed to have their hard work land, for the first time, "on the cutting room floor." The act of seizing the film to edit was unprecedented. The Katzenberg cut was a blunt novelty, but also the first

recognition that the role of editing in these films had been missing—and that the role could change.

Editor H. Lee Peterson was part of a generation of artists and executives steeped in live-action, both in terms a stylistic sensibility and methods. His initial encounter with feature animation came on *The Little Mermaid* (1989), the first in a series of musicals that launched a Disney revival in that era. He ran into traditional methods as they were working out the story, from storyboards to Story Reels. "The x-sheet ruled," he recalls. "Every frame was accounted for, dialogue and music. Basically, on that sheet of paper you're looking for tentpoles to put this thing up—and this is great, something that is one thousand nine hundred and seventy-three frames." (Eighty-two seconds.) Peterson experienced a strong reaction when he violated the orthodoxy: "Once I extended a scene [in storyboards] and they said, 'What are you doing? You're ruining this!'"

Peterson started to push the traditions a little further on *Aladdin* (1992). Instead of cutting and patching paper records to abstractly reflect sound-picture synchronization, he started to cut up selected transcriptions of actor Robin Williams' improvisations. Peterson called his process "ransom note editing."

While live-action approaches were helping to scratch at the surface of possibility, its tools had entered the standard studio practice, too. Sound had come to magnetic tape after World War II, and it was now possible to splice and edit on its own 35mm gauge reel. Editing tables—KEMs and Steenbecks—brought larger screens and easier operation than the old upright Moviolas. But changes were still time-consuming and even physically challenging. Story Reels were still shot on 35mm film, and overnight lab runs remained in the way of workable picture. Clear tape splices showed on each picture cut—a sequence that had been worked over would reveal the indecision in a flurry of bubbly patches on screen. Dull "bumps" often accompanied repairs to the 35mm magnetic sound track.

Peterson occupied the role of editor now. Yet his paper cuts show that the edits he planned to make demanded to be worked out very carefully ahead of time, as directors had been doing for decades. The cel animation process required it. Any changes were manually tracked to the frame on the x-sheet, as they always had been. Director Kirk Wise (*Beauty and the Beast*, 1991) confirmed that he was still grounded in the "old school" sense of editing. "In live-action they shoot a lot of film and then cut it after the fact," he said. "We don't have a lot of outtakes and extra footage left over."[18]

Fast Forward

This review of animation history stands as both continuity and contrast to the developments in film editing that appeared in the *Toy Story* moment. For here was a core of classically trained story artists and animators pitching to each other with pinned-up, pencil-drawn paper boards, continuing a long-standing tradition. Unkrich's arrival proved to be the unexpected, missing link between traditional animation and an entirely new approach.

Given his experience, Unkrich set about his assignment on *Toy Story* with a live-action editor's mindset; given his film school training, he tried to fill in the gaps in his animation knowledge by analyzing the canon. The paradox here lies in his recognition that traditional animation processes applied neither to the tools he had at hand, nor to the opportunities posed by Pixar's virtual sets and cameras. "I saw an opportunity to treat the film like any other film and just ignore the fact that it was animated," he recalls.

VIDEO 1.1 First Cuts (3:30)

Live-action editor confronts the first CGI animation, looking to the past for clues.

"You went from technologists and animators who didn't understand the language of film to a group of people who did understand the language of film," explains McDonald. "That is the primary transformation that took place in those early days. Lee was a filmmaker who understood long form, understood story arc—what needed to happen in ninety minutes. That was the evolution that took place. That's why they really valued him. He was open-minded, and he loved to just brainstorm, put an idea up there. Lee was able to do that on the Avid. I think up until that point, they had thought about editorial like some kind of a necessary evil—as if it was a constraint. It wasn't a constraint. Editorial became the opposite of a constraint."

Director Lasseter "started to understand the value that the editor brings to the storytelling process," recalls Unkrich. "He included us more and more in the story room where, rather than just being delivered the equivalent of dailies to our cutting room, it was like being invited to the

set and given the opportunity to whisper over the director's shoulder, or to talk to the writer a little bit and make a suggestion. They would pin up all the storyboards, and I would have the opportunity to look through the scene and catch problems ahead of time or identify moments where maybe we could be a little more cinematic, or the storytelling could be a little clearer, or a cut could work better. All those little things that an editor doesn't typically have control over, I could contribute at that early stage." Unkrich is referring to his experience in live-action, where an editor is not "typically" included in the story planning or the script writing stage. (His "cutter" ancestors in cel animation were certainly not included in this stage, either.)

The studio's leadership seemed well aware of the stakes in making the first computer-animated movie: theirs would be seen as defining a new medium. But they also knew that no amount of dazzling visuals would make a dull story riveting. An effective, emotional story would be the most highly valued key to the film's success, lasting in the memories of generations of viewers. Because every frame of animation is so expensive, the storyboard stage was the time to make mistakes and solve problems. The studio put their value system into practice on *Toy Story*, reworking and reworking and reworking the Story Reels until they were clear and engaging.

Instead of carving a feature-length runtime from hundreds of hours of live-action material captured on set, the animation editor starts in a void and must actively build a conception of the film before it is shot, with storyboards, or "unfinished comic book panels," as editor Bullock describes them. Up to 75% of a Pixar film's production timeline is filled with those storyboards made from pencil (or now, digital) sketches drawn by story artists, from which the editors construct, along with dialogue, a compelling, entertaining Story Reel experience. If it "plays" in pencil poses and non-professional performances, it will "sing" in Technicolor, voiced by stars.

The second critical difference the editor discovers here, compared to live-action editing: sound exists before picture. The freedom—and the responsibility—to construct performances out of disembodied actor recordings gets to the heart of the matter: a character cannot be animated until the vocal performance is locked. The voice recordings always came before the Story Reels, but now, with the flexibility of a digital medium, both dialogue and sound effects are not confined to the constraints of film and tape. The fact that sound is not tied to picture in animation as it is in live-action—given that live actors are bound inextricably to their

Unkrich says, *"A Bug's Life* ended up being such a gargantuan opus that I probably worked harder on it than any other movie."

Unkrich helped shape and solidify the studio's editing process going forward, based on lessons learned from early wrong guesses and low-ball estimates. *"A Bug's Life* represented a pretty radical departure from how we had made *Toy Story*, both from a technical standpoint, as well as just creatively," he recalls. *"Toy Story* was just breaking new ground, trying to figure out how the whole thing worked," says Bullock. "On *A Bug's Life*, we got to learn from the mistakes and completely revamp the system." The increased demands of the epic film, in addition to the growing studio slate, prompted growth in the editorial group—and a chance to test this way of working with new recruits. Unkrich first brought on someone who shared his film school pedigree, former USC colleague David Ian Salter. He observed Unkrich's involvement and how Pixar is "unique in realizing the importance of editorial feedback."

Move to the Center

This process, which puts editorial in the center of a production wheel, was honed on *A Bug's Life*—and has endured at Pixar since. "The film is made in editorial, it really is," says Anderson. "We have multiple departments, but the nexus is editorial." This notion of a nexus marks a significant paradigm shift from live-action, where editing is the last stop in a line, after pre-production and production. In comparison to animation at the time, what changed in the production process puts in sharp relief the expansive new role of the editor in animation. Putting the stages in numbered order here helps for clarity, but also risks creating the illusion that these projects always move forward, when in fact the process allows for, and even welcomes, mistakes that send everything backward, to be edited all over again. This happens at every point listed. To summarize:

1. **Story Pitch:** Scenes (storyboards) are still pitched and plussed in a group setting, much as they had been traditionally throughout the industry. The big difference is that now, editors are welcomed to the story room. There might be several iterations of this pitch before agreement to move them to the next step.
2. **Story Reels:** The boards and a script are delivered to the editorial team, no x- or bar sheets included, with the aim to translate the pitch to sound and picture on screen. ("Animatics," has been a term

in advertising and elsewhere for what is generally the same thing as the "Reels" or "Story Reels" at Pixar.) The boards have no duration—the editor decides how long to hold on an image. Also, the editor now has their digital hands on the dialogue, making complex, often miniscule changes in the performances. Free from the mechanical constraints and inflexibility of separate physical sound and picture tracks, they can finesse temporary score and sound effects, bathing in the luxury of multiple tracks. The process establishes editorial as the place where the film lives, in continuity with sound. It is visited and revisited often—daily, for years—to improve on story structure, character development, tone, pacing, and momentum. The computerized editing system will eventually track the frame-count changes automatically, rather than them having to be manually tracked on pieces of paper. The bar sheet and x-sheet have transformed into a "timeline" now under control of the editor.

3. **Layout:** Completely transformed: this is where the CGI begins. Instead of theatrically painted background art, virtual characters can now be seen through a virtual lens in a three-dimensional set. The principles of live-action cinematography apply so much that in a few years the layout credit would become "Director of Photography." Editors can give input on coverage and ask for additional footage. Again: a much less pre-determined, more malleable process than had been seen in either animation or live-action.

 The appearance of the sets and characters is crude and primitive compared to final animation, but the power of 3D presented an opportunity for students of cinema such as Unkrich. ["3D" here will mean that virtual sense of space and perspective, as opposed to the 3D effects associated with stereography and movies exhibited "in 3D."]

4. **Animation:** This expensive, time-consuming stage has fewer shot-based changes, but the editor will remain involved until the film delivers. The animators, as actors, add their interpretations to characters' expressions and actions. The editor has to make sure the integrity of the scene remains intact: that the shots "hook up" well and the original intent and effectiveness of the scene from the storyboard stage is honored. Subsequent stages, such as lighting and rendering, could be considered the modern analogs to "ink and paint," presenting the editor with fewer and fewer changes to review as the film settles into an overall, structural integrity.

VIDEO 1.2 Stages of Production (3:40)

Editor Torbin Bullock offers an introductory overview of the stages of production from an editor's point of view.

MR. POTATO HEAD™ © Hasbro, Inc. Used with permission.

Into the Core: Failing Fast

"Every one of our movies is lousy at some point," explains Docter. "It's just that we allow ourselves time to fix it."

How does Pixar use that time, and how do they fix things? If Pixar's proven process is not a series of story disasters followed by a "crunch mode" of creative heroism, of inspiration and force of wills—what exactly is it? The answer lies in a set of nuanced skills and concrete practices, at the heart of which is film editing. The distinct approach developed for CGI films, beginning with *Toy Story*, allowed the editor to move from the edge to the core of production. Pixar editors describe their contribution as delivered from the hub of a production wheel, with spokes such as story, performance, sound, and camera radiating out from—and returning to—the editing room.

All editing is understood as an invisible art—partly because one rarely has access to the problems and choices an editor faces, and partly because a classical narrative film usually works best when editing is not expressly noticed by the audience. The best film editors know how to hide their tracks; their work hides at the center of things. Film editor Nicholas C. Smith, a veteran of live-action before working at Pixar, declares, "It's an impossible conversation to even tell people what live-action editing is, and that's much more clear cut" than computer animation. Live-action is clear cut because the editor is in a line, behind the writer, the performance, and the production. "Workflows" there had traditionally been like rivers: things flow one way, with editing and post production at the end. But the Pixar workflow, with the editor in the center, is more like an Escher staircase. Instead of taking work and passing it on, it is constantly swirling around them, and they can reach out and touch numerous parts of it on any turn (production schedules permitting).

"At one point in the film," says editor Ken Schretzmann, "part of it's in storyboard, part of it's in layout, some of it's animated, some of it's being rendered, while some of the scenes are being rewritten. You think

you're done with a cut and something comes in from another department, and you make adjustments. It can make editors a bit crazy, but it's also exciting because, since you are working with such extraordinarily talented people, when you hand off a shot to another department, you know it's going to be so much better."

As all film production seems to move inexorably to a digital process, this new model has become common not only in animation but in live-action. Still, the editor's contribution has remained little-understood outside of the teams who work this way.

Certainly, Pixar editor Kevin Nolting looks forward to the day when a popular film critic can appreciate the role of the editor in creating any animated film. "At the Cannes Film Festival we premiered *Up* opening night. I saw the critic from *Time* magazine. I've seen this guy my whole life, so I went up and introduced myself, and said, 'I was the editor on *Up*.' And he said, 'Oh, dailies must have been easy for you.' So I tried to explain that actually, no, they weren't: 'Animation editors, not only do we cut the movie, we're involved in the story.' I don't think he got it."

Figure 1.1 Hub of the wheel diagram from *The Incredibles* (2004).

© Disney / Pixar.

Historically, this misunderstanding has made Pixar editors prone to oversimplify, joke, lie, or evade in response to the question, "What exactly do you do?"

VIDEO 1.3 "What Exactly Do You Do?" (3:05)

You're at a cocktail party, and someone asks what you do. If you "edit animation," the answer gets complicated.

The movement of the editor from the background to the foreground, from the periphery to the center of the Story Reel process, was recognized by Jobs as a metaphor from his software development experience: "In essence it lets us beta test and iterate our film before we make it," he said. "Totally different from live-action filmmaking. And we believe it's one of the reasons the hit rate can be substantially different." Knowing from numerous iterations with editorial that he had such a success with *Toy Story* does not make it any less daring that he took his company public before its movie had been seen by the public; it just reveals the inside knowledge, or secret, to which he had access.

Hundreds of computer-animated feature films have been made since *Toy Story*, as have "live-action" films with animated characters and numerous other, CGI elements. As a result, all of them bear at least a trace of the editing process that took shape in these early days at Pixar, when editors seized an opportunity to contribute in unprecedented ways.

Notes

1. Paik, K. 2007. *To Infinity and Beyond! The Story of Pixar Animation Studios.* Chronicle Books. p. 101.
2. Reilly, C. October 23, 2018, *Pixar Co-Founder and Godfather of 3D Animation Ed Catmull to Retire.* CNET.
3. PBS, *The Charlie Rose Show*, 1998.
4. Spark Animation. 2020. *The Women of Disney/Pixar's* Toy Story: *Defining Digital Her-izons.* https://sparkanimation.eventive.org/films/5f765edbe492370045637dd4. Accessed 2020-10-26.
5. Paik, K. 2007. *To Infinity and Beyond! The Story of Pixar Animation Studios.* Chronicle Books. p. 93.

6. "Interview with Tom Lawson, Dean of CalArts School of Art, January 2007." clancco.com/wp/2007/01/intervview_sergio-muoz-sarmiento_cal-arts_law/. Archived from the original on 2013-05-10. Accessed 2012-03-19.
7. Catmull, E. 2014. Chapter 6. *Creativity, Inc.* Random House.
8. Thomas, B. 1991. *Disney's Art of Animation*, Disney Editions. p. 14
9. Bell, D. *Oral History with Marc Davis*, Margaret Herrick Library, Academy of Motion Picture Arts and Sciences, Catalog no. OH136, p. 325.
10. Thomas, F. and O. Johnston. 1981. *The Illusion of Life: Disney Animation.* Disney Editions. p. 207.
11. Thomas, F. and O. Johnston. 1981. *The Illusion of Life: Disney Animation.* Disney Editions. p. 207.
12. Thomas, F. and O. Johnston. 1981. *The Illusion of Life: Disney Animation.* Disney Editions. p. 212.
13. Thomas, F. and O. Johnston. 1981. *The Illusion of Life: Disney Animation.* Disney Editions. p. 207.
14. Bell, D. *Oral History with Marc Davis*, Margaret Herrick Library, Academy of Motion Picture Arts and Sciences, Catalog no. OH136, p. 325.
15. Deja, A. 2015. Preface. *The Nine Old Men: Lesson, Techniques, and Inspiration from Disney's Great Animators.* Taylor & Francis.
16. *The Little Mermaid Platinum Edition* DVD. 2006. Buena Vista Home Entertainment.
17. Thomas, B. 1991. *Disney's Art of Animation*, Disney Editions. p. 114.
18. Thomas, B. 1991. *Disney's Art of Animation*, Disney Editions. p. 159.
19. Kit, B. January 18, 2019. "'Toy Story 3,' 'Coco' Director Lee Unkrich Leaving Pixar after 25 Years (Exclusive)." *Hollywood Reporter.*

"Story, Story, Story..." **2**
Edi-storial

> The way we work at Pixar is we write the script but then we quickly move on into Story Reel…all in an effort to basically sit in the theatre… and watch the movie before we shoot it.[1]
>
> —Pete Docter (*Monsters, Inc., Up, Inside Out, Soul*)

Origins of Story: The Screenplay and the Pitch

Live-action editors are often said to be the final writers of a film—shaping the story based on their reactions to footage arising from countless choices and chances on sets and locations. In animation, editors were historically left out of the story development process for many good reasons. But a creative environment open to new roles, combined with the powerful, new application of digital tools on *Toy Story*, made Pixar editors writers from the start of a production. Editors would go on to develop extended, boundary-busting partnerships with story artists, which elevated static, black-and-white drawings into engaging Story Reels on all their subsequent films. Using their cinematic imaginations, editors aim to make these pencil drawings feel like a movie, to "make it play" with dialogue, sound effects, and music.

Screenplays always stood as more of a cornerstone to live-action than animation. "Screenwriters as such have never been of much use to us," Walt Disney said. "Nearly all of our story men started as artists years ago. They think in terms of pictures. That's how we tell our stories,

DOI: 10.4324/9781003167945-3

Figure 2.1 Storyboards from *A Bug's Life* (1998).

© Disney/Pixar.

not with words."[2] Editor H. Lee Peterson confirms that during his time at Walt Disney Feature Animation in the 1990s, "We take the script, and that's like Part One. You set it aside. And then you storyboard it— it grows out of that. They don't have to hold on to a script." With the Burbank studio as both a creative inspiration and a source of production finance for Pixar, it follows that they have no writing department

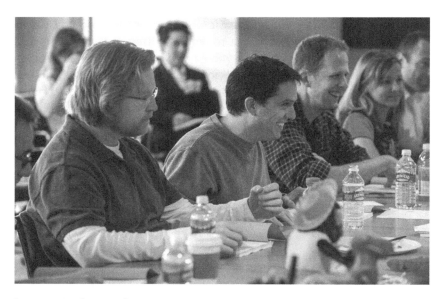

Photo 2.3 Pitches are fun (*Toy Story 3*, 2010).

© Pixar. Photo: Deborah Coleman.

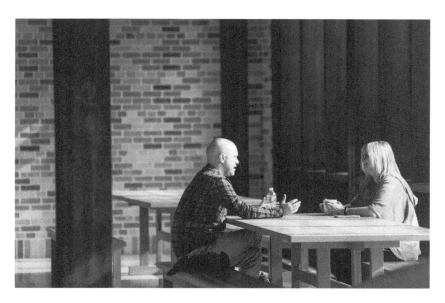

Photo 2.4 Editor Catherine Apple works through story ideas with director Dan
 Scanlon (*Onward*, 2020).

© Pixar. Photo: Deborah Coleman.

The story pitch is a ritual arena which Pixar carefully reconstructed from that classic story room—this was the core of that Disney legacy Pixar sought to emulate. Drawings are tacked on large cork boards, over which curtains are draped to prevent the assembled audience from getting ahead of the pitch (soon, digital tools would allow similar control over the presentation). The story artist has revised and rehearsed their sequence into a multimedia performance—voicing multiple characters (from Sergeant to Mom), simulating sound effects ("door creak!"), and miming physical sight gags (*duck that punch!*). Out of deference to the presenter's vulnerability in their solo effort, the pitch room is often charged with social encouragement, much like some acting auditions: easy laughs and a welcome reception, regardless of the critical response that will come after the initial pitch. When successful, this charismatic display gives the pitch audience a front row seat to the feeling a scene can have when it comes to life with actors, animation, and a detailed sense of place. Usually, there is at least some part of the sequence that will send the artist back to the drawing board for revisions before it can move into editorial.

The Pixar editor's presence in the pitches opens an almost imperceptible gap between old tradition and new approach. The story artist, like a stage performer, can sense in the moment—and adjust to—that audience and their energy in the room. The editor is practiced at gauging an audience reaction, and in the story room the editor also watches and listens, knowing all the tools they will *not* have at their disposal when this sequence of drawings lands in their editing room: the presenter's personality, voice, and acting. But also the tools they *will* have: frame-accurate timing, complex sound effects, and temporary music. Witnessing the pitch gives the editor a chance to start filling in the gaps and shoring up the strengths with ideas from their kit. Editors look to see whether the "coverage" is adequate and the transitions smooth before wrestling with them on a screen. If the editor senses a confusing gap from one panel to the next, they can ask for an in-between or alternate board on the spot.

Editor Anna Wolitzky explains, "It's very helpful to be in the story room while it's being pitched, because I can hear a lot about what the intention of the scene is. If they don't deliver that to me, I could bring it up to the director and the story artist: 'This isn't reading for me.' If somebody laughs during a pitch, I try to tune into that and think, 'Well, okay, what was everybody laughing about?'"

Editor Nicholas C. Smith describes "open discussions about how a sequence should be played, or how the movie should be played. Even if

you're just a fly on the wall, you're part of that conversation and it affects your work down the line because you know what these characters are supposed to be doing."

The Challenge of the Story Reel: Theory to Reality

The story artist's impressive hybrid of talent, skill, and enthusiasm does not necessarily translate to the screen. What if the joke or the emotional moment does not land when the editor cuts the boards together? Editor Axel Geddes observes that often, "In the story department where everything is theory, it worked great. Then they bring it into the lab where we run the scientific experiments—where we expose reality—it just doesn't work."

Creating a Story Reel out of the storyboards was always challenging, but the possibilities were limited in animation's Golden Age, when drawings were shot and edited on 35mm film, and any changes were labor-intensive and damaging to the film. No wonder the director had to plan it out on paper as best they could. Digital editing gave computer animation editors a new toolbox, allowing them to work non-destructively. That is, they could make one version of a scene, copy it, and risk trying something completely different—including complex, nuanced manipulations of sound and picture, resulting in more fully realized scenes. As a result, the editing room became a more flexible, ultimately transformative place at this crucial stage in the creation of the story.

Digital editing made it technically possible, but no less daunting creatively. A sequence arrives as a stack of boards (now digital files) that have been approved to go to editorial. The editor opens a new, empty project to set up the "experiment" that will "test" the ideas. Not only do editors start in a void—there are no boundaries. "We're really starting with nothing, just silence, and then starting to layer in and build, moment by moment, both sound and picture to try to create a reality for the audience," says Unkrich. "It's always been very interesting to me, the idea of the artifice of what we're doing. Every last, little thing that we put together—every component, every bit of picture, every syllable of dialogue, every sound effect, every little bit of music—they're all coming from these different places, and they shouldn't have anything to do with each other. But when you put them together just right, you end up with someone sitting in the audience having an epiphany, or crying, or laughing. And I love that."

Pixar editors spend years on one movie, contending with these malleable storyboards. They do not give up on those boards until they get them right. Editor Greg Snyder confirms that it is "relatively inexpensive and simple to make big story changes in your first versions of the Story Reel. Often we'll put together a scene and the director will want to take a completely different direction, and we'll throw it out or throw out half of it and start over." Director Andrew Stanton's motto is "Fail Early": use this drawing stage to get the bad ideas out of the way before moving on to the more permanent and costly stages of production. There is no template or formula for an effective story, so the commitment to work out bad ideas means trial and error. Producer Darla K. Anderson confirms, "I'm looking for an editor who understands that nothing is precious, that what matters most is story, story, story. That's easy to say but more difficult to manifest when you've spent a kajillion hours on something and it might just be trashed or jettisoned in lieu of a better idea in the moment that somebody might have." When they say, "Story is King" at Pixar, this is *how* they mean it.

This extended, iterative process is unusual. Editor Catherine Apple brought to Pixar her experience at numerous other big animation studios. Elsewhere, she found, "They depend a little bit more on the script— it's a different type of movie they're sometimes making." Reasons for greater adherence to a script might involve shorter production schedules, a musical format, or an emphasis on slapstick humor. The fluid nature of Pixar's story development over an extended period also includes the editor: "You're a lot more involved in the story process, because you go to a lot more script and story meetings," says Apple of her experience on *Onward* (2020). "I enjoy that part a lot. We are in the beginning of the project and in those meetings you can read between the lines, or see what someone wants to try. I personally think we should always be involved."

VIDEO 2.1 Timeline Years Long (1:05)

"Since it isn't part of live-action filmmaking, it's hard for people to imagine the amount of time we spend working with story— before animation, before actors, even. I made this timeline based on our experience making *Up*, to show how central this process really is to the creation of these films."

—Kevin Nolting

The Script and the Flip Book

When a pitch is given the "Okay" to move forward, the editor returns to the cutting room with the sequence script—always an important initial guide for any editor. But it is understood as incomplete. It will change, and editors will be part of that change. To illustrate the concept: in live-action there may be a three-ring binder for the script. When editors walk into a Pixar editing room they might see 30 three-ring script binders, each representing one sequence—and after a few years of revisions, each sequence can easily have 20 versions. (As with so many paper-based processes, these reference tools became file-based and easily accessible on wireless tablets and other screens, but the quantitative comparison remains accurate.)

Not only does the script keep changing, but the temporary "scratch" dialogue is eventually replaced by professional actors. The editor will then switch out all those lines with new ones, which the actor will invariably perform somewhat differently, often improvising new lines. So the editor keeps rethinking and adjusting the timing and pacing of the cut given these constantly evolving elements. Now factor in the sheer volume of media for both picture and sound that immediately pours into the empty void. Editor David Ian Salter explains that in live-action, you have "one piece of picture and one piece of sound. In computer animation there's a tremendous number of pieces that you're responsible for in an individual shot. It's at least five or ten times the number of drawings and individual pieces of audio." Hundreds of thousands of drawings will be created over the life of the production, and every line will have multiple takes to choose from.

The editors have another guide before they start building the Story Reels. Called a "flip book," it re-caps what they saw in the story room as a printout of the storyboard panels with the lines of dialogue written under them. This gives the editor a handy roadmap to match up the dialogue with the intended panel. But that relationship of boards to dialogue is not always clear and, along with the script itself, is often in a state of flux. Occasionally, the script's actual dialogue has not even been written yet. "That's how crazy it can get," explains Smith. "Sometimes the story artists would actually write in stuff themselves just to give an idea that there's actually dialogue going on."

The Story Artist and the Editor

The best guide for transposing the emotion of a successful pitch into a Story Reel may be the story artists themselves. Many of Pixar's most recognizable dramatic moments have arisen from the editor's close

partnership with a story artist. The "Married Life" scene in *Up* serves as a prime example of the "hypothesis" of a story pitch not yielding the predicted "results" of the editing experiment, demanding the two work through these trials to arrive at a successful version. Story supervisor Ronnie del Carmen acknowledges that when the editor puts together the Story Reel, "It doesn't behave the same way. Maybe it won't ever behave that same way because right now it is in editorial, and the reason that you're surprised, if you're the story artist, is because I pitched it and people liked it very much. But it might need a lot more re-examination."

On working with editor Kevin Nolting, he says, "We could just be stumped together: 'I don't know what to do about that.' 'Well, what do you think it needs?' You're making these moments with emotion and characters—workshopping, collaborating."

Larsen appreciates editor Smith's role in that regard: "He doesn't fall in love with the drawings the way I have. I'm also zipping through the sequence like rapid fire and then it needs to play a bit differently, be extended or compressed. He's thinking in terms of cadences, too, and what happened before or after—'how can I differentiate, or harmonize, with that?' When he makes changes, I become the audience again. I'm not anticipating the next pose, the next shot. I'm freed up to react. There's a different way of looking at it. The editor is really powerful for that."

In the optimistic Pixar culture, the editor's role as truth-teller can be pronounced. Smith sees the pitch room as an enthusiastic environment: "They're all laughing. It's all hysterical. Everyone says, 'This is going to be great.' It goes in editorial. We cut all the stuff in. We can make it play somewhat, and guess what? It's not entertaining. It's not funny. It's such a shock seeing it in the new medium, seeing it on screen. People say, 'Well, it worked in the pitch, but now it doesn't work in here.' We're the comedy killers." "Entertainment killers" (which editors have also been called) is an amusing label, but it identifies a role that all editors take seriously. The cutting room, Smith says, is "where the rubber hits the road."

A live-action editor deals with this reality check as well, when the director sees the first assembly of the raw footage and wonders why, for example, the crew does not laugh now, as they had watching dailies or in video village. But live-action editors can only work with what lands in their cutting room after shooting. They do not get to be a part of the writing process when the movie is first taking shape, where the Pixar editor is integral.

Fortunately, the editor can ask for different poses, shots, or even lines of dialogue. The logistics of such "reshoots" is an entirely different issue

pacing all contribute to a scene that comes to life out of the most simply crafted elements.

"Visual Writing" Methods

Editors have their guides: pitch, script, flip book, story artist. But once they sit down to start editing, how do they approach it? What are they looking at? Their practical approach is full of minute detail and counter-intuitive surprises unique to Story Reels. Few editors have experience to prepare them for the task; Golden Age animated films did not have creative precedents for an editor, since the timing and sequencing of storyboards had originally been planned out by the director and story artists. For live-action editors, the foreign language of editing storyboards has little in common with the one they know. Editor Robert Grahamjones explains, "The major divide between animation editing and live-action editing is all the manipulation you do with storyboards. In essence, I call it visual writing, and that component is not in live-action at all. In live-action you just have to pick the pieces that make the rhythm work in the way you want it to work, but there is rhythm. With boards you create your own rhythm, but it takes a while to understand it. There were several bigger Hollywood editors who came to Pixar and just couldn't crack the code."

Editor Salter also has a background in live-action. "Cutting storyboards is a very specific kind of editing," he says. "Editors who actually haven't tried can't fully appreciate how very specific the skill set is. In live-action, you're working with footage that plays at 24 frames a second and there's usually production sound that goes with it, so there are whole chunks of things that are already pre-built for you. Whereas in animation, you're responsible for placing every element, for building it from the ground up."

In live-action, because the editors are presented with a reality that occurs with actors interacting in actual sets or locations, they will often say the footage will "tell you what it wants to be, will tell you when to cut." The animation editor cannot follow the maxim "cut from the gut." Rather, they must imagine how a scene should play beat by beat, moment by moment—and build all of it. They have to choose when a character moves, when they speak, when they walk, when they turn, when they blink, when they think. None of that timing exists.

Editor Torbin Bullock describes a "level of reactivity that you basically get for free in live-action. Walter Murch [film editor and author of *Blink*

of an Eye] talks about this idea that we have a tendency to make cuts at places where characters would normally blink. There appears to be some physiological connection between a person thinking of a new idea and blinking, that's why editing works. You're cutting to a new idea. But it's all reactive. In animation, you don't have any of that."

All film editing, at its most basic, is about change—about transitions that create momentum and involvement. However, a change in a Story Reel—from one storyboard to another—presents unique challenges for the editor. Storyboards are missing live-action's constant flow of movement and internal rhythm, whether it be actors, objects, or the camera itself. Instead, the editor is cutting from one frozen moment to another. Because of that, any change in the image will draw the visual attention of the audience. Most of these changes are not meant to reflect "cuts" from one shot to the next, but rather moments of action and expression within the same shot.

Storyboards from *Monsters, Inc.* illustrate how subtle a change can be: Sulley is listening to Boo in drawing 32312 in Figure 2.2. The lines are economical and the change in his expression is subtle, almost imperceptible, from board to board. Pinned on a wall, these two pieces of paper are a kind of visual game, a challenge to find the difference.

The editor fixes these images together in time: when the two boards are viewed in sequence, anyone can immediately read the surprise and curiosity registering in Sulley's eyes as they widen. From as few as two well-timed images, the story and eventually the animation come to life: there is thinking and feeling happening on the screen. A sequence of boards like this, where the background and framing stay the same, are called A-B drawings and can extend to C, D, and so on—meaning additional slight changes in expression, while the background stays the same.

VIDEO 2.4 Moving Stills (:04)

But when cut next to each other and viewed in sequence on a screen, the same change in these drawings is a clear but subtle emotional expression. Unlike Hitchcock—and most live-action storyboards— the drawings here show no camera move, no blocking. The emphasis is on reading a character's emotion quickly and clearly (*Monsters, Inc.*, 2001).

Figure 2.2 When a cut is not a cut (two stills from *Monsters, Inc.*, 2001).
© Disney/Pixar.

(*Monsters, Inc.* was made when story artists photocopied or redrew backgrounds from A to B, causing the backgrounds to "bounce" slightly when edited back-to-back. This is evident in the two frames displayed here. The slight bounce in the boards was never a distraction for Story Reels that played. Now that the drawings are done on digital tablets and registered digitally, backgrounds are consistent.)

Above all else, the edit must be clear, ensuring that each change in storyboards can be taken in (as opposed to noticed) by the audience. For instance, two characters change position from one board to the next: one character suddenly turns on the left side of the screen, and the other character on the right side of the screen grabs something. The audience's eyes will inevitably go to one motion or the other. Their eyes do not

catch both, which means they are missing information and bound for confusion.

As a result, editors are hyper-aware of where the audience is looking within the frame and tracking their "eye fix" to lead them from one shot to the next without confusion or distraction. Editor Smith explains, "In live-action, you'd see where to look because you'd see action over here. In storyboards, you cut to a board, and you're like, 'Where do I look?,' because nothing is moving. You need to get to a motion board quickly within the first two or three frames so your eye can go where the action is meant to be. In a dialogue scene, when you cut to a character, it's good to have some mouth movement right away so you know who's talking, especially if it's multiple characters in the shot, so your eye is told where to go."

The editor is also free to decide how long to hold on each board. "With storyboards," finds Grahamjones, "you're almost always dictating the rhythm from the start because you have the choice of how long to put the boards up for." Editor Nolting found this very disorienting: "Holy crap, I can make this scene a mile long, and there's nothing to guide me. That's the hardest thing for editors."

"It took me a while to get used to cutting boards—boards as a whole other way of thinking," Smith remembers of his early encounters. A shot may be ten boards and each board is five frames because that's how fast that person is walking. Maybe you say, 'Well, he's not walking fast enough.' So you go down to four."

In terms of screen time, ten boards at four frames each total 40 frames—about one second and a half of screen time (at 24 frames per second). That is how minuscule these decisions can be. Sometimes, Smith says, "It's best if it's almost close to animation, meaning you have a new board every two or three frames. (Animation would be every frame.)" The other end of the spectrum would be a straight dialogue scene, where a board can last for dozens of frames (several seconds). Schretzmann elaborates on the need to establish movement, "If you want to give the impression that a character is walking, you've got to cut to the next board pretty quickly after the cut. If you hold onto that storyboard a second, you're telling the audience the character stopped and he's standing there now, he's not walking. All of a sudden you have these intro-edit issues that you're cutting and there are different things you have to think about just to present the storyboards." Conversely, an empty frame at the beginning of a cut can be useful, to make sure the audience has time to get the information that follows.

Editors learn to read the action of a board, understanding the artist's intent and techniques. For instance, if a character is moving his arm from the down position to the up position, the editor might also get an in-between drawing of his arm—and realize the value of holding on to that in-between frame for only a very short moment—a trick to smooth out the motion of the arm going up.

Schretzmann describes another example involving something as simple as interpreting a jump. If he sees a board with a character in a down position when he lands and then a board where there's a little bounce after that, he realizes, "Oh I'm not supposed to hold on that frame where his knees are bent, that's clearly like the 'A' [the outgoing frame] to him landing so that's just a quick bounce and then the next frame ['B'] is where I hold it."

In live-action, editors can break rules of continuity. They can cut, for instance, from something moving to the left side of the screen to something in motion from the right to create excitement, a visceral reaction. But in storyboards, because nothing is moving at all, the audience would just be disoriented if a character or object jumps from one side of the screen to another.

All editors develop their own approach to getting started. "My system was just having something to grab hold of for a start, and then you have somewhere to go," says Grahamjones, "because you don't want to be reinventing the wheel every time you start off with these blank boards. So I began with each board being on for twelve frames, then when you start adjusting: 'Okay, I want this little section here to just be six frames, or eight frames.'"

There is no hard and fast rule when editors are figuring out the timing of boards, especially since the drawings do not give them the full range of action; the specifics of the characters' actions will change once they are moving in three dimensions. But here the editor has an opportunity to *prescribe* timing that makes the sequence play, creating a template for the movement of the characters when they are animated.

The editor is free to decide on timing and sequencing of boards which involve a character's performance, because a change in facial expression—which in live-action would take place in a single shot—involves multiple boards. So how long do you hold on those boards? What does the audience need to make those emotions clear? Whether it's a dark-night-of-the-soul moment or a pratfall, the editor has creative control over how long to hold on a board.

Photo 2.6 Steve Bloom edits *Coco* (2017).

© Pixar. Photo: Deborah Coleman.

Photo 2.7 Director Brad Bird (left) works out a story point with editor Darren
Holmes during the creation of *Ratatouille* (2007).

© Pixar. Photo: Deborah Coleman.

Photo 2.8 Editor Greg Amundson runs a review (*Up*, 2008).

© Pixar. Photo: Deborah Coleman.

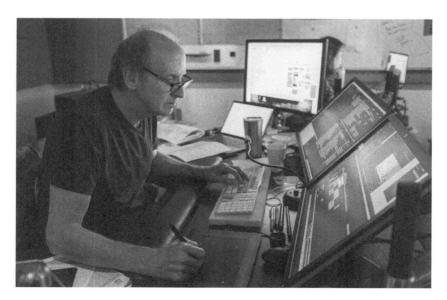

Photo 2.9 Editor Kevin Nolting has got *Soul* (2020).

© Pixar. Photo: Deborah Coleman.

Photo 2.10 Editor Kevin Nolting runs an Edi-storial session with director Pete Docter and co-director and co-writer Kemp Powers.

© Pixar. Photo: Deborah Coleman.

Sound in Story Reels

Editor Grahamjones notes, "You can choose whatever dialogue you want, there's no picture that's dictating that this is going to be the best take because it's what's visually most interesting, in addition to what the dialogue is. In animation they're not connected at all. You have both of those things that you're juggling. It gives you more freedom, but it makes it hard to make a choice."

"You're working in concert with your eyes *and* your ears. You're not just turning one set on. You get a sketch, but don't be fooled. That's not it. That's like the internet dating profile of the scene," laughs editor Edie Ichioka. "That's only half the story. You haven't had coffee with this person."

The type of scene can often guide the editor in making that choice. For a dialogue-heavy scene, Reimers starts with those verbal rhythms, to "craft that performance, make sure that people actually sound like they're talking to each other, that the inflection and the intonation is right, that they're hitting the right words at the right moment. Then I

start timing out the boards, and when I feel that's good, I start placing my sound effects." Editor Stephen Schaffer's approach is to "time out the boards briefly. I won't spend too much time. Then I will cut the dialogue in as I go, so that I can just let the shots breathe as I'm moving down the line, do that simultaneously."

For an action scene, sound effects become more important for the initial assembly of boards in order to time out the actions of the characters. Schaffer describes that approach: "I will cut the boards as tight to the action as I can. Then it's laying in sound effects, because typically with those scenes it's efforts, or grunts, or a yell here and there, so you can layer them in within the action, get the sound effects to match the picture." Sound also can be a priority when editing a scene full of physical comedy. In that case, Schretzmann feels, "Hard effects like door slams and body falls sell your reel."

Ultimately, whichever the editor decides to focus on first, the sound—dialogue or effects—drives the rhythms and sets the pace of the storyboards. Del Carmen fully appreciates the way in which the editor is "thinking in sound, thinking in terms of the cadences. What I did were still drawings in sequence. None of them are talking, they don't have sound embedded in them, and the acting is one pose. The editor will create that illusion of continuous tone and movement, and you will forget that you're watching boards that are flashed one after the other. Everyone will think that they've been watching a filmed movie. That's the illusion, and it's done very well only because the editor does all of that."

A Technical Turnaround

With the advent in the early 2000s of high-quality, pressure-sensitive pens and other digital drawing tools, storyboards escaped the confines of physical pieces of paper. Artists' drawings were thus born digital, as image files. Story artist Larsen explains that, in the past, he would take his sketches and "pin them up on boards, if you had to move something physically, you're like, 'Oh my God—hundreds of drawings, I've got to take it all down, just to see if it'd work.' But with this you could digitally copy stuff, give me more poses, do what you need for the film."

Pixar engineers took further advantage of this development in software called "Pitch Docter" (as in director Pete Docter, who championed the effort). This proprietary application is purpose-built to enable the

the emotional plateau they sought. Instead, Del Carmen and Nolting realized the *preceding* scene, in which Carl and Ellie meet, went off course in its tone. Bidding for physical humor, a childhood version of Ellie surprises Carl with a punch, followed by a montage of the two punching each other silly from grade school to the geriatric ward. Nolting recognizes that, "Part of the reason this wasn't as emotional is all the plot points we were trying to hit. We just overdid it. She's the adventurous one and he's the chicken. And that's pretty much what the whole thing was about."

VIDEO 2.5 Story and the Editor—Case Study: "Carl and Ellie Meet" (2:05)

Story supervisor and editor discuss a collaboration that led to a winning introduction to the main characters of *Up*—after this surprising wrong turn (*Up*, 2009).

They also had created another sequence that basically made the same mistake, a montage of Ellie and Carl dating: swimming, dancing, riding in a hot air balloon—again showing that she is braver than he, which is revealed when they first meet as children.

In fact, their first meeting in the house is, for Nolting, "one of my favorite scenes in the movie." They have immediate chemistry without the long build-up to romance. "It's still essentially the same feeling but it's so much more endearing."

Here is how this shortened, sweetened sequence plays out: the childhood couple leaps into newlywed life by way of a startling time cut—the sound of a child's balloon popping synchronizes to the flash of a wedding photographer. Thus, ten years of their relationship and several minutes of film collapse like a telescope.

VIDEO 2.6 Story and the Editor—Case Study: "Married Life" (3:55)

How a beloved sequence came to life in storyboards (*Up*, 2009).

Nolting views this fluid process—which ultimately made "Married Life" more impactful—to be typical when working with Docter: "Pete's movies tend to change a lot more because he's so flexible about that. In

storyboard stages we're throwing stuff out all the time. We don't worry too much about polishing it. When you work this way, you start to have faith in it, so you're not so panicked. The first couple of versions of the movie are not very good, but you know where you're at in the process. So you know you're going to have time to figure out those problems, and don't worry about it."

Nolting knows this is exceptional in large-scale filmmaking efforts. "The scary thing is, under a normal production schedule in Hollywood, this longer sequence is the version that would have gone out because the movie would have been good enough. It was that iteration time we get, especially with Pete. It makes all the difference."

Another decision that came about during the storyboard process was to not use any dialogue for the "Married Life" montage—lending it the quality and feel of a film from the silent era. They eventually discarded sound effects, too. Nolting remembers that when they were on the sound mixing stage, "Pete just said, 'Let's just try it with no sound effects.' We put the sound effects early on, and with the music and the visuals it wasn't as emotional. So it helped us refine it in a way."

Michael Giacchino's score carries much of the emotional weight of the sequence; the filmmakers recognized the more it was featured, the better the music could do that. The noteworthy aspect of this decision process is how they backed into it; looking at the completed scene, one might easily think they asked the composer for some touching music and boarded a life to that mood and duration. But story artists and editors labored for years before that soulful music so beautifully underlined the emotion—the work that the triad had created.

Del Carmen acknowledges the trusting environment that nurtures this experimental process. "Control is such an illusion in our lives," he says. "It's something that you want, it's like all of us want, some control over our lives—it keeps our arteries from hardening, we think. The reason that we crave it is because it feels like you're able to manage the chaos. Filmmaking is mostly chaos, and you embrace it, and dive in, and make it work for you. You get the results that you deserve."

Toy Story 3: "The End of the Line"

In *Toy Story* and *Toy Story 2*, the toys had faced the heartbreak of not being played with, being stolen, and being given away. But at a climactic point in *Toy Story 3*, Unkrich explains, "We were going to bring this to

a monumental conclusion. Not only throw them away but bring them right to the brink of even existing. There is no way out. So what are they left to do except look at each other and realize that this is it, and they take each other's hands, and accept their fate."

There was very little dialogue in the scene, so this was a particularly visual storytelling exercise. A lot of time was spent working it out in storyboard form, with Unkrich being characteristically very hands-on. Unkrich decided—when dealing with this particularly challenging scene—to go "really old school. We printed out all the storyboards and pinned them up, moved them around. We were cutting and sketching new shot ideas and really shaping it."

Schretzmann's and Unkrich's work had intersected over their years at Pixar, when Unkrich had been both editor and co-director. With Unkrich directing *Toy Story 3*, Schretzmann, as lead editor, looked forward to the opportunity to "learn more about editing, to be challenged." Also, he felt "we were pretty much on the same wavelength cutting-wise, because Lee knew how I was going to put it together. When scenes came to me, they cut so much better. He fixed a lot of problems in the story room before it even got to me."

Despite that story room polish, Unkrich and Schretzmann still had to face many challenges in the cutting room. They were both aware of every dramatic beat and micro-beat—and how delicate the task was to make the sequence build and pay off in an emotionally satisfying way.

They also had to stay true to the specific behavior and relationships of the *Toy Story* characters, since an entire generation of moviegoers felt intimately familiar with them. In the midst of this process, Schretzmann says both he and Unkrich had an inkling that the scene could be better: "We couldn't put our finger on it. I just wanted to get it straight in my head what I was aiming for. Sometimes you have to do that as an editor. Just to understand all the beats that go together."

In an early version of the scene, Woody reacts to the inferno along with the others. In the final version, however, Woody is not shown fully reacting—at first. Having him continue climbing the mountain of trash to get away from the fire, while the others have stopped and accepted their fate, fits Woody's character: he *would* be the last one to give up. The resignation of the other characters finally registers on Woody's face, he then exchanges looks with Buzz and takes his hand—compounding the emotional resonance of the moment.

Schretzmann points out "how important it was for Woody to hold Buzz's hand because in an earlier sequence they refused to shake hands.

That was something, globally, we were aware of." A prime example of what filmmakers at Pixar refers to as "weaving": setting up threads early that will pay off later.

The fine-tuned timing and sequencing achieved in this climactic sequence came as a result of the lengthy period of time that Pixar editors are given to work through story and character issues. This opportunity is especially rewarding for Unkrich, who, as layout artist Jeremy Lasky says, "always needs to try a bunch of things to make sure that his instincts the first time were right. And by the time we got done [at the layout stage] I remember being in Lee's Avid. He had finished his cut and he turned to me and said, 'You know, I just went back and looked at the boards again and realized that it's kind of the same.' So when he finally did lock it for animation, he was 100 percent confident that what he had was the best version of that scene we could come up with. Even though it turns out it was very similar to where we started."

Ultimately, Unkrich says, "It was emotional. It was working for everybody. Moving ahead, it was a matter of not breaking that and just staying true to it every step of the way." As the sequence began to course through the production pipeline—animation, lighting, effects, and rendering—Unkrich and Schretzmann knew which critical, emotional aspects of the scene needed to stay intact. If all goes well, each of those production steps adds to the original intent, and the final reel reviews in the theater can surprise even those same editors who built that scene with still drawings.

When Schretzmann watched the final version of that incinerator scene, "I didn't realize how big a scene it was until we got things animated and lit. It's a different effect when you're watching them go into a drawing of a fire—but when you see the space, the darkness, and the flames, that's a huge impact. They're going into *that*? A dramatic beat in Story Reels that went up to six or seven in the movie goes up to ten."

VIDEO 2.7 Story and the Editor—Case Study: "End of the Line" (2:55)

How subtle changes in timing and sequencing of pivotal moments make the difference in an emotionally powerful sequence (*Toy Story 3*, 2010).

MR. POTATO HEAD™ © Hasbro, Inc. Used with permission.

Brave: Finding an Opening— "Tapestry," "Winter," and "Picnic"

The movie *Brave* presented an unusual challenge for the editor: Smith had to work consecutively with two very different directors and somehow honor both of their visions. The first director, Brenda Chapman, chose to focus mainly on the relationship between the Queen Elinor and Merida, her princess daughter. In the story, which takes place in tenth-century Scotland, the highly spirited Merida defies her refined mother, who is trying to mold her into a traditional bride-to-be. Her father, a king and hunter, is the opposite of refined—encouraging Merida's wild and daring nature.

After years of working with Smith, Chapman was replaced by Mark Andrews. Smith could see they had "different strengths—emotion was very strong with Brenda and Mark is very strong with camera, and strong with gags. The sense of humor is completely different." But somehow Smith was able to help unify the two sensibilities into an entertaining and compelling story.

The contrasting nature of the directors and the merging of both of their approaches plays out very clearly in the three incarnations of *Brave's* opening montage.

The first version, "The Bear and the Bow," is clearly Chapman's, focusing exclusively on the mother and daughter. A montage of their hands stitches a tapestry, setting up Merida from compliant child to rebellious adolescent.

When Andrews took over, he came up with an entirely different opening: a winter scene that only shows Merida's father battling Mord'u, a monstrous bear, who has significance later. But, as Smith says, "I cared about Brenda's vision of the project. I did want to try and retain as much of the bones that were there before, preserve the mother and daughter relationship. It becomes a little tricky, especially on animation where it's three-plus years working with one director. But maybe it was a good thing. Pixar editors have to show a tremendous amount of patience and perspective. You have to dig deep to remember what you liked about certain sequences. But you can, and we did. We fought to retain a lot of stuff that was in the original movie."

Grahamjones says, "When Mark took over, he tried to veer off a bit from Brenda's original idea to put his own stamp on it, but the DNA in the material naturally curved back into Brenda's realm. The editors are very influential in recognizing that type of DNA."

In the final incarnation of the opening, the team was able to combine the two directors' very different ideas into a sequence that effectively sets up many numerous key story points. Smith notes that in his own way, "Mark embraced the emotion of it. He did a great job in coming to the finish line. So maybe you need to strip it all out in order to bring it back and see it for what it is." The editors were able to identify why certain elements in each of the versions worked, regardless of which director championed them—and carry those elements steadily forward through the many changes they were asked to execute.

VIDEO 2.8 Story and the Editor–Case Study: "Opening" (6:00)

The evolution of an opening: so many ways to set up characters, plot, and tone (*Brave*, 2012).

The Takeaway

At the storyboard stage, more than any other, editors have the freedom to construct something based entirely on their internal rhythms and tastes. They sweat it out for many years, giving everything they have, inventing and building up from thousands of little pieces of media, committing to so many decisions to create a coherent whole. The editors also have to keep their eyes on the endgame. As Bullock explains, "The rough draft of a painting is the drawing, but you're still looking at it as a piece of art. In storyboards you're trying to make the movie before you make the movie."

Story artist Larson is very aware of the editor's responsibility, "We're going from drawings to 3D and the editor is always living on that balance. They're the only ones. I don't live on that. I make up drawings."

The storyboarding process clarifies what the film is all about. As editor Geddes explains, "We're trying to give all the emotional beats the time that they need and the support they need in order to be conveyed in a way that the audience can interact with the characters and get emotionally invested."

Even though the drawings are often rough and can look strangely static, the editor must make a scene play—and the repercussions of those decisions are clearly felt. The filmmakers see the irony of spending all this time crafting Story Reels into finely cut jewels the movie's audience

will never see. Schretzmann confirms that "although the drawings will never be seen by the audience, when I'm cutting production dialogue I'm really particular about it because I know that it's going to stick, it's going to be in the final version. The story has to work, my overall cutting pattern better be right."

Unkrich restates the goal: "We want to end up with a set of reels that accurately represents the truest potential for what this film can be." The expressive artwork will be largely invisible even to the production itself as the hungry pipeline moves them into the next stage, layout, where CGI characters become robotic with stoic faces. When the Story Reels do their job, those who do see them will forget they are watching black and white drawings, because the fundamentals have been worked through. That emotional charge—the pathos, or the comedy—will live in the editor's timeline, as bedrock treasure beneath the sedimentary layers of subsequent departments' additions. Those successful moments will ripple out and inspire the creative people who work in the stages that follow.

Notes

1. NPR interview with Dave Davies, Nov. 27, 2009.
2. Thomas, B. 1958. *Walt Disney: The Art of Animation*. Simon and Schuster. p. 22.
3. Hullfish, Steve, March 3, 2020. *Art of the Cut Podcast*.
4. Pallant, C. and S. Price. 2015. *Storyboarding: A Critical History*. Palgrave Macmillan. p. 64.

Conducting a Concerto **3**
Sound

Sound is the side door to people's brains.
—Gary Rydstrom, Sound Designer (*Toy Story,
Monsters, Inc., Finding Nemo, Brave*)

Photo 3.1 Lifted (2006).

© Pixar.

In the earliest days of film sound, percussive rhythm provided the cues for visual rhythm in the animation. *Steamboat Willie* (1928) was pioneering in its technical application of synchronized sound—but the short that

DOI: 10.4324/9781003167945-4

popularized Mickey Mouse was also undertaken by artists with an idea to create something new. "I do not believe there was much thought given to the music as one thing and the animation as another," remembered animator Wilfred Jackson. "I believe we conceived of them as elements which we were trying to fuse into a whole new thing that would be more than simply movement plus sound."[1] It was less edited than it was performed: as long as the music (recorded live in a single, unedited take) and picture (drawn carefully for days) conformed to each other—and the planned 120 beats per minute—a delight awaited audiences unfamiliar with synchronous sound. Subtitled "A Sound Cartoon," this "union" of audio and image was, in fact, the draw, representing "…a high order of cartoon ingenuity, cleverly combined with sound effects. The union brought laughs galore."[2]

Musicians performed together, following a written "score," where sound effects were just another instrument: "Eight bars of flutes, followed by a window pane shattering."[3] These "bar sheets" were an innovation of a talented pianist who first impressed Walt Disney as a silent film accompanist in Kansas City—Carl Stalling, whose diagrams combining musical notation with frame counts became something of a template for the era.

Disney's commercial success with "sound cartoons" inspired imitators and tinkerers to make their own early explorations of music-driven animation. Many of them had learned techniques at Disney, which may have minimized the variation in methods across competitors at the time. Warner Bros.' first Looney Tune, from Disney alums Hugh Harman and Rudolf Ising, was titled to make a punning reference to this post-synchronizing process, *Sinkin' in the Bathtub* (1930). Looney Tunes would also benefit when Carl Stalling brought his pioneering Disney techniques to that series, a great example being *Pigs in a Polka* (1943), where he pushed the comic effects of "over synchronization."

Paramount tested boundaries with Hollywood outsider Oskar Fischinger, whose own approach to light-sound synesthesia did not find commercial support in the studios; his abstract films with intentionally loose sync, such as *Allegretto*, went to museums as "visual music," not to movie theaters as "cartoons."

In all these cases, the sound arrived first, creating a skeleton on which one could hang the animation. That the orchestra included whistles, "moos," "oinks," and vocalizations foretold the elements future editors would have at their disposal: music, sound effects, and dialogue. But no

one at that point could imagine how much control over these elements would eventually rest in the hands of an editor.

X-sheet, the Cutter's Key

At first, it was easier to leave characters whistling or humming. Animated characters were expressed more as *doing* than *saying*. Even as the technical ability to include intelligible voice performances advanced, there was not much dialogue in early sound animation. There are fewer words in *Bambi* (under 1000) than in many Twitter threads. Fleischer Studios' Betty Boop did not have much to say, but her utterances were used, like musical notes, to establish the rhythms and inspiration for hand-drawn animation. Dialogue began as another "instrument" in the arrangement: once recorded, the results could be transposed back into frames by way of the exposure sheet, or x-sheet: "a reading of the recording by the cutter, giving the exact number of frames for each syllable and pointing out where the accents fall."[4]

Story Reels were "pre-cut" to the tempo of recordings that were carefully conducted to suit timing plans for animation. In the beginning, the sound was registered on special cameras exposing an optical track. This naturally required a time-consuming lab run. When the ability to mix one or two additional sound elements arrived, it, too, was a one-shot, real-time recording that exposed film. No wonder editors were less involved in this period—edits of the film were destructive, scraping away frames in the process of making each join of two ends, cemented in a chemical bond. Even when magnetic recording arrived after World War II, the material constraints were blunt: splicing magnetic sound film was time-consuming and physically difficult to undo; editing choices had to be made carefully, sparingly.

They say sound is 50 percent of a film-going experience; certainly, it is a big reason the editor's role on a computer-animated production became so significant. The opportunity for elaborate sound work has a lot to do with the arrival of digital editing. What a pivotal turning point that made of the mid-1990s technology: with virtually unlimited audio tracks and the fast, non-destructive flexibility to experiment, the editor could now construct an elaborate sonic world in fluid relationship with the rhythm of the image—all to serve a compelling, engaging Story Reel. The composer and the actual musical score with

its orchestra performing in real time will come last, not first. There were many others experimenting with digital editing in the 1990s, but certainly Pixar editors helped pioneer and refine this groundbreaking approach—indeed, it helped create a central role for the editor in the studio's production process.

It was an approach that confounded many, and not only in the field of animation: after *Toy Story*, guest editors were often called in to help in the crunch time before a big deadline. The first observations they would always make? "Look at how many tracks are being carried!" Even live-action editors who had made the move to digital editing at the time were accustomed to a production track (the "A Track"), a temp music track, and maybe two effects tracks. Seeing all 24 tracks filled up seemed foreign, excessive even, to editors from conventional live-action backgrounds where it was neither practical nor worth the effort. "Temporary sound tracks have gotten more and more elaborate," says editor Steve Bloom. "We can do eight or nine hard effects tracks, a couple of ambience tracks, five or six music tracks, some dialogue tracks—that's a lot to carry in a sequence."

GALLERY: Conducting a Concerto: *#TimelineTuesday* fascination.

Photo 3.2 Timeline from *Brave* (2012).

© Disney / Pixar.

Photo 3.3 Timeline from *Coco* (2017).

© Disney/Pixar.

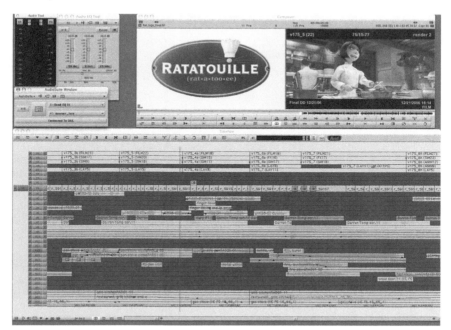

Photo 3.4 Timeline from *Ratatouille* (2007).

© Disney/Pixar.

Photo 3.5 Timeline from *Incredibles 2* (2018).

© Disney/Pixar.

Photo 3.6 Timeline from *Incredibles 2* (2018).

© Disney/Pixar.

These methods quickly took over in live-action filmmaking, as the power of the tools boosted the influence available to all editors.

Sound effects in a Story Reel do the important work of grounding the action of sparsely drawn characters in a specific, believable, physical space and location. Add the sounds of real materials (e.g., "hard effects" of footsteps and door slams) and "background" sound (e.g., "ambience" of birds chirping, traffic, room tone), and the system's dozens of tracks are easily filled in the service of bringing those broad, static drawings to life.

While the "real" music will come later, the editor must simulate the role that the score will play in focusing on emotion for the audience. As is common practice in live-action, "temp" music from various sources simulates the effect a score could have. These multiple audio tracks fill a deficit in the picture to be sure, but they comprise a complex garden to tend for a so-called "picture" editor.

VIDEO 3.1 Sound and the Editor–Track Tour (: 45)

Editor Nicholas C. Smith walks through what lives in all his tracks for a scene from *Brave* (2012).

Dialogue

When the editor creates a character-driven narrative at the Story Reel stage, vocal performances forge the heart of things. "Dialogue is one of those core emotional centers of the film," notes producer Darla K. Anderson. "I just respect it immensely and I give it the time it needs. Like all good art it has to be true." She describes the work of editor and director Lee Unkrich on the many films they made together. "When you look at how Lee puts together a session or even a line—and brings it to the exact place it needs to be in an edit room, and makes it sound as natural and full of love, or sorrow, or whatever emotion it is—he has to be an innovator in that realm, with all the digital tools, to have parsed together all these perfect performances. It's practically like magic."

The effect may be magical, but the process of achieving those results comes from editors learning to hone their intuition for spoken human interaction. Using only their ears, they must find that emotional center

for the characters—without seeing the actor's posture, gestures, or facial expression. As producer and casting director Kevin Reher recognizes, "Dialogue editing is an art unto itself."

Unkrich realized the unique responsibility and freedom he had when editing dialogue for animation. "In live-action," he explains, "you have a scene between two people, presumably the director has filmed a few different angles of that conversation and then presumably multiple takes of any given shot, and in the cutting room, you have some degree of control over the performance of the actor. If I want to use the front part of one take and the second part of another take, I need to cut away to somebody listening for a moment, and then I can seamlessly make a cut so it sounds like one solid performance, even though it's actually made of two different takes. This is standard editing I'm talking about. But in animation, we have a degree of control that becomes almost microscopic compared to that."

Editor David Salter experienced the same mind-boggling freedom that his former film school classmate, Lee Unkrich, had experienced when he first came to work at Pixar, grappling with these untethered vocal performances. "Unlike with live-action," Salter points out, "the relationship among the elements, picture, and sound, is not fixed. You're responsible for their relative placement. Every line of dialogue can be assembled in an infinite number of ways. That's one of the reasons it takes years instead of months."

VIDEO 3.2 Perfect Performance—It's All About Dialogue (1:10)

Animation editors work breath by breath, syllable by syllable.

Editor Ken Schretzmann explains the microscopic precision required to shape a performance. "When I'm cutting dialogue, how the words or the phrases or the sounds are spaced out really makes a difference. I'm constantly fiddling with how tight and how loose the dialogue is, and on the Avid you move things one frame at a time. Maybe it just sounds unnaturally fast, or if I slide it a frame later it feels like an unnatural pause. It's amazing what a difference a 24th of a second makes in dialogue. It's so specific. I love that."

"I don't have to compromise at all," says Unkrich. "Two or three hours will go by on a line sometimes, because I just can't get it. I can't solve

one little part of it, and I keep going through every single take again and listen to that one little part, or then go into other takes of completely unrelated lines, trying to find a breath that will let me connect piece A to piece C."

Building a vocal performance breath by breath, syllable by syllable is like painting a beach scene with one grain of sand at a time. Editor Edie Ichioka reflects on the way that kind of perfection is encouraged. "One thing that I really learned in spades at Pixar is to take it to a totally granular level and do things—that extra five percent—that no one's going to notice except for you: cut not just inter-sentence, but inter-word, inter-syllable, different cuts to form the perfect delivery. It's wonderful to craft something so completely, yet so invisibly. That is something I will always carry with me from Pixar for any animated project or any voice-over where you can really manipulate things that well. I love the ability to manipulate sound so completely." Editor Stephen Schaffer feels, "It's given me a great freedom. We're so intricately involved in the creation of those performances."

Editor Jim Stewart (*Monsters, Inc.*) has heard some say, "'Oh I miss actors.' Well, you still have the actors, but you don't have the problems— the bad habits and cliché gestures and 'um this' and 'um that' and garbling words and not saying the beginning of sentences correctly. You have a lot more freedom to just get the best of every recording session."

The number one priority for an editor in creating those well-crafted performances is to make them believable. What might surprise some is that even a film about talking fish strives for believability—which is not to be mistaken for realism. The audience will not think talking fish are real, but we *will* believe in them, because they have relatable feelings. Sometimes, in order for the audience to be emotionally invested in that way, the editor has to focus on the smallest details. As Schretzmann explains, "If you have two lines stuck together and there's no breath in between, there's something about it that doesn't ring true. But you put one inhale in and suddenly it's *believable*. It is an interesting thing, the ear you develop cutting for animation, because you hear things in dialogue that nobody hears. Some of them sound real, sound true, some of them sound scripted. You can't put your finger on it, but it sounds spontaneous and believable. You just become a lot more sensitive, developing the ear for a true performance, the true emotion, too." Consider the counter-example: Woody's "there's a snake in my boot!" pull-string pronouncements are made flat and lifeless to contrast the emotional range achieved in his "living" speech.

GALLERY: In Character

Photo 3.7 Lee Unkrich with Tim Allen (*Toy Story 3*, 2010).
© Pixar. Photo: Deborah Coleman.

Photo 3.8 Lee Unkrich with Ned Beatty (*Toy Story 3*, 2010).
© Pixar. Photo: Deborah Coleman.

Photo 3.9 Editorial and production team with Ed Asner (*Up*, 2009).

© Pixar. Photo: Deborah Coleman.

Photo 3.10 Editorial and production team with Christopher Plummer (*Up*, 2009).

© Pixar.

Photo 3.11 Productions document microphone setups to get a consistency not available in live-action location recording.

Photo 3.12 Carpet or leather covering on the music stands reduces reflections.

Photo 3.13 Editors attempting to perform live Foley to picture.

© Pixar. Photo: Deborah Coleman.

Photo 3.14 It's not easy, but it's fun.

© Pixar. Photo: Deborah Coleman.

Photo 3.15 Location sound recording techniques bring specific, real-world effects—from imaginative perspectives.

Photo 3.16 Dialogue mixer Vince Caro precisely positions microphones at Pixar.

© Pixar. Photo: Deborah Coleman

Photo 3.17 Dialogue mixer Vince Caro running the session at Pixar.

© Pixar. Photo: Deborah Coleman.

Photo 3.18 Dialogue mixer Vince Caro running the session at Pixar.

© Pixar. Photo: Deborah Coleman.

Experienced editors often describe their pursuit of believability as an instinctual process, something that "feels right." But that instinct is honed after training their sensibilities through trial and error, and drawing on knowledge beyond the cutting room. Editor Axel Geddes observes, "If you have any acting skills or have any of that experience, you can tap into that for making some of those decisions. Because you have to empathize with each of the characters and figure out, how would they be feeling at this given moment?" Schretzmann fine-tunes his sensitivity to credible performance as an attentive student of the dialogue all around him. "I listen to more talk radio than I listen to music," he says. "I'm constantly reminded of the natural rhythm of the way people talk: the subtleties, the rhythms, and how just one little change can affect the meaning of it."

The editor's responsibility to maintain a standard for character believability also plays out when working on sequel franchises. In the case of the *Toy Story* films, the actors were voicing the same characters literally for decades. But even if the actors' performances and the recordings have a technical consistency, the characters can sound different from one film to the next. Not because of changing vocal cords, but rather the editor's approach to constructing the character.

On *Toy Story 3*, Schretzmann found that Unkrich, who had edited *Toy Story* and co-directed and edited *Toy Story 2*, "had a very clear ear for what these characters should sound like. I didn't. When I first started cutting, he would tell me, 'That doesn't sound like Woody. That doesn't sound like Buzz.' Somehow along the way I developed an ear for the characters as well. It just sounds Woody-like." By practicing the art of careful listening, Schretzmann experienced an almost eerie familiarity with the characters. "If I'm at home and the TV's on, and suddenly there's a voice-over and it's Tim Allen—I know exactly who it is. I know the sound of their voice so intimately I can hear a breath and tell you who it is. It's a weird thing to know someone so intimately through their speaking voice."

VIDEO 3.3 Deconstructing Dialogue—Case Study: Woody (2:40)

Ken Schretzmann shares thoughts about—and the timeline for—*Toy Story 3* (2010) dialogue he edited with Lee Unkrich.

MR. POTATO HEAD™ © Hasbro, Inc. Used with permission.

Inventing Interaction

Nicholas C. Smith explains how this sensibility for building the believable vocal performance cannot depend on normal cues found in a live-action editor's palette. "You have to train your ear in a different way to listen to the dialogue, because you don't have the facial expressions, and you don't have that inherent rhythm of interaction. You rarely have two actors performing at the same time. They're all done separately in studios, with the director prompting them. So you have to create that rhythm."

In his 30 years of working in live-action, Smith had learned to rely on that natural rhythm between actors, to trust it as a source of inspiration. "I was just beginning to cut when I was working with Sam [O'Steen, editor of *The Graduate* and *Chinatown*]. "I said to him, 'How do you decide when an actor answers the other actor? What's the rhythm of that?' He said, 'Well, you go by their performance. You hear the other actor's performance on the track and that's your starting point. And you just follow that.' Sam really trusted their rhythms and their professional expertise of the performance on the day. So that was a huge note, but when you come to animation that doesn't exist."

While animation editors don't have the same guides of real interaction to help them, editors such as Ichioka keep track of the bottom line: "Your timing is a human timing. It's not clicking through frame by frame. It's like dancing by putting your feet on the right numbered shoe print on the ground. That's knowing where your feet go, but that's not what you're trying to accomplish. That's not dancing."

Schretzmann says, "You have to believe that these characters are thinking. When one character says something you have to believe the other character had a moment to take it in and then respond. If it's an emotional moment, the dialogue tends to get spaced out quite a bit. But when they're in an argument they're overlapping, it's rapid fire, they're interrupting each other."

The endless control animation editors have with dialogue can also be a liability. "In animation, there's nothing stopping you from pulling out every last bit of air, every pause," explains Salter. "People don't have to take breaths in animation if you don't want them to, because you can cut those out, which in live-action you can do occasionally, but most of the time you can't. You start getting a little trim-happy once you get into that mode. It's seen as a positive thing to tighten your film, make it play faster and better and like a screwball comedy from the 1940s. But you can't keep that frenetic pace going for the whole picture."

Smith concurs, "You get to a point where it's so tight it doesn't feel like the characters are actually listening to each other, so you have to be careful of that. When characters stop listening to each other, even bears and fish, you don't believe the conversation. It's just informational and so you lose the audience. They have to be engaged emotionally and dramatically."

Some editors describe it as "dense clarity"—creating that simultaneous effect without losing intelligibility. It requires attentive editing. In *Finding Nemo,* Salter explains, "when Dory and Marlin would banter, it sounds like they're both just talking nonstop, but what's really happening is only one is saying anything you need to hear at one time and some sounds that you don't have to pay attention to can go in the background. So even though you try to create the feeling of simultaneity, actually, you're only featuring one at a time. Just like a solo in a concerto, where the violin suddenly comes to the foreground. It's something that Lee [Unkrich] clued me into early on: never have more than one storytelling element in the forefront at one time. The viewer only needs to take in one key thing."

Two characters' separately recorded dialogue—whether scripted or improvised—is challenging enough to bring to life. A larger group further complicates the simulated interaction. Says Schretzmann, "Let's say you have a crowd of five, six characters. They're all pleading with Woody [in the 'Day Care' sequence from *Toy Story 3,* when Woody is deciding] whether to stay or go. Each character is recorded individually, so I've got Mr. Potato Head saying, 'Please don't go. Please don't go.' Or Slinky saying, 'Don't go. Don't go.' I have to build all these tracks of the different characters and assemble it in a way where it won't be just this cacophony. So it's a little bit of trial and error to pepper that moment with all the different voices, where a few of the lines cut through. I'm building these tracks and I'm aware of what I want to stand out and what the audience should hear. That's tricky."

Unkrich sees an inherent paradox in using all these hair-splitting precision tools to create something natural-sounding and believable. "It's not like we're capturing this moment of time where everything's together on the set and there's magic and there's actors working together. Whatever I can do to strip away any feeling of fakery, so that people can start to not think about that stuff, and just let them steep themselves in the moment."

Case Study: Russell

It was in the spirit of stripping away fakery that the role of Russell, the young Wilderness Explorer in *Up,* went to a boy with no previous

acting experience. Jordan Nagai was no show-biz kid, and that unvarnished quality instantly sounds believable as a charming eight-year-old—the most natural child actors are often the ones with the least formal training. As editor Kevin Nolting explains, "Of all the kids, the quality of his voice was just what we wanted, and [director Pete Docter] felt it was very important to get an authentic sounding voice." Polishing the performance to fit in the rapid-fire pace and distinct comedic style of *Up* fell to editors Nolting and Katherine Ringgold. They describe going syllable by syllable, and building up a full performance from "little blocks of words. That scene at the door where they meet is hilarious."

"And that's the beauty of animation," says Nolting, "because you don't have to cut to a live-action actor. You animate *after* you cut the dialogue. You can hack their dialogue up into syllables if you want. It forced me to be that much more conscious of how just one little inflection can change the meaning of the line, or to listen better to dialogue—and choose better."

VIDEO 3.4 Deconstructing Dialogue—Case Study: Russell (1:35)

Through microscopically fine cutting, editors Kevin Nolting and Katherine Ringgold preserve the authenticity in a voice for *Up* (2009).

Case Study: Linguini

Lou Romano played the memorable role of insecure, bumbling chef Linguini in *Ratatouille*. Editor Greg Snyder explains, "We were all big fans of Lou's voice, and his hesitancy and nervousness."

Snyder's role is to look beyond the sound of the performance: "I'm trying to think while I'm cutting dialogue: not just looking at the storyboards and serving the expression on the screen, but looking for a way to plus that." He describes the process as though he is mining for nuggets where other people see bedrock. "Maybe there's an inflection here that we can put in. I like this laugh this character is using, I like this little ad lib they put in. Often they end up in this next pass redrawing those expressions and incorporating the dialogue work into the next version of boards. I also always try to imagine what the animation is going to look like at the end: where are the opportunities to lay down some dialogue that an animator can find a hook into, or inspire the

animation to be something more than what's on the Story Reel? Just find some juice for it—something a little extra." Snyder's contribution to Romano's performance can be heard in the scene where Remy, a rat, blindfolds Linguini and, perched on the young man's head, pulls his hair to direct his cooking. Little dialogue was written for the scene. "It was great because I was able to take a lot of remarks that Lou is making to Brad [Bird, director] during the session that weren't in the script. That was really empowering to be able to do that and to deliver what Brad needed. It's ultimate freedom, when the director says, 'Hey, just find some stuff that works here and go for it.'"

VIDEO 3.5 Deconstructing Dialogue—Case Study: Linguini (2:38)

Editor Greg Snyder recounts how he crafted a spontaneous, live presence from Lou Romano's vocal performance of the character Linguini in *Ratatouille*'s "Hair Pull" sequence (2007).

Vocalizations

Dialogue is the foundation of the "illusion of life" sought in most character animation. If the words are bricks, then vocalizations—those little non-verbal utterances—are the mortar. Vocalizations become a huge part of the editor's life and there are never enough; they are always searching for more to add to their collections. Ichioka asks for "an unreasonable number of vocalizations. 'That little gasp you do,' I love that stuff, and I will cut that in. The hiccups, little things, or just breaths, or there's a lot of running. If I loop that, it's going to sound really looped. Let's get some more." Schretzmann wanted something so specific on *Toy Story 3*, he coined a phrase to get what he wanted: "nose sigh."

Editor Sarah Reimers describes vocalizations as "a cough, a throat clear, a sigh, a gasp, a breath, all of these little subtle things that we use to make our characters seem really alive, to have some weight and some volume. They may give a heavy line and then catch their breath, and we craft that from all over the place. That little breath could have been something the actor did in between reading lines. It wasn't actually something they did as part of a line, but we listen for all of that, and we catalog all of that: it's gold to us."

input to the director, but it also serves the editors once they dive in and start assembling the Story Reels because no one lives with the arrangement of voices as much as the editor.

AUDIO 3.7 Arranging a Composition with Voices (:30)

Notice how these voices in the *Toy Story 3* (2010) ensemble could not sound any more different from each other: gender, tone, accent, age, grain—the range is fully considered in the casting.

Even when made decisively, these decisions must be made at least twice. First for the "scratch" performances of non-professional voices that will comprise many iterations of Story Reels, and then all over again when time comes to engage professional acting talent.

Scratch That

The objectives in casting for scratch dialogue are necessarily different than for the final production voice. Certainly, someone with the approximate vocal register of the character in question is desirable: apparent age, gender, tone, and volume are all taken into consideration. While acting ability is obviously desirable, the pool of talent is the employee roster of the studio—because those are the people who can be available on frequent, short-notice demand for a scene reading. A mic is often set up in an editing room to get the material directly into the editor's timeline. The reason could be a race to screening deadline. Also, scratch actors actually have other jobs in the studio to drop when they get that frequent call asking, "Can you come down to editorial to record a few quick lines?"

Yet directors can fall in love with temp voices. They can become irrationally attached to the scratch sound of a character; the writing process is so iterative they might even start unconsciously re-writing dialogue to suit that temp voice. One Pixar project nearly fell prey to the delusion that an adult man, who had been doing scratch as a boy character, was a good choice for production. Because the filmmakers had spent a couple of years growing accustomed to that performance, it just seemed to be a quirky and amusing impersonation of a boy. Placing high value currency on the elusive quality of *believability* required the supervising film

editor to voice serious reservations about the more caricatured choice. The question was then neutrally raised to an outside audience of a work-in-progress, where it only took one person to point out that they were confused by the boy's voice. Many others agreed, and the producer was off with the casting director on a cross-country search for the right eight- to twelve-year-old voice. They would ultimately cast the younger brother of a boy who came to audition for the voice of Russell in *Up*.

Another example of an actor impersonating a character to comic effect occurred on *Brave*. The role of The Witch was pivotal to the story's advancement, but because they felt challenged to make her both untraditional and unique, the filmmakers were constantly experimenting with the character. Editor Nicholas C. Smith remembers, "We just pitched up [a man's] voice a couple of semi-tones. Everybody loved that. We all knew it was going to be temp, but everybody thought it was funny and charming."

They hired renowned British actress Julie Walters to replace the male voice. Although she is a revered actor, "There was this disappointment," remembers Smith. "This happens sometimes. You get used to hearing something in a certain way. You're living with this stuff for a couple years." There was "a big debate back and forth" and then at one point, they had editor Robert Grahamjones put the old voice back in to see if, as Smith says, "We were fooling ourselves. At the end of the day it's for the wrong reason that it was funny."

They stayed with Walters' voice and personality-filled performance.

The very comforting familiarity of the scratch voice is hard to relinquish, as talented as that new, production-ready actor might be. For the editor, changing the performer from "scratch" to "cast" means a complete overhaul of all previous dialogue editing work. Perhaps the professional actors ad lib some great material or simply change the cadence, timing, or general quality of their delivery. The switch from scratch to production dialogue doesn't happen all at once. The editor may have to replace one scratch actor's performance with a professional one, then a month or two later a different character voice, and so on; the editor is constantly adjusting the lines, rhythms, and pacing.

The ongoing requirement to "replace" the already-cut dialogue with a new performance by a different voice is not really as simple as that. The editor is trying to preserve the emotional beats that worked in the Story Reel, and at the same time, make the most of the professional actor's performance. This challenge, unique to animation, has given rise to various techniques among editors for managing the double duty.

Editor Steve Bloom notes, "When Lee said, 'I have the scratch and it's working,' essentially what he's saying is, 'I want to make the production dialogue hit the same spots.' Whether we did it in exactly the same way didn't really matter. It was, 'This is what I'm trying to get.'"

VIDEO 3.8 Enhanced Performance—An Approach to Dialogue (14:30)

Editor Lee Unkrich shares a deep dive into his technique for replacing scratch performance with production dialogue from *Coco* (2017).

When it comes to professional upgrades, sometimes the director carries false hope that the final casting choice will make certain issues with a character go away. But, of course, some problems are rooted not in the quality of the voice, nor in the performance. Rather, they arise from the writing. Successful editors take on the role of realist, bringing attention to issues on screen that a change in voice casting might not solve.

On Set: The Recording Session and the Editor

Once the film is cast, the recording begins—first for scratch, then again for production. Many, many rewrites and iterations ensue, over months and years. Some actors might accept an invitation to voice an animated character, under the impression it is a lightweight task compared to appearing on camera. While the demands of makeup, stunts, and costume are nonexistent, the actor must adapt to their absence. No other actors to play against, no facial expressions or gestures to convey intent: *"Look ma, no hands!"*

Schretzmann observes, "That's the tough thing about acting for animation. Tom Hanks is great that way. There's so much going on, and there's so much believability in it." Hanks knows all too well that voice acting is tougher than it looks. "It's really hard work—honestly," he says. "Woody is very tense and the recording sessions go on for four or five hours, so I always come out of a session with my diaphragm having had a workout. It is exhausting."[5]

The work of a voice actor requires the endurance and standards of a marathoner to maintain perfect consistency across years—because they

will return to the recording studio so many times, often to re-perform material that has been very subtly tweaked.

Many live-action editors say they prefer not to be on set during production, because witnessing things "outside the frame" taints their perspective. Some animation editors share this wish to stay off the animation version of the set. "I find it distracting to watch them," says Schretzmann. "It's fun to watch an actor work but it's very different to turn off the picture and just hear the voice, because they can add so much with their physical movement. But in animation all that counts is what they conveyed in their voice. It's amazing: you can see them acting their asses off and nothing sounds really natural. You feel like, 'that is way too big,' and then you cut it in the reels and it sounds perfectly normal. We ask the actors to do it faster, to do it louder, to do it bigger. There's something about animation that requires that everything is slightly heightened compared to live-action."

Schretzmann often elects to participate in the session remotely by an audio-only, high quality tie-line. Other animation editors relish the chance to attend the creation of their most valuable raw resource. Producer Darla K. Anderson always invites them to the recording session, whether in person or by wire, because, she says, "When they can see how the actor is thinking and performing and doing all the takes, and seeing the whole, it ultimately helps their ability to make the right choices."

Unkrich adds, "The editor listening to a session is often editing 'live' in their heads—listening for the bits and pieces they know they'll need to piece together the scene and requesting additional takes if they feel they don't quite have what they need." The editor also can observe the interaction between director and actor at a recording session and learn more about that director's intentions for a moment or a scene.

Editors attending a session have a lot to listen for: they can keep an ear out for the uniformity of character accents, or even a necklace that might be jangling—or recognize that the talent needs a drink of water. They might also speak up to move any requests for the actor to yell or scream to the end of the session, so the talent's voice is not spent before everything needed has been recorded. "There's a lot of policing that really needs to take place," Ichioka points out. Some of those issues are specifically editorial, such as: "'Oh no, she was not on-axis [i.e., speaking directly into the mic].'" But whatever details the editors are monitoring, it's always helpful if they attend those sessions. As Ichioka says, "It's important to take the role of bad guy and feel good about it."

When the lines of scratch recordings are replaced with production dialogue, as Reimers explains, "Sometimes the scratch is a little better, or the line was changed after we recorded the production dialogue. So you have a mix within your timeline of scratch and production, and those are the things you start tracking very, very carefully."

Character Building

The surgical precision available to editors in shaping vocal performances can yield wildly differing outcomes—especially for fantasy creatures. Whether alien or animal, the editor gives these characters a language of "spoken" sounds that elicit relatable emotion for an audience. The following examples from *WALL•E* and *Brave* illustrate a set of editorial challenges, and solutions, for creating characters that are not human.

WALL•E: Relatable Robots

Director Andrew Stanton, who cowrote the *WALL•E* screenplay, knew he faced an uphill battle on moving the project, which had been floating around the studio for years, into production. On *Finding Nemo*, Stanton started his development process with scuba lessons for the crew—so the group could use their own experience to transport the audience to that other underwater world. Such research and team-building were typical (*Cars* went to Route 66, *Up* to Venezuela's Tepui, *Brave* to the Scottish Highlands, and so on). With commercial space travel impossible to experience, Stanton wagered his *WALL•E* "R&D" budget on a more abstract journey. He set off to create a dystopic future so emotionally compelling—in storyboards—that the first act could culminate in a burgeoning robot romance. If the story artists and editors could sell a love affair between machines, the filmmaker felt, skittish studio executives could overlook the postapocalyptic "trash planet" setting of the film and be convinced to "greenlight" the project.

Stanton recalls, "dealing with sound effects on our rough initial storyboard reels to a level of commentary and critique that I would usually wait for in post-production."[6] To create relatable robot speech, the editors worked toward the same advanced level with sound designer E.J. Holowicki and music editor David Slusser—a jazz musician, who, Geddes says, "would sometimes blow into his sax and then tweak it electronically

to make these different sounds you would believe came from WALL•E. We also had a rubber squeak we called the 'what-the,' this startled reaction from WALL•E. And blurps and beeps."

The innovative sounds were only a part of the process of connecting to the robots, particularly WALL•E. "One of the things I think we realized pretty quickly," Geddes recalls, "is that if you want the audience to know what the character is saying, you're not going to convey any real information with those beeps and boops, but you can convey emotion. So you have to be really clever about your camera placement, and your staging, and what your characters are doing, and the way WALL•E's eyes moved up and down—that stuff is conveying more emotion than anything else. I think the only way to do it is to inhabit it as the editor."[7]

By combining WALL•E's reactions in his movements, his eyes, and the evolved designer sounds, the editors crafted "this cocktail of being able to connect—to understand—what he was saying and, without thinking, what he was thinking."

WALL•E's trash-compacting utility bot and EVE's carbon-seeking droid are not programmed to feel love and longing. But editors, working with the sound designers' synthesized gibberish—on a foundation of traditional cinematic storytelling—convinced the audience of deep, heartfelt emotion in this unlikely boy-meets-girl plot.

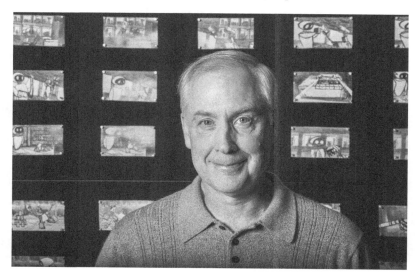

Photo 3.19 Ben Burtt, sound designer.

© Pixar. Photo: Deborah Coleman.

Photo 3.20 Ben Burtt creating emotive robot voices at Pixar (*WALL•E*, 2008).

© Pixar. Photo: Deborah Coleman.ßßß

Photo 3.21 Director Andrew Stanton listens closely at a mix playback with Ben
 Burtt (*WALL•E*, 2008).

© Pixar. Photo: Deborah Coleman.

"It's amazing if you watch it how much of it has stayed exactly the same," reflects Geddes on the silent first act of the film. "Not exactly shot-for-shot, but most of those beats happened." With very little human speech, always highly processed, Act One of the finished film is regarded as a tour de force of pure cinema—studiously elaborating on a visual language developed back before movies had sound at all, with music, sound effects, and imaginative post-human robot garble.

VIDEO 3.10 Building Character—Case Study: Relatable Robots (3:20)

How does it sound when relatable robots speak in *WALL•E* (2008)?

When the creative team tried to introduce a host of additional robots to these early Story Reels, the characters lost the clichéd clarity of boy-meets-girl. What would be the emotional purpose of each supporting robot? And how would that sound? Without clear definition, these ancillary characters get lost, as it were, in the noise. A deleted "Sewer scene" from the Pixar vault shows how this supporting cast started as an incoherent group. There are some comical and surreal moments as tones, zips, and rings form an indecipherable cacophony. But finally, the musicality of complementary "voices," as in a live music band's arrangement of instruments, is missing.

VIDEO 3.11 Building Character—Case Study: Un-Relatable Robots (1:15)

From chaos to order. Supporting robots in *WALL•E* (2008) begin as most UN-relatable characters.

"It got so much better when we got sound designer Ben Burtt involved," recalls Geddes. "He has such a great wealth of experience and knowledge about how to create those things." Indeed, the creator of *Star Wars* character voices such as R2-D2's would bring a legacy of science fiction voice creation. That beloved robot may have been all chirps and beeps, too—but importantly, it had C-3PO's British butler accent to play off, or to translate as needed for clarity or humor.

Burtt sculpted the sound of WALL•E robots to figure as distinct, purpose-built characters, but the additional human characters introduced after the first act remained a challenge. The filmmakers wondered—if robots could be made sensible with a little bit of human performance thrown in, could 29th-century humans be made sensible in a language nobody speaks, a futuristic babel performed in outsized, childish emotion?

Editor Smith describes a risk-embracing creative spirit: "Andrew Stanton and Bob Peterson would write dialogue sequences with this gibberish. One of our complaints was these very long dialogue sequences—and you don't know what the $%*! they're talking about. We're going, 'Really? We have to cut all of this and I don't know what they're saying?' But some of it was funny." That idea was ultimately thrown out, but the editors were committed to trying, because sometimes the most unlikely experimentation actually works. "It's like moving a mountain," says Geddes about that kind of commitment. "And if you've only got the one shovel you can only do it one shovel full at a time. So you just have to pick a place and go."

VIDEO 3.12 Building Character—Case Study: Subhuman Speech (1:20)

This never-seen clip from the Pixar vault was deleted before it was ever animated. This early effort to compose an incomprehensible word salad is worthy of Lewis Carroll's "Jabberwocky."

Many have compared WALL•E to a Buster Keaton or Charlie Chaplin film. It is certainly no accident: the story's first 20 minutes with virtually no dialogue were relished as opportunity for animators creating the character performance itself. For them, freedom from dialogue meant the chance to run the field in their domain: pure pantomime. There are actually decades worth of film with no dialogue to study—from the 1890s to the 1930s. And study they did: the crew reviewed the entire collected works of Chaplin and Keaton. Editor Stephen Schaffer became attuned to the liberty granted by the absence of dialogue: "Dialogue often dictates the timing of a shot and scene—so with pantomime acting, the animator has more freedom to explore the full performance. If you watch Keaton you see that while he is doing this great performance, there isn't a whole lot of cutting going on—just sitting there with the camera, observing.

We tried to capture this feeling in WALL•E by letting the animators create more of an open performance, rather than giving them a set frame range to work with."

Brave: Bear Talk

For *Brave*, nonhuman "speech" would need to serve a very different story line, a character in crisis: the Queen Elinor turns into a bear. What does that sound like? How are emotions convincingly conveyed? As with *WALL•E*, the stakes for the project were high: an element central to the success of the story. As with *WALL•E*, polish normally reserved for post-production was thrust into early Story Reel screenings, years before the finish. As editor Smith describes it, "We have to treat the bear vocalizations like production dialogue—meaning, we're serious about this, and this is what it's going to sound like. So if anybody has any problems about what it sounds like, let's get that out now and start working it. She was a real character, and this was production dialogue: once it goes to animation, that's it."

Photo 3.22 Sound designer Gary Rydstrom (*Brave*, 2012).

© Pixar. Photo: Deborah Coleman.

This time, editors would work to mix the musical vocal qualities of a human (Emma Thompson, who played Queen Elinor)—not with artificially synthesized robot samples, but very real, organic bear grunts, growls, and efforts recorded at zoos and animal rescues. Just as with the robots, though, bringing too much human into the balance broke the believability. "It was a big struggle to get Mum's character into 'bear,' but not have her sound like she's speaking English," recalls Smith. "Emma Thompson tried some stuff, and it was minimal."

Part of the problem was that the bear ingredient was limited: bears just do not vocalize across a wide range, nor do they vary the expression of the tone they do produce. The available catalog of bear expressions is a thin volume. (Chewbacca in Burtt's *Star Wars* universe is bear-based.) Mum-Bear started to sound like a crass cartoon dog on TV, not a majestic movie bear, feared Smith. "We did not want to go to *Scooby Doo*-ville, and we did not want to go to Astro [from *The Jetsons*]."

With the shape of the problem thus defined by this early editorial exploration, Pixar's in-house sound editor E.J. Holowicki again partnered with the film's sound designer, Gary Rydstrom, to solve some of the issues.

Smith remembers, "E.J. went out and recorded a ton of bear. There's not a huge range. We went through thousands of recordings of this stuff. There was a Kodiak bear and a black bear that we liked a lot, so we zeroed in on certain bears. But we could only take it to a certain point. Gary would take the bear vocalizations that we had and stretch them. He would use camel. He would use tiger. He would be able to manipulate it a lot more than we were able to. Then we basically culled from that library of his sounds and had a more evolved version. Then he would take that stuff and tweak it even more."

The before and after differences are subtle, but significant. Smith says, "With Gary's it feels like she's trying to talk in a way. It feels like she's trying to manipulate her voice more than a bear would be able to. It was hugely helpful to the animators because they had a solid thing to work with."

VIDEO 3.13 Building Character—Case Study: Bear Talk (:45)

This ain't no Yogi, this ain't no Scooby, this ain't no foolin' around in *Brave* (2012).

Dante, the expressive Xolo dog in *Coco,* had a similar journey, even though his character did not require him to speak a language. No single dog could produce the range of expression they wanted the character to have. "There were a number of dog recordings—all different kinds of dogs. We eventually settled on a particular size dog that we wanted Dante to sound like. But within that, there was a whole bunch of barking. So it was just picking the barks, finding ones that went up and finding ones that go down. Some of them were used for the final."

VIDEO 3.14 Barking, with Feeling—Case Study: Dante Speaks (:20)

It takes a kennel to perform a single dog barking in *Coco* (2017).

Sound Effects

In animation, when editors are putting together the Story Reels, they are making *all* those sound effects choices; they're basically inventing that sonic reality. "You don't have a production track like you do in live-action," says Smith. "You create the production track. You create the world. So it's a lot more involved." This is just one example of the animation adage: "nothing comes for free." Even something as subtle as a room tone has to be created. A live-action production would capture that tone on location, or on set, during the performance. The vocal performance for animation is recorded in acoustically ideal, consistent conditions to allow for detailed intercutting across sessions—no room tone or ambient sound comes from the recording studio. Once again, the silver advantage lining this cloud of burdensome effort is control. Even the air can sound like anything the filmmakers demand. The impact of sound is different in animation because storyboards are still, minimalistic comic book panels. A sound effect such as a door slam or a footstep helps create greater impact to land the comedic or dramatic moment.

In many ways, Pixar editors are the heirs to an approach developed by Tregoweth Brown, the editor for Looney Tunes during the Golden Age. Brown brought sound effects from the real world into the animation soundtrack. Previously, a cymbal was hit during the studio music recording for a pre-timed crash effect, or a flute glissando performed for a character in flight; Brown found comical surprise in a car's skid for

crashes, or a jet engine for flight. (His method of recording and editing sound effects was widely adopted, a precursor to the massive online libraries available to editors in the digital era.) Pixar would apply the technique but make a bold stylistic departure from the slapstick and parody—which invisibly imparts an important tone to its films.

"Early on, I was making the mistake of treating this like a cartoon," remembers Schretzmann. "Pixar does not do that. They established that with *Toy Story*, and they could have easily made the wrong choice. They could have said, 'All right, this is a cartoon and everything could have been silly.' But they went for reality, their CG characters were believable. So, we just continued with that, putting in real footsteps and real sounds of people getting punched. That was a shift."

Creating Tone

That approach to sound was established and appreciated when Unkrich was building his first soundtracks on *Toy Story*. "Early on in *Toy Story*," Unkrich explains, "I saw the building of the soundtracks as being something beyond just filling in missing sounds. I built out these tracks, and when I showed the scene to John and Andrew and Pete and Joe, those guys, the scene worked really, really well. I think at first, they couldn't quite put their finger on what was working so well about it, but I remember it being [story artist] Joe Ranft who made a comment that he appreciated the sound was doing so much to help with the feeling of the scene."

VIDEO 3.15 Sonic Underscore—Penny Drops and Rainfall (1:00)

Making it play with specific sounds from the real world (*Toy Story*, 1996).

In a traditional, linear pipeline, such focus on polished sound would come at the end. But Pixar editors saw the hefty contribution made by detailed sound effects work at the Story Reel stage. The studio responded, building up its sound resources. At first a loose team of multitalented sound artists grew out of these initial forays, beginning with Gary Rydstrom on the Lucasfilm team of Sprocket Systems (later Skywalker Sound), and also on the Pixar side with David Slusser (hear his sultry *noir* sax in the early short film *Red's Dream*).

Editors and sound artists are always working with invented worlds and characters on Pixar films and, after *Monsters, Inc.,* with its particularly large population of otherworldly creatures, the studio recognized more than ever the importance of their sound team. For their subsequent film, *Finding Nemo,* Pixar established a permanent, more sizable sound team in editorial. Pixar editors have access to numerous commercial sound effects libraries with, as sound editor Barney Jones explains, "a very good database look-up system, where they can search for 'tin cans on pavement.' And if they just can't find it, we have facility for recording, for tweaking and reverberating and changing pitch."

Editors play a central role in translating any director's sound ideas into reality—both in creating temp-for-screening versions, as well as developing a vision to hand off to the sound designer. Editor Bloom sees his role as not only guiding the designer "to have the right quality the director is looking for in terms of what it sounds like. But it also has to have the right inflection so that it works for the scene, works for the story."

Editors tune in carefully to the director's experience and vocabulary, and play detective as needed. Bloom explains, "If it's somebody like Lee [Unkrich], it's: 'What do you want here?' If it's a director like Enrico Casarosa (*La Luna, Luca*) it would be more leading questions: 'So what do you think these stars are made out of? Are they made out of ceramic or are they made out of glass? Do you want a tinkly sound? Do you want a tall sound? Do you want a musical sound?' We'll be in a room with the sound designer and we'll lead him to a more descriptive answer, useful for the sound designer. The last thing that person wants to hear is 'Well, just play me some things and I'll react to them.'"

In the crushing rush to mount screenings, there are certainly generic library effects used to sell the story. But early on, Pixar realized the waste of throwing out all that work mere weeks before the film's completion at the final mix. They began to invite the film's sound designer to early screenings to help develop these films' key sounds. Beyond the cases where character voices needed fabrication, every film has a set of signature sounds for key characters. "We work here on sound effects that are not in the libraries," says Jones. Working in the same Avid projects, these collaborators extend the film editor's reach, accelerating the turnaround of more polished, screen-able scenes.

Bloom explains, "If you search sound effects libraries for a particular sound and they don't have that, you have to make it out of something, some other sounds. An example would be the magic petal sounds [in *Coco*] that send Miguel back to the land of the living and back to the land

of the dead. That was kind of blue-sky design—it could be anything. Lee asked for something musical and magic-y. That's a big universe. Barney Jones, who was our sound and music person, got some crystal sounds, some whooshy sounds, and some things that were a combination of those. And the bell tree is kind of magic, but we ended up not using that because it's a little too 'Tinkerbell.' We experimented with some crackly leaf sounds since the petals were blowing around. But, ultimately, we decided they're not dry leaves, and we don't want that." The potpourri of sounds that Bloom and Jones created for that 'musical, magic-y' effect were ultimately replaced by Chris Boyes, the sound designer—just like Story Reels, the editors' collaborative experimentation became a source of inspiration.

Imagine the thwack of Mater's tow cable in *Cars*, or the stuttering fin-flip of Nemo, or the mechanical servo motors on WALL•E: each of those sounds is the product of great trial and error—not only in the creation of that sound—but in its placement and frequency. If that custom library can be developed during the Story Reel phase, the director can respond to wrong turns and happy accidents with a luxury they will not have at the final mix: time. The editor can also get a feel for just how to use that custom library of signature sounds. For instance, hearing Nemo's fins every time he appeared caused clutter in the sound mix; it was distracting. By playing with it early, editors got a sense of how and when to use such signature sounds.

The development of the wisps in *Brave* exemplifies the development of a signature sound in parallel with—as part of—the story process. "Whenever you see horror movies and there's children whispering, it's terrifying," observes Smith. That's how we came to the wisps. E.J. Holowicki was heavily involved and then at the back end, Gary Rydstrom, who ultimately mixed the movie. They whispered Gaelic phrases. Some of them are chants and chattering. Plus they would manipulate the voice to make it feel like it was moving. That was a three-year process, before we found the right sound for the wisps."

Arranging the Concerto: Effects with Dialogue

The rule is often "less is more": editors must be mindful of what the audience needs to listen to among those many layers of sounds, and are just as often clearing things out to exercise the engaging power of suggestion, over the dulling power of continuous sound.

GALLERY: Jelly Fish Scene: Finding Nemo

Photo 3.23 Squishy jellyfish (*Finding Nemo*, 2003).
© Disney / Pixar.

Photo 3.24 Squishy jellyfish (*Finding Nemo*, 2003).
© Disney / Pixar.

Photo 3.25 Squishy jellyfish (*Finding Nemo*, 2003).
© Disney / Pixar.

emotionally," says Schaffer. "So I try to stay away from that as much as I can, until I have to present it to the director. Then I try to always have a piece of music if I feel the scene needs it."

"The editor also might for the first pass knuckle down and look at the sequence without music because they're waiting until the sequence has tightened up, and know what the beats are—then try music," explains Jones. "Some editors also don't have music on when they're cutting a scene, they're just working on the beats and the sound effects. They've got so much to carry with the sound effects."

Sometimes a scene "specifically calls for no music for creative reasons," explains Greg Snyder. But overall, "music is really important, on any first pass of a Story Reel, to help bring emotional cues to the scene, or a sense of rhythm."

Editor Edie Ichioka brought music lessons learned from her live-action background, specifically assisting editor Walter Murch, a firm believer in the happy accident. "'Oh, I left this unmuted but those actually go really well together. Let's put that in.' In *The English Patient* he had the Turkish singer over Bach—who would have put those two things together? It was like the Reese's peanut butter cup of music editing."

Schretzmann compares music editing to editing dialogue in Story Reels, "Just like developing the ear for a true performance, the true emotion, you can't push emotion on the audience. It has to feel organic. I think I learned from Andrew Stanton over and over again, 'Don't just start the music at the obvious place.' You want the emotion to catch up with the audience and the music really represents the emotion of the scene."

With music for Story Reels, Jones observes, "A lot of editors have a few pockets full of favorite cues that they use: their favorite tension, their favorite love, their favorite chase—their favorites that work for temp, the first cut of music." The Pixar editors' use of music to make the storyboards "sing" goes far beyond tasteful playlists. But none of these editors are working the music alone: there is too little time, and the outcome is too influential to those internal screenings. For this help, they turn to music editors. There is a blurring of job description boundaries. Editor Axel Geddes likes to bring the music editor into the process early on, at the storyboard stage: "Ideally we bring them in for the pitch. They'll come in and the director will be there, and the writer, and the head of story, and the story artist who has drawn the scene. If you can get your music editor there, it's great because then they can go away and start ruminating on what that scene is about, what's the emotional through-line, and what kind of music would work, while folding in the director's tastes."

The director's taste and the nature of the film impact the musical accompaniment the editor chooses at the storyboard stage. Jones explains the difference between, for instance, cartoonish versus atmospheric: "Composer Randy Newman set up an aesthetic on his first *Toy Story* where he hit every footstep and every turn of emotion. It worked very well. He just nailed every change of emotion, every step, every indecision and decision. I remember hearing or reading an interview where he said, 'When you're working on a Pixar movie you've got twelve weeks of ten-hour days, seven days a week, that you've got to just compose, or you're not going to make the deadline because you've got to hit every footstep, everything.' He said, 'My cousin Tom [Newman], he got lucky. He got the fish movie. [*Finding Nemo*] They don't have feet.' If the fish don't have feet, you can be much more atmospheric, and it's a lot easier. You don't have to have as many beats that hit."

Directors and editors also have different ways of working at the storyboard stage. For example, on *Coco*, Jones explains that Unkrich is "very decisive about whether or not it works. He never says, 'Close enough for temp.' That's a common thing people say, but Lee doesn't do that. He's like, 'No, we need to get this right.'

"A lot of people would say, 'There's no reason to do that. You're going to have the composer starting in a month—or the composer is already starting—and still, we're trying to tweak the music. What's the point?' Well, the point is he wants to hear it the way it is. He wants to hear it right, and he doesn't smile until it is."

There's another challenge with music for a Pixar editor. "The normal world of movies doesn't actually last very long, because the movie doesn't take three or five years to edit," explains Jones. "It takes less than a year. So, it's okay to use something you've used before, and nobody's going to really care. But with these movies, we're really establishing the character of the music, and we change it out and change it out. Also, it doesn't necessarily get better, or they get bored. *Brave* was a big example of that, because it took seven years to make."

So while these editors work for years before the picture "locks," not only do they try to maintain their objectivity, but they and the music editors audition and detail vast libraries of musical scores. Over the years Pixar created a highly detailed database, which refers to the enormous collection of music, much of which has been logged in a rigorous musical vocabulary. So, when a scene is handed to the editors, usually with precious little time before a screening, they have that vast library of cues to mine with instant word searches.

"Hollywood scores" which Jones says, "all sort of sound the same, because they're recorded in similar rooms with very similar orchestras. You can cut from *Raiders of the Lost Ark* to *Sense and Sensibility* very easily—from beat to beat. We've gone through a vetting process where the director, and the editor, we've all established what sorts of musical feelings work. *Brave* and *Coco* both have these authentic flavors to their music. With *Brave*, it was Scottish and Celtic-flavored music. For *Coco*, we've got a stash of mariachi and guitar music."

Schretzmann has a purpose in mind when selecting temp music, "The key is to always really think about the perspective. Whose POV is the scene and what are they feeling?" He describes a scene from *Cars* where the venerable Doc Hudson in taking a nostalgic drive around the dirt track, "You think it's a car moving, so let's get some fun action music. I don't know why but I stumbled on a cue that was more lyrical. It was an 'ah-ha' moment, like it's not about action. It's about Doc Hudson and his glory days, and the way he feels. I was going against the grain, and that's when music works really well—when you're not choosing the obvious. If I screwed it up it could have easily been just some hillbilly music and just made a fun moment. Maybe we would have never cracked that moment. If we find temp music, and it's right, it's really giving the composer a guide as to what we're trying to get at. That's a lot of responsibility, that's something that I have an influence on as an editor, is the choice of temp music."

The Dangers of Recycling: "Make It More Like the Temp"

The challenge for a composer—particularly on long-term Pixar projects—is that, Jones says, "We're creating a template for the composer to fill in. So, we're creating this thing that says, 'Here's where the cue starts, here's where it changes, here's where it gets fast, here's where it gets slow. Here's where it gets weepy.' The director has spent three to five years, getting really intricate with his cut: this is how the director wants the movie to sound. The composer comes to that and wants to bring a fresh voice to it. That's a really hard job."

With computer animation, the difficulty of the job is compounded by an additional time pressure. A composer cannot begin writing music until major sections are animated and locked for length, and although changes in complex arrangements of 100-piece orchestras are possible, they are delicate, expensive, and to be avoided.

Photo 3.26 Editor Kevin Nolting shares his cut from *Soul* (2020) with composer Jon Batiste.

© Pixar. Photo: Deborah Coleman.

Photo 3.27 Editor Kevin Nolting shares his cut from *Soul* (2020) with composer Jon Batiste.

© Pixar. Photo: Deborah Coleman.

The Mix: End Result

All sound films finish with a final mix. But Pixar editors understand that their slow, deliberate construction of the sound world on a film gives them an advantage many live-action editors lack: the years spent working with dialogue, effects, and music in such a detailed way—before they come together in the mix. These editors can play a long-term role in coordinating—in arranging—all the sound elements and avoid conflicts that otherwise arise. As Ichioka describes it, "It's a very intricate dance. If you don't work in concert with your sound department—front-load it—you're going to get an inferior product. On *Toy Story 2,* I learned to meet with the sound department and the composer in the same room. Otherwise you get to the mix stage and you go, 'Wait, I covered the sound effects for the scene of characters crossing the road.' 'Well, I did it with music.' Then there's an interdisciplinary argument on the stage: who wins this one? But it was worked out and choreographed so you don't say, 'How are we going to comb this out, this is a mess?' Which doesn't mean that people can't change their minds. It just means there's a plan, which is important to any battle."

All editors working on digital systems now are accustomed to maintaining a large number of tracks—sound effects, dialogue, and music. Yet it might surprise many working that way to know that those who developed the practice, making complex and intricate changes for years to those tracks, were animation editors. As a result, they bring a unique level of skill and knowledge to the table. Jones stresses, "Here, we're trying to go whole hog, and the editors spend more time on sound than on picture"—all of it, in any proportion, in the service of storytelling.

Because the process is so iterative, editors also have, with both picture and sound, "years of cutting experience" says Schretzmann. "I know how to mix a film now. I've learned how to become a music editor. I've learned the effect music has on a scene, and some of the tricks you can do to support the scene, and maybe add momentum. I've also become a much better sound effects editor, more at Pixar than I would have on live-action film, because I'm doing so much sound work. And I'm doing it so many times. I have such freedom as an editor to construct something based on my internal rhythms and tastes, entirely."

Those rhythms and tastes—the editors' initial choices for music and sound to make the Story Reels play—become woven into the fabric of the movie. Only now, at these final sound playback screenings, will that sonic world become what the editor has been trying to simulate all along.

When the layout team begins, the editor has already been working on the Story Reels longer than anyone, refining the dialogue along with the boards. Ideally, the virtual shooting starts after the final dialogue is cut, so that timing of the performances can inform the visual design and length of each shot. Edit first, shoot later. Because computer animation reverses the process of live-action film production, the editor's involvement before and during the shoot can earn a creative influence many editors would prize. The editor is "on set," advising on composition, staging, and timing. By helping to deliver virtual shots from still drawings, the editor becomes, in a sense, both midwife and guardian for this newborn stage of filmmaking. "I love that part of the process," says editor Kevin Nolting, who describes it as "remaking the movie visually."

Director John Lasseter's experiments with this new dimension in animation began long before Pixar, when he was working as an animator at Walt Disney Feature Animation in the early 1980s. The studio lot was buzzing over Disney's groundbreaking *Tron* (1982), which was set inside a video game and had an iconic sequence with "lightcycles" racing across a virtual, three-dimension landscape. Lasseter, trained as a traditional animator, was instantly excited by the possibilities of animated characters moving in a computer-generated set.

The year following that early example of computer-aided layout, Lasseter and fellow animator Glen Keane ventured into a bold experiment. With a scene inspired by Maurice Sendak's *Where the Wild Things Are*, they hand-animated characters in computer-generated backgrounds. The camera language of live-action cinematography was now in play.

"What excited me when I first saw the first computer animation back in about 1981 was that it was three-dimensional," Lasseter recalled. "You were able to create a world that was totally dimensional. We were able to move in and around objects—which you had never been able to do in hand drawn animation."[4]

The test reveals an enthusiastic playfulness with the newly mobile animation camera. But like an untended garden hose turned on, full force, the camera writhes and swings, as if it were an animated character itself—a little too liberated, disobeying the rules of gravity.

VIDEO 4.1 Sets, Not Cels—Animating in Space (:35)

Filmmakers discuss the big change brought to animation by cameras in a three-dimensional world.

Surely the combination of Lasseter's traditional experience, and his proven willingness to experiment with the new tools, made him an attractive recruit to Edwin Catmull's computer division at Lucasfilm. Hired undercover with the clever job title "Interface Designer," the ex-Disney animator became the creative engine behind numerous short films of increasingly sophisticated characters, sets, and ultimately story. Yet they remained mostly static, proscenium-based compositions: the performance of the character—that is, the animation—was the thing.

As that young studio split off into Pixar, it began to train on commercials, which got more adventurous at the extremes: the camera was either frozen or on a playground swing—swooping, spinning, and flying. Sometimes it worked, as in the "Boxer" spot, which used the camera to take on a knocked-down boxer's point of view, à la *Raging Bull* (1980) in miniature (using a mouthwash bottle as the protagonist). The experimentation had begun, and a live-action visual vocabulary— now even including "hand held" cameras—was emerging from the practice.

The short film *Tin Toy* (1988) announced the studio's progress in getting CGI to inhabit a live-action architecture. The camera panned with the characters, it tilted up, it went wide, and it moved in close—all in the service of a carefully crafted character's point of view (Tinny's). One person behind much of that cinematic fluency was Craig Good, a former Lucasfilm janitor who had availed himself of some company computer training classes to win the assignment of "additional animator" on the short. It was early days, and everyone was multitasking. Good recalls getting the additional, uncredited assignment to set up shots, "because I was the one who complained the loudest about 'computer graphics camera moves.'" These tasks of cinematography in CGI had not yet earned a name (2D's "layout" or otherwise) in the credits. As a vocal critic of the "unmotivated, swoopy moves" in experimental CGI film festivals of the time, he was known to say, "Pass the Dramamine." His colleagues figured if they gave him the role of setting up shots, they would not get that complaint. Setting up shots was very technical then, and creating all that classical coverage for *Tin Toy* was heavy lifting. The small crew felt it and designed the following year's *Knick Knack* to go back to a simpler proscenium-style presentation in a comically enclosed space. There was simple coverage and one featured set piece, a vertiginous "crane-tracking" camera move.

Toy Story: Layout Awakening

Setting up the camera and staging the blocking for every one of the shots on a 30-second-long commercial is a conceivable load for one person to carry. But it is ridiculous on a 1600-shot feature on deadline pace. For its first feature-length endeavor, the studio suddenly had to build a creative and technical team from its crew—less than half of whom had used computers before. B.Z. Petroff was the manager of this new department, "Layout." She remembers the creative problems being nearly insoluble: "How do you invent a computer graphic camera when you've been working in a flat, 2D world your entire life? That was the biggest challenge in layout. There's film language and then there is animation language, and film language is quite different. When you're in 3D that film language really comes to play. The whole team needed to learn how to make a movie."[5]

Training in 2D animation layout generated something of a blind spot to the cinematic shot-planning opportunities in a virtual environment. But everyone recognized the value to *Toy Story* of editor Lee Unkrich's film-school-trained, live-action sensibility. Catmull concurs, "Pixar, on every level, has always been a joint effort with a group of people who… build on each other's strengths and together make things happen that wouldn't happen otherwise."[6]

Unkrich was invited to some of the very first early layout meetings. "Prior," he explains, "the editors weren't really involved in that process where we define how the camera's moving, how the characters are blocked relative to the camera. But I started to make suggestions in those early meetings, thinking really structurally about how to have coverage that made sense and wasn't just a bunch of random shots that didn't necessarily go together."

That early collaboration became a central feature of all future Pixar films: the engagement of the editor on the planning and coordination of the camerawork. "One of the things Lee started here at Pixar was the idea—and it was a new idea to animation—that you can essentially remake the movie in layout," recalls Nolting. "Traditionally in 2D animation, editors cut storyboards, and then the layout would come into editorial, and they would essentially keep everything the same length, and just make sure the layout fit in to what the storyboards did. It was Lee who realized, coming from live-action and having this camera, this set, you don't have to do it that way. You can actually start rethinking how

you block the scene, and now that you can see the reality of the set, you can move the camera."

Unkrich remembers those exhilarating moments of discovery as "designing footage that transcended the 2D. We would have printouts of the sets, like bird's eye views. I would just go shot by shot, and come up with a shooting plan of how we could film all of this stuff. We needed to take the leap to having this feel like a feature film. I found that intoxicating because that's not something that an editor would normally be involved in." Unkrich and Good shared a sensibility, and it was essential to the "feels like a movie" sensation people felt watching the first computer-animated feature film. What viewers meant when they said that, was that it felt like a *live-action* movie. "On *Toy Story*," remembers Good, "I argued loudly for a very conservative film grammar for the camera, figuring that the movie was going to look strange enough to audiences that we may as well not push it on the camera front. So it was all shot on sticks or cranes." The layout process would mature over the years, but this fundamental principle of classical narrative film grammar, applied in the layout stage, remains unchanging. Editors who followed found it full of new possibility; editor David Ian Salter recognized layout as "the biggest leap the picture makes," allowing the editor to "revisit the material with a cinematic eye, the classic principles that we learned in film school."

Compare and Contrast

Editor Darren Holmes came to CGI from the tradition of 2D animation, where storyboards did represent the camera angles; layout would build on that foundation. "They would pin all the storyboards up of the cut scene. Occasionally, head of layout would say, 'What if we put these two shots together and make it a pan all the way through, or do a long push-in?' If it potentially changed the timing of cuts, then I would go back, readjust. But then you've pretty much locked your cut in that storyboard room." With this as long-held tradition, it was hardly a given that the first CGI cameras would adopt classic, live-action cinematic language, nor that the editor would have a hand in this expressive stage.

It is useful to sample what other CGI films of the same era as *Toy Story* were doing to highlight the ways in which Pixar's early approach stood out. Layout artist Nol Meyer was early in his career on DreamWorks Animation's *The Prince of Egypt* (1998). The film used a hybrid approach,

with 2D cels for character animation and 3D CGI for epic architecture in perspective, and spectacular visual effects. Meyer describes the "work-book step" as "the only place where the layout artist added anything that approximated 'cinematography' (i.e., combining shots, removing shots, changing camera angles or character blocking). However, real changes from the storyboards were rare."

Other, entirely CGI features at the time did not appreciate the value of the editor's contribution to shot planning, to cinematography. Editor H. Lee Peterson worked on *Dinosaur* (2000), where he was not involved in layout. A traditional, segregated visual effects department and editor were responsible more for ensuring correct incoming shot lengths, like accountants balancing a ledger, rather than building performances and pacing story. The lead picture editor's process was considered separate from all that shot planning. It would not have felt like a missed opportunity because in live-action, editors almost never participate in camera decisions or have an ongoing collaboration with the cinematographer; their assumed role is to make the best out of whatever lands in the cutting room.

How much input the CGI animation editor has at the layout stages involves many factors: chemistry among layout artist and editor and director; how much time the editor can afford to spend on layout reviews; how forceful an editor wants their camera opinions to be; and even how flexible the editor is, particularly one transitioning from 2D to 3D animation.

Meyer found that, in some cases, editors were at least initially very attached to the Story Reel sequence they had worked on for so long before ever seeing layout. "This often caused a lot of confusion, even conflict, once layout started up and new shots and coverage were showing up in the editor's inbox from the layout/director reviews." He learned to talk extensively with the editor about the reviews and what to expect. At Pixar, as well, editors after *Toy Story* vary in the amount of dialogue and input they have with the cinematographer.

"As the technology got better," says Meyer, "editors and directors began to understand that you could really make an accurate version of the movie that would answer so many questions for the downstream departments right out of layout, if they choose to take advantage of it. And step away from an antiquated workflow that was the legacy of animation's 2D origins."

Certainly, on *Toy Story*, that technology was at its nascent stage. The layout department then was a mere twelve souls. Unkrich perceived the

group as undervalued: "With the exception of Craig Good, pretty much everyone else saw layout as a way station for green technical artists who had aspirations to work in other departments. But it was clear to me, and it was clear to the people working in layout who were passionate about filmmaking, that layout needed to have a lot more respect than it did, because it was such a fundamental part of laying the cinematic foundation for the movie to come."

A Bug's Life: Foundation for Layout

Unkrich expanded that cinematic role on *A Bug's Life*. Before that film, Unkrich says, the layout department "pretty much went off on their own, created the layout, and then it went right to the animators. I realized we were missing a really crucial step, which was to have that layout come back to editorial for a whole other pass of working and shaping. Once we flipped that switch, it opened up a whole host of possibilities creatively for me in the cutting room."

When layout artist Jeremy Lasky came to work on *A Bug's Life*, he says, "We came from all sorts of backgrounds, because there was no other studio doing this work. We had painters, we had live-action camera operators, we had camera people who worked on *Tim Burton's The Nightmare Before Christmas* (1993) and *James and the Giant Peach* (1996) from [stop motion studio] Skellington. There were a couple people there because they didn't have a home and they were very technical. It was this weird mix. The supervisor of layout at the time, Ewan Johnson, wanted the department to be this collection of cinematographers. So he was hiring people he thought would become that group, and Lee came in and was helping push them toward understanding how to make that sensibility work in a 3D computer graphic space. Teaching us how to think in 3D in terms of live-action, even though we were manipulating it ourselves."

But Unkrich pushed only up to a point, aware that the audience needed to be grounded in a familiar cinematic language. While breaking out of the 2D proscenium tradition, he also knew not to swing the camera around, as if on a rope, just because they could. "We really tried to only do with the camera what you could do with the camera on the live-action film set," he says. "We stuck to those rules all the way through, and I think it paid off in spades. The audience was seeing a movie that felt like a familiar movie that they would see like any other movie, but it was so

very different than anything that they'd ever seen. I think that dichotomy, at least subconsciously, was interesting to people."

Finding that sweet spot between relatable experience and surreal thrill ride demanded discipline. Lead layout artist Robert Anderson was one of those stop motion veterans, arriving at Pixar after working in the camera department on *James and the Giant Peach*. That painstaking frame-by-frame process of posing puppets is constrained by physical limitations of real space, arguably more so than live-action, because of the miniature scale. No surprise, then, that Anderson embraced the unfettered freedom of computer animation: "We can make anything. We have complete control. We can do anything we want. We can go crazy. Then it becomes a problem of setting limits: if you break all the rules then no one's going to understand. That's why we do come up with camera plans." Lasky reflects on "those early reviews with [Unkrich]—there were a lot of notes, embarrassingly enough, about eye line and stage line. Lee really put us in shape. Pixar was like grad school for me. It was an amazing period in the history of the company, especially for that department. It was the beginning of it really being about cinematography."

Terms of Art

While Pixar's layout process draws heavily from the traditions of classical cinematography, familiar terms are borrowed and adapted to the unique environment.

Location Scout

A location scout happens on a live-action film production, but the term shifts meaning in this virtual world. The actual person called a location scout in live-action literally hunts for actual places to serve as the "EXT. NIGHT, CITY" in the screenplay. Sometimes they get clever and have Toronto stand in for New York—regardless, those places actually exist, and can be photographed.

In CGI, there is no list of locations for the production unit to scout. Instead, they must imagine, design, and build all of them. Every "asset," every single thing seen on the screen, is developed by the production designer. Story Reels inform all of it: locations, characters, props, fire,

water, earth, and sky. Layout artists can assist in the development of these locations with "camera scouts," placing characters in rough sets and checking the field of view with different lenses, to help determine if any aspect of the set needs modification—a wall extension or section of ceiling, for example.

In live-action the editor would never be a part of the location scout. Odds are high that it happens before the editor is even hired. On a CGI project, the editor likely formed opinions about coverage while creating those Story Reels, and their input is welcomed at a location scout. The 3D set has been built and can be seen in plan view, which is like a blueprint—an overhead perspective. Potential framing can be seen through virtual lenses. There is then a group meeting where everyone can see through the director's viewfinder. Sometimes a crude model might be built to give the team something real to manipulate. On *A Bug's Life* this took the form of a miniature video camera adapted as a "bug cam" that could show live framings on a cardboard set from a diminutive perspective. Scale is a central concern in all of these CGI worlds: whether King Kong- or ant-sized, the subtle visual cues relating to size and perspective take shape in layout. On *A Bug's Life*, the team also studied micro-cinematography (especially the 1996 documentary *Microcosmos*), to analyze and imitate the cues that convey a dew-drop–sized world.

Blocking, Staging, Camera Movement

These scouting sessions inevitably turn to the way the characters will appear in the location and how their scenes will be staged. The Story Reels inevitably influence, even if the express goal is to take a fresh look at everything. "We don't want to be locked into what we've done in storyboards," explains editor Ken Schretzmann. "We want to rethink how to re-block it and re-shoot it, what could be better." One key difference is that the boards are static, and layout work will turn into shots, with movement of specific durations. So it must be asked: are characters stationary? If they move, in what direction? Does the camera follow them? If so, is it a panning or tracking move?

Schretzmann remembers solving some very sophisticated cinematic conundrums with Lasky on *Cars* (2006) in this fashion, these discussions resembling grown men on a child's playdate. "I had a bunch of toy cars in my room, on my coffee table. We would talk about blocking the scene and we would literally move the cars around and talk about where the

camera went. That was a really fun time because Jeremy and I figured some things out that way." Lasky explains, "For me, it's all about seeing what's going to fail. Once I get these characters in this space, the director is thinking, 'What's not going to work?'"

One particular staging problem involved two minivans arriving in town after getting lost off the highway. Sally, the local lawyer, wants to get the tourists excited by all that Radiator Springs has to offer, introducing them to all the local characters and their shops. Schretzmann explains, "In the storyboards it was all staged at the intersection, and they all just parked and stood there in a circle and played out all this dialogue. Every character had their moment." Lasky elaborates, "They're surrounded by all the townspeople, who are all shouting at them in turn, 'Why don't you buy some tires?' 'Why don't you buy some gas?' 'Look at these souvenirs.' Then finally they get flustered and they leave. It was just this weird dead space sort of scene. And as is typically the case, it's only after it comes to editorial that you see it's not working." Schretzmann explains, "We came up with the idea that this couple's driving down the road, that they'll encounter each character and it gives each one an opportunity to introduce their shop, but we'll do it through movement."

Editor Kevin Nolting was invited to "plus" the concept. Instead of toy cars, he played with freeze frames, flips, crops, and picture-in-picture drawings of the town in mock-ups on the Avid, "to try to make it feel like they were moving. Anything you can do in storyboards in the Avid you can do in layout as far as matting things." So, although the mockup was "very clunky, Jeremy embraced it right away. And he went back and started making new shots."

The sequence worked. "Now instead of this kind of weird dead sequence where they're sitting there, all of our shots are tracking and we're passing a character and their residence or place of business in the same shot together," explains Lasky. "That's always my go-to example of editorial, of how you can really make those things work."

VIDEO 4.2 Driving the Camera—Case Study: "Customers!" (2:35)

Director of Photography Jeremy Lasky discusses collaborating with editors Kevin Nolting and Ken Schretzmann on the staging and camerawork in this introductory scene in *Cars* (2006).

The Sally Porsche character appears courtesy Porsche AG.

Coverage

As clarity emerges about the choreography of the players in the scene—including the camera itself—the plan begins to settle around point of view. Wide angle or telephoto? Close up or distant? Low or high? Over the shoulder or clean? "Each lens has a different property. It might go too wide, things might distort," explains editor Axel Geddes. "If you go too telephoto, the depth of field might be too shallow." Geddes's discussion of lenses reveals the editor's involvement with the director of photography ("DP") in CGI layout. A live-action DP might hear about a problem after the editor assembles the footage that would require additional coverage before they finish shooting, but at the planning stage that DP would not hear from an editor: "Make sure when you get to this section, give me some extra coverage in this area because I wanna try this thing." Indeed, an editor nosing in on a live-action set with a wish to "try this thing" sounds like the beginning of an interdepartmental war. But to this Pixar DP, "It's like a little heads up so that when we deliver, he's already getting the stuff that he needs."

This creative exchange with layout, says Geddes, "is definitely my favorite part of the process. It's a great opportunity. We've done all of this work in storyboards and proved that the scene works. And then layout is when we have to make it work in the real world, the virtual real world."

Editor Catherine Apple found the editor's involvement to be quite a contrast to all her previous experience. "The biggest difference is layout. We work much more closely with layout at Pixar than we do at other studios, which I love. They give us a lot more choices. We go back and forth quite a bit and with the changes we make, you can really tell the visual difference. The way we work through the problems is much more as a team between layout, the director, and myself."

"The editor knows that continuity and understands all of the things that have led to the decisions there. So often the editor is the best guide for working through that story footage to understand how did the director arrive here," Lasky says. "There are times when you have this piece of action that you can block once and cover in a bunch of interesting ways to give the editor raw footage to work with."

"We try not to make a thousand shots, because it's hard for the editor to slog through that and see what the intent is. Even when there's not additional coverage," Lasky continues, "we're leaving plenty of heads and tails because even if we think we're going to cut in a certain place, the editor has the flexibility to change that cut around and go anywhere."

> **VIDEO 4.3 Layout and the Editor—Case Study: "The Cleaner"** (1:40)
>
> Lee Unkrich describes collaborating with layout to generate live-action–style camera coverage, from which he builds the scene's montage for *Toy Story 2* (1999).

An editor who came from live-action rather than traditional animation might go through less of an adjustment to the new possibilities offered by CGI layout. Meyer described editor Maryann Brandon's (*Star Trek*, *Mission: Impossible III*) experience guest editing on *How to Train Your Dragon* (2010). "For her the idea of coverage was totally normal. She loved that she could call up cinematographer Gil Zimmerman for any shot she was missing while she was putting together the cut. At the time this type of relationship with the editor was something I had not experienced."

Shot Breakdown

After all the scouting, staging, and covering, it is time to commit to a plan and deliver it to the editor. That set of careful decisions is set down as instructions in a shot breakdown, a list of shots named and numbered in the order they will appear, with careful consideration of the duration of each shot. A shot breakdown meeting is the place for the director to make those decisions, in consultation with creative stakeholders in story, layout, and editorial. Even when it is a clear roadmap, one board may not translate to one shot. For example, a reaction may be broken up in multiple boards but expressed in one shot. Or, conversely, an action depicted in one board can result in multiple, different camera angles at the layout stage.

Layout artist Anderson declares, "That camera is going to reinforce the story. I'd say, 'I see what's boarded here and I can tell you're probably really in love with that shot, your iconic shot. We want to get all these other pieces to work with that now, coming up with a camera plan.'" And yet they "have a greater latitude in layout to diverge from what was pitched in the storyboards, because storyboards are two dimensions—and once we're in our real world of CG, we can play around a little bit more. So we're not tied to that map and we are always trying to improve it." There is a practical side to this iteration. New ideas are encouraged because production costs rise further down the pipeline; layout is

relatively inexpensive. But that also means a solemn obligation to get the basics correct because later repairs are expensive.

Layout Review and Back Again

Those shots are "built" in layout and "shipped" to the editor. The editor assembles the shots they receive in preparation for a layout review. These shots are not the endgame as they would be in live-action; it is, in fact, common for the editor to request additional coverage. Yet they're not actually directing on the set, either. It's something in between, explains editor Nicholas C. Smith: "I wouldn't know how to walk into a room with a bunch of actors standing around, and say, 'Okay, I want the camera here. I want to move it over here.' But this was different because you can basically re-shoot an entire sequence in layout. The whole process here is super collaborative."

Lasky agrees, "We're relying on the editor. It's like a great extra set of eyes on the footage, thinking in a specific way that is similar, but different than the way we think of shots. Someone that prevents us from getting too caught up in the beauty of that camera move or that composition. In live-action, DPs do this gorgeous shot and it gets to editorial and the editor says, 'Well, I can't use it. I don't have time for it.' Or 'It doesn't fit here,' and it just gets thrown away. In live-action there would be no opportunity to make it work. There is no discussion, there's no way for me to say, 'What if I just made that a little faster? Would you use it then?' A Pixar editor might say, 'Yeah, that'll be great.' 'Great. Let me go do that.'"

From the editor's side, Geddes is among those who appreciate the chance to say, "This doesn't really work when I cut these two things together because of this, or this. The eye line isn't right, or there's something about the feeling that I have here. It's just not working."

"We have the ability" says editor Robert Grahamjones, "to ask for shots, to alter shots, or say, 'Wouldn't this shot be a little more interesting in a two-shot as opposed to being a close-up on this character? If we went over this shoulder, maybe we could do it from a slightly different angle.' And if the layout artist or the director can't quite decide between a couple shots, we say, 'Well, send all of them, and once we're cutting it together, then we'll make the decision then.' Our perspective is always, send more. Try more. Experiment."

Nolting describes the collaboration as "constant back and forth; we're reshooting the movie on the fly, basically." Like all the tools, layout systems

have increased in speed over time since *Toy Story*, and layout artists are now able to bring a layout system into a cutting room to interact in real time with the set. Draft quality, but fast. "If they did a long shot with a camera move, it used to be they had to walk away from their desk," remembers Nolting. "Now they can do it in the cutting room in a minute." Collapsing the tasks into one session like this is analogous to Edi-storial, where the story artist can draw and make changes with a drawing tablet right in the editing room. Nolting sees the advantages and notes the limits. "Some things are too complex, and the layout artist will say, 'I'll just do it at my desk.' But when we want to block a scene, if we're just doing minor adjustments like, 'Oh, this should be a close-up instead of a medium shot,' they can just quickly make it, show it to the director, and we're done."

Whether the interplay takes place in compressed time inside the cutting room or from one desk to another, Grahamjones aims to keep the relationship between layout artist and editor "good and fluid—I like to show it to the layout department first, making sure that layout and editorial are on the same page. Sometimes they had an idea that just didn't translate, so then I fix certain things or show them certain things that didn't work—they have a chance to get at it at an early stage. Then it's just the director, the editor and the layout lead, three people in a room going over the layout, and that way, the layout person is on board. You're presenting it as a team to the director, and the director will have ideas about changing things, but at least the two of you know where each other's coming from."

The Stiff Robots

The CGI editor must remember and keep alive in their mind's eye the emotional performance the story artists created in the boards. Because even if some of their drawings were rough and spare, those gifted artists brought personality through facial expression, gesture, and pose. Once the editor is working in layout, those drawings are buried in the Avid timeline, covered up by robotic figures skating around the virtual set. The fully realized illusion of life created by the animators is yet to come; layout and editorial are setting the stage for that work.

Schretzmann avers, "I already knew the map of the action but the characters are like dolls that slide around, just a quick render, it doesn't have all the details, there was no expression. It took a while to figure out what exactly is happening in the shot because you didn't see it."

"We didn't have the performance happening." Unkrich explains, "It's not becoming the living, breathing, real thing until fairly late in the process. We have to constantly imagine the potential that could be there."

The challenges of working with these stiff robotic characters play out every time a version of the cut with layout is screened for audiences un-versed in that uncanny, pre-animation world of layout. Editor Sarah Reimers confirms, "Layout tends to be difficult for audiences to decipher. All the characters are bald, without skin, or surfaces. Everything is very monotone without a lot of detail."

Those limitations do not keep editors from trying to work out performance details. "We want this little micro-expression to happen, we might ask the layout artist to at least give an indication of that timing," explains Axel Geddes. "Blocking in the layout department is so much more advanced than it was when I first started here, when it was all T poses [i.e., frozen character posed with arms straight out] gliding through the scenes." Blocking is an important step toward an expressive performance, which an animator will bring to life. Until then, the editor monitors the emotional moments as they were originally intended, in the Story Reel. "As an editor we must not lose track of what was working about the scene—or the beat, or the gag—in storyboards,"[7] says Geddes. "Once it gets into camera, maybe it doesn't work anymore because you've placed the camera in a different place, or it's just a little off-axis with their face since you're not getting the emotional beat that you want. Maybe it was a single because that's how it's just drawn in story, and then you have it as a two shot. And you're, 'Oh, that doesn't work anymore.' Then it was something we'd have to address."

Story artist Brian Larsen appreciates the challenges the editor faces, "An editor going from drawings to 3D is always living on that balance, constantly not really editing the real stuff. Yet they're constantly going back and forth, having to switch their mindset. It's just a hard place to be in, on the front end. But you have to be smart enough to know, as an editor on the back end it's got to become a different animal. It's got to live differently."

Geography and Pace

There's another reality, another change the editor is involved in when they go from storyboard to layout—and that is the reality of the three-dimensional space. H. Lee Peterson explains, "In traditional animation, characters could go across the room in all sorts of different ways. But

now the characters are sort of tethered to physics. That was really difficult, the fact that physics was meeting reality and it's a real space. That was a big wake-up for me."

"A lot of scenes are so easy to do in storyboards, and then you get to layout and realize, 'Oh Buzz can't just take two steps and he's across the room,'" Schretzmann explains. "You always deal with geography issues in layout." Stewart adds that when editing storyboards, "You take some shortcuts and you move things along faster than it's going to play when it's for real." Schaffer, too: "We always cheat storyboards. When we move it on to layout, a scene that was a minute and a half, that scene has to take three minutes. You can't physically possibly move characters that quickly in layout."

"The room that in storyboards is eight by ten feet is now 40 by 100 feet, so just to get somebody across the room is massive," explains Smith. The reality of characters moving through dimensional space adds time, but so do camera moves. "Depending how fast you want somebody to move through a door or whip pan, it might be too fast the way they gave it to you, so you have to slow it down to have that timing you want. There's a lot of manipulation of the individual shots within the shots and sometimes multiple times within a shot."

Directors' Ways of Working

There are many variables at play when transitioning to layout, each affecting how recognizable these shots will be to storyboard artists. One variable is the directors themselves. Some focus so closely on character and performance at the storyboard stage, they look past the geography of space in boards. Others polish the storyboards as a blueprint for layout, staging, and camera.

The variations in directors' approaches may depend partly on their backgrounds (animator, story artist or, in Unkrich's case, editor.) For example, Unkrich likes to, "make it as smooth as possible," explains Smith. While with animator Docter, "It's somewhat worked out, but in layout we change quite a bit." Larsen observes that animators-turned-directors tend to, at the storyboard stage, "play to camera for performance." That defers most of the shot-making decisions to layout, resulting in more coverage there.

Smith also says the approach "depends on their personality. A director rules the vibe." He describes the difference between the first director

on *Brave*, Brenda Chapman, and the second one he worked with, Mark Andrews. "The difference between Brenda and Mark was fairly vast in terms of how they worked. Brenda would ruminate more; Mark was very decisive." And they both started out as story artists.

Another factor is the story artists themselves; how cinematic their particular approach is when they draw the boards can impact how much changes from storyboard to layout. Smith, a live-action veteran, very much appreciated Larsen's contribution when working with him on *Brave*: "Some storyboard artists have a filmic eye, and they sort of see more in 3D, they see the frame and composition. It gives the editor more flexibility and it's easier to cut. It's a language I understand more. If you never get to that stage in storyboards, which can happen, then there's much more play in layout because you have to figure it out then."

Larsen confirms that on *Brave*, he and director Andrews were both camera-conscious. "We would try to plan as much as we can in boards. Mark is already thinking, make it this way in the boards so I know that layout can do that, I know that I can get my shot. So he's already thinking ahead."

Once they got to layout on *Brave*, the collaboration among layout artist, editor, and director had a specific dynamic. Smith explains, "Mark is much more camera-interested, -savvy maybe. So he was very vocal about what he wanted done but he was also willing to let Robert [Anderson] give him ideas—different angles, different takes, different camera moves, wider, tighter, higher, lower."

Anderson confirmed that he "worked really well with Mark Andrews because Nick and Mark and I sat down, we talked through the camera plan. So we knew the targets to hit, the things that were precious to the director. The relationship was so healthy."

Early in the story of *Brave*, Queen Elinor realizes a spell has been cast, turning her into a bear. Meanwhile, her daughter Merida has enlisted her triplet siblings to help Mum-Bear get out of the castle without the king discovering what has become of his wife. But he believes a killer bear is on the loose, sparking a frantic chase through the halls of the medieval castle. Smith explains, "This sequence was quite late on. Layout was already on the crew. So everything was in place—what the castle looked like—the sets had already been built, and Larsen was able to look at a lot of the sets before he started drawing, including the virtual castle."

Even though Larsen draws his storyboards with clearer geography than most, and he was able to see the sets before drawing, the logistics of the scene remained complex. So, while in some cases, the boards closely

matched layout, a comparison makes it clear just how much pacing and timing changed in layout due to the physical reality required by sets and a camera.

VIDEO 4.4 Layout and the Editor—Case Study: "Castle Hunt" (4:15)

Editor Nicholas C. Smith and Story Supervisor Brian Larsen discuss the move from storyboards to layout on a complex chase scene in *Brave* (2012).

Cameras Made of Software

While layout emerged as the smart place to make camera plans, the editors' desire to support storyboards with the visual language of cinematography was impossible to ignore in that earlier stage. Pixar explored a range of hybrid methods, with varying success. In some ways, this meant going back to the mode of cel animation, in which the storyboards and hand drawn art were themselves the expression of camera plans. The earliest of attempts were homemade knockoffs of the sliding camera stands used in cel work. As Bullock explains, "Storyboards were shot all on video with something like a security camera on this kind of super funky down-shooter made out of plywood with incandescent lights over it. But on the plywood, they mounted HO railroad flatbed cars, for model railroads, and tracks, so that they could get camera moves and pans, and then sort of try to drag it across."

On *A Bug's Life* (1996), Unkrich began experimenting with a then-little-known program called Adobe After Effects. He found he could create complex moves through space using flat art. It was like having the capability of a multiplane camera crew. Nearly every Pixar movie has since used After Effects in its Story Reels to a greater or lesser degree. Unkrich says, "In retrospect, the work that we did on *A Bug's Life* with After Effects was important at the time because it was a stepping stone to where we've ultimately come."

Years later, *The Incredibles* (2004) would use After Effects in storyboarding to a new extent, where every element in the reels moved (not only the camera, but characters and lighting cues as well). Director Brad Bird had brought certain key people with him from *The Iron Giant* (1999), a hybrid of 2D and 3D animation: his editor, Stephen Schaffer; his story artist,

Mark Andrews; and Andy Jimenez, who did not really fit into any pre-existing department. Would it be layout? He wasn't moving the actual (virtual) cameras. Story? He wasn't drawing expressive characters. Editorial? He was not editing sound or shots. Ultimately Jimenez sat among story artists, who would team with him to draw emotionally legible character poses and expressions. But because he delivered shots to Schaffer with software that showed camera moves and coverage, his collaboration with editorial looked most like layout's. "We were already thinking about, okay, the camera moves left. Right here on the next shot, it's going to whip pan left-right. Schaffer could find that cut with actually seeing the movement."

VIDEO 4.5 Using 2D Cameras in 3D Scene Planning (2:00)

From the multiplane camera, to polished After Effects, to scribbles: different approaches, or "horses for courses."

Jimenez used the term "animatics" to describe his built sequences, which were not strictly 2D. Using complex multiplane and particle packages, the reels had at least a two-and-a-half-D effect. It worked exceedingly well on that film, especially since director Brad Bird had already visualized every scene. "The one thing that I thought was very telling about *The Incredibles* was that it had been on Brad's mind forever," explains Jimenez. "Brad came in with that movie, and he saw the movie in his brain beforehand. Nobody's brought a picture into Pixar that they knew what it was going to be beforehand. That film was so different than anything else in that regard." Schaffer confirms, "That [Bird's] script was so solid to begin with. I believe he had it around for like ten years, so he really knew what he wanted per scene. It was a locked thing." Other keys to the success included Jimenez's skill visualizing and planning the action scenes, dedicating his role to that (he was credited as a director of photography), and Schaffer's familiarity with Jimenez from *Iron Giant*.

Jimenez describes working on an iconic scene from *The Incredibles,* "100 Mile Dash." Dash, the young boy in a superhero family, gleefully discovers his particular superpower—speed—while being chased by the bad guys. "Once it goes to layout," Jimenez points out, "the acting in the drawings is lost. Dash isn't articulated, so after the story pitch was done, I would start tagging the shots that I thought, 'This should be an

animatic. This works.' The story artist would just draw me this run cycle of Dash, front and side, that I could animate so he could spend his time on all the acting but didn't have to worry about any of the background. And Steve Schaffer would be there and that was where a lot of the conversation would happen."

VIDEO 4.6 Moving Storyboards—Case Study: "100 Mile Dash" (4:15)

Editor Stephen Schaffer and Director of Photography Andrew Jimenez discuss their unusual approach to an action scene that combines the precision of visual effects-style "pre-vis" with Pixar-style, character-based storyboards. Director Brad Bird described the scene as "the cobbler of the movie meal" for *The Incredibles* (2004).

Schaffer confirmed that he worked closely with Jimenez on those shots: "Speed them up or slow them down, and then we'd both kind of look at it and agree, 'Okay, this is the right speed.' A lot of back and forth. We'd build 10 or 15 shots, we'd get it to where we'd like it, and then we'd bring Brad in and, 'Yeah, great, keep going.'"

When that scene eventually moved on to layout, Schaffer explains, "It was fairly lock solid, shot by shot. I don't think there was a lot of experimenting. I'd work with the layout lead, and we'd come up with three or four alt shots, and we'd show them to Brad, and he'd say, 'No, I want the boards. I learned quickly that, if I was going to present anything new to Brad, I had to first show him what he was expecting—which was the storyboards."

Anderson was frustrated that he couldn't "plus" the scene with his CGI cinematography skills. He felt constrained by the use of this 2D, albeit computerized, technique. "He's got beautiful brilliant boards, but we still had this mantra of, 'If it's like the boards then we're not taking it to the next level,'" Anderson recalls. "That was a little bit of a conflict for us. There were some opportunities to really hone camera skills but Brad really knew what he wanted."

The adjustment to the world of virtual space and cameras did require one major adjustment in layout, related again to scale. "The flying ships, when we got them in the layout and kind of did the same frame range, they went too fast. They looked like toys. So a lot of those shots we'd have to slow down and Dash would just run that much further in the shot. So that was probably the biggest change."

The pitfall could be that, "You get one shot done through After Effects and then it feels like the shots around it need it," notes Anderson. "If you start making these reels look too fancy, too slick, one shot that will look beautiful, nice camera moves, and then the director feels like. 'Oh, I have to get the shot next to it.' And then you end up doing half the sequence. And certainly, depending on what stage we're at in pre-production, if it's close to moving into layout, a lot of times I'll tell the director, 'Let's not waste our time on this. We've been living with this for so long, we know this shot's going to work, let's just move it to layout, let them do the camera work, and we'll see what they come up with.'"

Anderson wasn't the only skeptic. Jimenez says they were told, "You're going to slow the process. You're adding layout, an extra department, into story. But I think we saved time on the '100 Mile Dash.' It was about 92 shots, roughly, in the sequence in our animatic—and the first pass of that sequence was done in two-and-a-half weeks, which I think is an incredible amount of time considering what we figured out, not just our story but how fast the camera would be. We figured out what the longest portion of the forest should be—what's the longest runway we need to build instead of doing what I think would normally be done." Building only specific parts of sets that were needed helped the production, since the scope of *The Incredibles* required more sets than the studio had ever created for a single film.

The Incredibles arrived uniquely positioned to use these digital story tools to an unusual degree. The movie had gestated for years outside the studio, resulting in extreme preplanning. The chemistry of the tight-knit crew had already been fine-tuned on the ambitious *Iron Giant*, but overall, the question remains, how much refining is productive? What is a detailed animatic conveying, to whom? Does it successfully inform the camera and sets teams? Or is it meant only to edify or entertain a preview screening audience?

Soon enough, Anderson would find himself the lead layout artist on Bird's *Ratatouille* (2007), but circumstances took them down a different path: "Brad didn't have time to do all that boarding. Contrary to *The Incredibles* where he says 'this is the scene that you are building,' they'd call me in to a story pitch and we would start building the sequence, even though the story is still iterating. That was a situation where we didn't have time to really nail the storyboards to look the way we wanted. It was a tight schedule to finish that film transitioning to camera from Story Reel so I think he really found how useful layout

can be. He really embraced being able to, on the fly, change camera moves and be very creative that way without having to draw everything out and blueprint it."

The use of After Effects in storyboards over the years illustrates the adaptive push and pull of technology at Pixar. In one respect it was a powerful camera planning aid; in other ways it was a retrograde application of 2D multiplane techniques that did not fully realize the potential of a CGI cinematographer with a command of all available options. Both approaches have merit, and the strength of the studio shows in its flexibility to allow for different creative problem-solving among different teams, depending on the circumstances.

Creatively Collapsing the Process

For one particular sequence on *Ratatouille,* this looser way of working also meant collapsing the stages of layout and what follows, animation. While an unusual solution, it illustrates a fluidity available only in this virtual environment. It was inspired by the aim to keep the complex movement of the characters feeling spontaneous and alive… on a tight deadline.

The sequence involves the expert cook and main rat character, Remy, secretively hiding under Linguini's chef's hat and pulling his hair to direct his movements in order to maintain the ruse that he is a master chef. The elaborate and comic choreography of the characters flying all around the kitchen was a challenge to pull off—and came together in an unusual way.

After he edited the choice readings of the actors into the storyboards, editor Darren Holmes explains that before it went into layout, as would happen typically, "There was an interaction that the animator wanted to have so he went to do a rough blocking off of the first cut of the dialogue. We brought those into editorial, I cut around and tried to build a more fast-paced cut of it and then they continued to refine in layout to animation."

And although the animation wasn't fully rendered, those shots captured more specific movements than layout might have provided, which allowed them to create final camera coverage more efficiently—and, as Holmes affirmed, it allowed for a spontaneity that resulted in a beautifully executed sequence.

> **VIDEO 4.7 Cooking with Layout—Case Study: "Kitchen Tour"** (1:50)
>
> Editor Darren Holmes discusses an unusual approach working with animation to bend the layout to support performance for *Ratatouille* (2007).

Animation—Dailies, Hookups, and Keeping It Lean

The storyboard and layout stages are sequence-based, while the perspective of the editor is not only sequence-based but entire-movie-based. The animation stage, on the other hand, is shot-based. Animators are also dealing more in minutiae, and because the process is much more expensive and time-consuming, animation is not nearly as fluid and changeable as the previous stages. The editor's contribution, however, remains vital.

All editors are trying to keep the movie lean in order to create narrative momentum and involvement, but the animation editor plays a particularly active role as guardian of that leanness. It's not an easy role to play, especially at the animation stage. Animators, who are truly the actors, are extremely talented and enthusiastic. They're creating the final, fully realized emotions, gestures, and actions of the characters—the illusion of life. Like all actors, they have been known to chew scenery.

Grahamjones confirms, "Sometimes the animators are suffering from shot-itis, concerned about making their splash with this scene, and doing all these things that sometimes aren't really necessary. But also because the scene was cut, it was blocked in a certain way so it would hook up with the next shot. I know that Kevin Nolting likes to take a laptop to animation dailies. I go back to my room and look at it later, and then say to the director, 'You know, this thing here could be a problem.' It could be pacing or character things: 'Would that character actually be that jubilant right there at that little spot there?' When the editor's in animation dailies, they're not caught up in how great an animated shot is, the magic of what it is. That's a good thing."

As Smith explains, "Now you have facial expressions. You have these little minute things going on that you don't see in boards, because you get one board for a second, and you sort of sit on it. But it's not doing anything, particularly, except for what you're hearing. When you bring animation in, the eyebrows are twitching, ears are wiggling. It may be

as subtle as time between breaths, time between lines just to sell some facial thing or hand gesture. They want to slow it down a little bit, just so you can see that stuff." Animation dailies are "more or less a discussion between the director and the animators. I do sit in there for dailies. In the process of them expanding it, we are constantly fighting against that, in a way, to keep the movie tight. Because the animators—I mean, they're great, but they focus on ten shots and not the whole movie. So we're in there being the cop and asking, 'What's the whole movie? What's the whole sequence, and how do we keep it flowing, how do we keep it rolling?' They're focusing on this little gem here, which is great, but it may not fit in the movie."

It may not be something that slows the movie down but changes the intent. "There was one sequence in *Brave* where there was this very fast back and forth, when Mum and Merida were having a fight," Smith explains. "The animators started opening it up because they wanted to see more action, or more acting. I said, 'No, it's driven by dialogue and you have to keep that energy, and you have to keep that drama. Once you open it up, you're going to lose that.' So that was one instance where I said something."

Editors are welcomed in dailies while the set is still "hot." They can still ask for changes, just at a more microscopic level. For instance, they can request a blink of an eye to be at a different place relative to the line of dialog, which can have a significant impact, when it might not otherwise. As Unkrich says, "Without there being someone thinking about it from an editorial perspective, these valuable shots could be wasted."

The editor also has to watch out for the integrity of the shots and the transitions. As early on as *Toy Story,* Unkrich was aware of how important the editorial perspective was and how important it was for animators to "have a very clear roadmap to know what the compositions are, how the camera's moving, how they must try to maintain not only the specifics of each shot, but the length which created a certain pace and rhythm. Even something as specific as a character's head turning across a cut, how that has to be maintained in animation because everything in storyboards and layout was done for a reason."

Unkrich would learn to sit next to the director in the screening room for animation dailies. "I'd throw in my two cents about a shot having opened up too much, or hookups not working. I would just lean over and say, 'You know, if we have Bo Peep start to lift her staff in this shot it will hook up better into the next shot.' So it was like I was editing but without using my hands."

> **VIDEO 4.8 Laser Layout—Case Study: "Space Ranger"** (2:25)
>
> Watch the highly designed editing of a seminal moment in *Toy Story* (1995)—fastidiously classical in continuity of pose and assured guidance of a character's—and a viewer's—"eye fix." (Starts without sound.)

Schretzmann stays vigilant past dailies: "I'll keep an eye on the continuity over the cuts and as the shots trickle in. I'll keep dropping them into my cut and make sure everything's working. Sometimes it'll be an action thing and I'll get a 'handle on the A and B' [extra footage at the beginning and end of a shot] and I'll make a choice in editorial of where to make the cut. The animators try to work within the frame range I gave them so that it maintains the cut that I wanted, but there are some shots that change pretty dramatically and I have to make a decision about will it work in the cut. I try to make it work because I figure there's a reason the animator did it, but if it really breaks it, I'll talk to the director about changing it."

Layout artists are also invested in what their department brought to the table. "Sometimes an animator will come into dailies and say, 'I just decided I would try this thing,'" explains Lasky. "And either it's totally wrong, meaning there's a reason we had the camera where we did and a reason we staged it that way and the director agreed and the editor agreed and I agreed, and the animator disregarded it and we have to go back and change it. Or the animator's idea is great, it's what an actor brings to a scene, and the director says, 'Yes. I wanna do that.' Then it becomes the editor's job to say, 'Here's what we need to do to these shots so we don't cross the line.' Or, 'at the end of the shot the character needs to be here to hook up with the next shot that we already finaled.' Helping guide the director to choose the most important things."

Camera Polish and Eye Fixes

But even if the animator doesn't make a significant change—sometimes, after sequences are supposedly locked after animation, camera coverage has to change to make adjustments. And then the DP and the layout department's "camera polish" artists get involved, as do the editors.

"We have the capacity to move the camera a little bit after it's been animated, which is something you can't do in live-action," explains

Schretzmann. "You can push the camera slightly in more, make camera adjustments now that they're in a different place. But the problem is there's a limit to how much, because the acting and the animation is only for that specific angle on that camera. If you move the camera too much the animation does 'break.' It just looks weird from a different side. So you may have to send it back to animation to fix it. If you have Woody acting out a scene you'd think you could put the camera behind him and you still have something good, but it doesn't work that way. It's not a marionette. It's something that's just acted towards the camera."

The other issue involving layout, animation, and editorial is tracking eye fixes, which editor Torbin Bullock describes as "where your eye is and where it goes." In CGI there is a lot of information for the audience to digest: they are seeing a detailed world not familiar to them, so the editor cannot take for granted that their viewers understand what is happening in, for example, a monster world. It helps keep them focused and following the story from shot to shot to shot if their eyes don't have to jump around, and it also prevents them from missing crucial frames. Laser pointers are used in layout reviews to target the "area of interest" in a shot (often the central character's eyes), and see how close that is to the area of interest on the next shot.

Photo 4.2 Lee Unkrich works with layout artist Craig Good (*Toy Story 3*, 2010).
© Pixar. Photo: Deborah Coleman.

Photo 4.3 Lee Unkrich works with director of photography Jeremy Lasky (*Toy Story 3*, 2010).

© Pixar. Photo: Deborah Coleman.

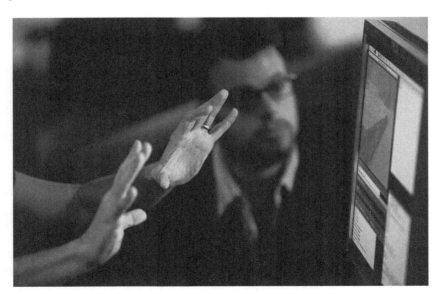

Photo 4.4 Lee Unkrich works with director of photography Jeremy Lasky (*Toy Story 3*, 2010).

© Pixar. Photo: Deborah Coleman.

Lasky said, "A lot of what Lee taught me when I started was about eye fix, keeping the viewer engaged, paying attention through the course of the film. But tracking it through animation is a lot more difficult, because animators don't tend to think that way and their first goal is performance. So camera polish spends a lot of time getting those to work in the cut."

As layout artists' knowledge and experience grew at the studio, so did the size of their ranks. That first small, resourceful crew on *Toy Story* developed in sophistication, from technical construction workers to cinematic architects, ultimately earning the esteem Unkrich felt they always deserved. "Supervising Layout Artists" eventually arrived at "Director of Photography—Camera," sharing the Director of Photography credit with the person responsible for lighting, a process that comes later in the production pipeline. The pioneering efforts using computers to convey cinematic grammar in collaboration with the editor evolved in a way that benefited that collaboration, as Unkrich observed when he was making *Coco*, over twenty years after *Toy Story*: "There are so many filmmakers working in that department. I also found that layout artists have a lot of animation chops. Instead of characters just sliding around on ice, we have Miguel actually running through a scene, rather than just gliding through. It makes it much easier to find compositions that work, poses the characters are likely to be in. You can much more easily imagine what the film is going to look like at the layout stage than we ever could in the past."

As the layout artist's skill sets and their tools may have evolved, their key partner has always been the editor. Lasky says, "The editor for us understands all of the things that have led to the decisions. I don't feel comfortable unless something is vetted by the editor. Whether it's eye fix or it's keeping on track with story or timing or pacing or any of those things, nothing really matters until it's run through editorial. All these shots are great by themselves, but they don't really mean anything in terms of a film, until they're ordered and manipulated correctly. For us, the editor is the center of the film."

Notes

1. *The Merv Griffin Show*, 1979.
2. Thomas, F. and O. Johnston. 1981. *The Illusion of Life* p. 212.
3. Thomas, B. 1991. *Disney's Art of Animation*, Disney Editions. p. 47.

4. *Charlie Rose Show*, 1998.
5. Spark Animation 2020, *The Women of Disney/Pixar's Toy Story: Defining Digital Her-izons* (2020).
6. Paik, K. 2007. *To Infinity and Beyond! The Story of Pixar Animation Studios*. Chronicle Books. p. 294.
7. Hullfish, Steve, *Art of the Cut Podcast*, March 3, 2020.

Cutting Jell-O

5

Workplace Challenges

Editors are this strange breed of Warrior-People. They know they're going to work the longest hours. They know that all sits on their shoulders.
—Darla K. Anderson, Producer (*A Bug's Life, Monsters, Inc.,
Toy Story 3, Coco*)

Photo 5.1 WALL•E (2008).

© Disney / Pixar.

DOI: 10.4324/9781003167945-6

People of Character

Is there a personality type best suited for becoming an editor? The old cliché of the isolated technician in a windowless room surviving on pizza fails completely to describe the breadth and depth of character represented among editors. Their work demands the emotional intelligence of a polymath—including endurance, empathy, receptiveness, humor, and honesty. But the question itself is flawed, for it treats the editor in isolation, when in fact they are part of a group dynamic. Other key creative individuals will contribute to the character of the collaborative enterprise, as will the broader context—the time and the place. "Workplace culture" is nearly as amorphous and slippery as an editor "type." But there is no question that Pixar's culture in its formative years was distinct from any other film studio's. This chapter examines this elusive dynamic between individual and institution.

Pioneers at the Outpost

After *Toy Story*, productions recognized the value of hiring editors from different creative backgrounds, outside of animation. Live-action experience was considered a particular asset, given the invaluable contribution from Unkrich. Jim Stewart was one such editor who trekked up from Los Angeles. "They were looking for a live-action editor to come into animation because they treat animation like live-action—which is a great way of looking at it," he recalls.

Most of the editors who ended up in "Hidden City" during that period in the mid- to late 1990s had been inspired to pursue their careers by a previous generation of live-action filmmakers who had also broken out of the Hollywood mold. Unkrich says, "Anyone who knows me knows I'm a huge fan of Stanley Kubrick. He was always a great model for me. Everything that I do, I try to make sure that it's unique, and specific, and interesting." (See Unkrich's book[1] as well as his online ode to *The Shining* [www.theoverlookhotel.com].)

Those who arrived to edit the growing slate of films were both surprised and confounded as they found themselves in uncharted territory: a distinctly un-Hollywood culture with uncomfortably honest and public creative exchanges. The convergence of these cinephiles with

Pixar's other storytellers, both artists and technologists, impacted Pixar's unique approach to making movies.

"It was a very casual atmosphere in the whole Bay Area at that time," remembers editor David Ian Salter. "It was fun to have Steve Jobs around in this very casual atmosphere. Company meetings were all fit in on a first name basis." Editor Ken Schretzmann had also ventured North from the live-action world—and encountered culture shock. "My first impression was, 'How does anyone get work done here?' I had been so used to being a very serious worker and being surrounded by people who are very serious. I definitely had the feeling like, 'what is wrong with these people? They're just way too happy here.' They worked hard and they played hard, and I got into the spirit of the fun of it. It felt like, 'I'm not in Kansas anymore'—this is going to be an amazing experience."

VIDEO 5.1 Made in Point Richmond—"You've Stepped into a Different World" (2:55)

Editors reflect on the exotic environment they encountered upon arriving in Point Richmond, also known as "Hidden City."

"It felt like joining the Yankees," says editor Greg Snyder. "It was like an All-Star team. There were new things being tried all the time, there was a confidence to this place and a sense that you were part of making history, making really great movies."

Editor Ellen Keneshea, who had worked in traditional animation in Los Angeles before being hired for *A Bug's Life,* sensed the very different atmosphere: "It was much freer and felt much more alive. I think to me that was the biggest thing. It felt much more like artists had free rein. It was more seat-of-your-pants."

The commercial success of *A Bug's Life* (1998) enabled the studio to stop renting offices and buy its own property in nearby Emeryville. It would try to consciously enshrine sources of its success in its new building. For example, the grand atrium space in the middle of the building was designed to create cross-disciplinary, serendipitous meetups. After touring with the studio's 400 or so employees in 1999 through the construction site, Jobs spoke to the group. "A lot of care

has gone into this building, a lot of innovation. I hope that you feel it's going to feel a little like us," he said. "It makes me feel like it's a reflection of the institution that we're building called Pixar—which has a set of values, and a way of doing things, and a culture, and ideals, and a place where we want to see things go. And I hope this is some reflection of that, and most important, I hope it helps us get there easier, with less hassle."

VIDEO 5.2 Tales from Frontier—Building a Studio Culture (3:10)

Editors remember how Steve Jobs built a Northern California film studio, both culturally and in bricks and steel.

Figure 5.1 It's a long run. Anyone who has run all 26.2 miles in a marathon knows it is not a sprint: It takes planning, pacing, and persevering.

Endurance: Marathon

The Pixar editor runs a marathon on their creative journey to a feature film finish line. As with any ultra-distance run, extensive training, detailed planning, and a supportive team go into the effort. Ultimately, the effort is a test of mental endurance and will. Having already studied in depth the key milestones on the course (story, layout, and animation), this chapter turns to more human, intangible factors: how editors sustain

fortitude of mind and spirit for the long run, through unrelenting heart-break hills, distracting minutiae, and plain old fatigue.

"'Marathon' is a good word," says editor Steve Bloom. "I like to concentrate on the forward movement. I've always been one that's not worried about the mountain, just worried about the next step and climbing up the slope one foot at a time. That's just my personality, but exterior factors help a lot, that you don't have any control over. *Coco* was very fortunate that we had a story that was working. You could see that every time. Yes, it was a lot of work, but it was getting better. Other projects are not as fortunate, they feel like they're going around in circles, or that every step is a dead end. By the end of the cycle, you're back in the place that you were. That can be very demoralizing."

"Everything changes!" was Schretzmann's first impression when he started editing at Pixar. "The script gets rewritten every day, dialogue is being replaced, and layout and animation change the cut—it never solidifies. It's like cutting Jell-O. You have to stay centered and watch everything." Most of those changes are minuscule shifts, Jell-O jiggling: newly recorded phrases, cleaned-up character drawings, revised animated gestures, discontinuities caused by visual effects. In trimming, tailoring, and flattering this constantly undulating blob, the editor tries to make the unsettled Jell-O tell a story, feel whole. The recipe, if there were one, is no linear procedure either, shifting back and forth between stages of completion so that a cut scene is more like a multi-colored Rubik's Cube... made of Jell-O.

Across all these axes, the torrent of detail and media requires constant monitoring. Editors are on vigilant quality control, tracking the integrity of the editing and the movie overall on an extremely detailed level. For example, the floor in the scene hitherto rendered as flat grey now shows up as detailed, fine-grain oak wood flooring. The editor attends to the change this provokes down the line—in the sound made by character footsteps on the new surface. Until the movie is in theaters, the ground is never solid under the editor's feet.

"The minutiae is tiny, but it's gigantic," declares editor Nicholas C. Smith who, like Schretzmann, originally came from years of working in live-action. "We're moving little, tiny increments all the time, and the notes that you get seem insignificant. You would never get these kind of notes in live-action, because you can't do a lot of the stuff you can do here."

"One shot can be fifty individual storyboards," explains editor Sarah Reimers. "An entire scene can be nine hundred storyboards. And

there's hundreds and hundreds of pieces of tiny audio media in these timelines."

Yet editors are expected to hold the entire movie in their heads. Unkrich explains that in animation, "Yes, I do have to be responsible for the film as a whole, the arc of the story, structure, pacing throughout the film—to step back from the whole film and be very objective. But at the same time, there are moments where I'm digging down to the tiniest minutiae, even more than I ever would have in live-action." The effort to stay above the flood of scenes' micro-details makes it hard to keep the important macro-problems in simultaneous perspective. There's even a term at Pixar describing that trap of narrowing vision, that blindness to the overview:

> **Sequencitis** | ˈsēkwənsˈsīdəs | (noun) A condition of working on a sequence or a scene, to the exclusion of the rest of the movie. Way too much time is spent on one scene without stepping back.

What causes this malady? "In live-action, scenes are shot by location, so every time you change locations you have a new scene," notes Smith. "Here each sequence is a little movie unto itself. So when you put the movie up, sometimes it feels like there's all these mini-movies because it takes so long to work on these sequences. It might take you two or three weeks to figure it out—that it's too much information. You still have to get it to flow like a movie. You have to eliminate the stuff you don't need."

Editor Katherine Ringgold feels that editors are able to make those eliminations "because we go through all those iterations, we don't get attached to what we're working on. By the time it gets to the other departments, it's pretty far along. When it's being animated, for example, it rarely changes so the animators can get attached to what they're doing."

Seeing all the sequences and their iterations over the length of a production can, however, make editors lose their objectivity. Animation, documentary, and live-action—any editor grapples with this. Having edited all of the above, Robert Grahamjones explains, "Every editor is very aware of the problem of seeing things over and over and over. You remind yourself constantly: 'Am I changing this just because I'm getting tired of it, or is there something inherent in it that is not working?'"

Editors know the significance of their initial reactions. "We get the footage in and we cut it together, and we're the first ones to see

it as cinema," says editor Greg Snyder. "So those first impressions are important—and it's important to stand by them."

"It's easier for the editor to keep the story in mind," reports Grahamjones, "because the directors go into a lot of these lighting meetings, shading meetings—all these technical decisions that have to be made." Understandably, this creates a challenge to keep perspective and objectivity at those later stages. "One of the editor's prime responsibilities is reminding the director what it was like when they experienced that moment the first time."

Editor Kevin Nolting, who has edited several films with director Pete Docter, recognizes the pattern. "Over the course of four years, Pete's focus is going to get narrower and narrower and narrower until the last year it's almost to the pixel level, where for the next nine months on this movie he's going to be looking literally at pixels, frames, and shots. It's my job to maintain the big picture perspective and not let him get lost in details, to constantly remind him that, 'we did this for a reason.'"

Conversely, the editor is obliged sometimes to play the opposing role of naysayer, arguing that a new moment the director has fallen in love with no longer plays in the context of the film at large. Basically, the editor is proxy for the audience, and must stay the course, all the way through the last 0.2 miles of the 26.2-mile marathon. As Snyder says, "If you feel like something's not working, you have to hold the director's feet to the fire."

Case Study: "Yeti's Cave"

Pixar's ultimate example of curing sequencitis involves a problem scene in *Monsters, Inc.* The number of versions, the variety of approaches, and the duration of the effort form a fabled testament to the perseverance of story and editorial teams. The team of editors (Stewart, Grahamjones, Schretzmann) made many valiant attempts to make the scene serve its intended function.

"Yeti's Cave" is a pivotal scene for the lead characters: Mike and Sulley are exiled from their workplace, end up in the Himalayas, and meet Yeti, a friendly abominable snowman. As lead editor, Jim Stewart, explains, "Mike and Sulley have a falling out. Then they're stuck there. That was the one scene that was the most talky. After all this craziness in the movie, it got to settle down—it's the emotional core of the story."

Grahamjones recalls "Rob Gibbs was the story artist that I worked most closely with and whenever he would do another iteration on 'Yeti's Cave,' I can remember him rolling his eyes saying, 'Okay, here we go again.' He was fantastic, though, because he always brought a lot of energy to a new take on it, which is always helpful because it's very hard when you cut a scene over twenty times, completely differently. I can't even remember all the iterations."

There were different humorous bits, different things Mike and Sulley argued about, different back stories for Yeti. Ultimately the scene ended up much shorter and they did not resolve their differences, setting up a positive will-they-won't-they-make-up tension after that scene, in the third act.

VIDEO 5.3 Sequencitis—Case Study: "Yeti's Cave" (4:40)

Editors Jim Stewart and Ken Schretzmann join producer Darla K. Anderson to discuss a notorious scene in Pixar editorial lore from *Monsters, Inc.* (2001).

"Yeti's Cave" became legendary at Pixar for its many iterations. Schretzmann went on to edit *Cars,* "and funny thing, there was a scene called 'Caraoke.' We started getting into it again and again. Rob Gibbs' boards and me cutting, and we were saying, 'Is this the 'Yeti's Cave' of this movie?' It got traction and people are now always guessing, 'What do you think is going to be the 'Yeti's Cave' of this movie?'" (In the case of "Caraoke," the solution lay not in a massive rewrite but rather in a complete excision fairly early on.)

"In *Brave,*" echoes Grahamjones, "there was a similar scene, originally titled 'The Witch's Cottage.' I personally cut that scene maybe forty times. Scenes are worked over and over and over because they have to be in the film, they're pivotal. You can try to manipulate in a lot of different ways. If there had been another six months it would have evolved into something else. But when the calendar gets to a certain day and it's time for the truck to move out the door, you move out the door with the scenes the way they are. This is very similar to live-action. The last version was not necessarily the best version, but it was the version that we were holding when the time ran out."

There is one positive aspect to the long, slow movement of animation production compared to live-action: the project makes visible progress. It comes to life. A live-action film editor finds, instead, a fixed landscape of takes delivered by the production. Unless it is a big visual effects (aka animated) film, that landscape will likely remain frozen for as long as the editor is on the film.

Humor: Is This Still Funny?

Humor may be the hardest thing to stay objective about. "You have to have faith in what you've done," asserts Nolting. That objectivity was truly tested on *Brave.* "Stuff people thought was hysterical was really boring three years later. But it was still funny, so you have to remember that stuff. It's true on live-action movies, too," maintains Smith. "You have to remember your first reaction."

"We don't laugh out loud at jokes very much after a while, because we hear them and see them thousands of times over the course of four years," says Ringgold. "But I recognize when a joke is super funny at the beginning, it's going to still be funny—unless the joke isn't working anymore because the things around it changed, because it's not set up the same way. So it depends on the situation."

This complicated issue of reworking or not reworking a funny scene played out with a sequence in *Monsters University* (2013), at the misfit frat house, where Oozma Kappas are initiating Mike and Sulley. As Snyder explains, "It was really killing in the Story Reel. It was killing so well that we got the note to do more of it—which we did. After a while you start to mess with that and you start to feel like, 'Well, is this still funny? Are we breaking this?' Finally, it was a dance between the timing of the sound effects and the timing of the dialogue. I think we reanimated it a couple of times." The end result of all the tweaking on the "Initiation" sequence became a comedy highlight of the movie.

> **VIDEO 5.4 "Is This Still Funny?" Case Study: "Initiation"** (4:15)
>
> Editor Greg Snyder talks about his role in "keeping the funny" in *Monsters University* (2013).

The Cutting Room: It Takes a Village

Along with the multi-layered types of media in the cut come the various webs of human relationships addressing each production stage. The scale of the creative collaboration is vast. Coming from live-action, Stewart says he was "always expecting that toward the end the director was going to sit with me all day long and we would finish the movie, like what you do in live-action. There's no way they have time. You have to schedule days ahead of time, and it's not like you're getting a one-on-one creative back and forth: everybody else wants to be in the room."

Bloom echoes this problem of the director as a limited resource: "The director is tightly scheduled. If that person is ready, you have to be ready—a much more exterior determination of the schedule."

"In live-action you're in the room with the director all day long for days and weeks," explains Keneshea. "Here you're very seldom alone with the director. There's always fifty people taking notes—because you make a change in a live-action film and it doesn't affect two hundred people. But of course here it does, so everybody has to know what's been decided and what's changing."

Schretzmann describes his first experience showing his Story Reel sequences on *Monsters, Inc.* "In live-action, you show your cut privately to the director, and you have a one-on-one discussion. Here, it was so public. The room was filled with directors, a couple managers, a producer, other assistants, and people in the back clacking away on their laptops taking notes. Editors like being in the background of the film process. Here I was in the spotlight during reviews. I remember my hands were shaking so much I had trouble operating the Avid. It took a little getting used to."

Even when the director is available to work with an editor, the process of working together and the logistics of making changes get complicated. As Reimers explains, "Folks coming from the live-action world don't always understand why an animation editor will be hesitant to sit down for extended director sessions. When the director says, 'Hey, can you trim this shot up?'—it's not a matter of going to one piece of media and trimming it back a few frames. Those few frames he wants trimmed back could be five boards. And boards do not have synced and attached audio. The audio is a whole other beast underneath it. Keeping it all in sync, fixing it as you go along: it's mind-boggling."

"Learning the job was not just about editing," says Bloom. "People skills, team management—administration stuff that took me away from the cutting. Bit of a surprise."

GALLERY: Editorial Family Portraits

Photo 5.2 Editorial crew from *WALL•E* (2008).

Crew Photo.

Photo 5.3 Editorial crew from *Ratatouille* (2007).

© Pixar. Photo: Deborah Coleman.

Photo 5.4 Editorial crew from *Toy Story 3* (2010).

Photo by Bill Kinder.

Photo 5.5 Editorial crew from *A Bug's Life* (1998).

Photo by Bill Kinder.

Photo 5.6 Editorial crew from *Cars* (2006).

Photo by Patrick Siemer.

Tilting the Scale

The back-and-forth process among story artist, editor, and director happens over the course of several years. "Story is redrawing a scene fifty times, and we're re-cutting it fifty times. Story and editorial get beat up pretty good," according to Smith.

His experience on *Brave* exemplifies an especially iterative story-board stage. In fact, the production was the longest in Pixar history: over six years, as opposed to three or four. This was due first to a change in the film's release date, and then, well into production, a change of directors. This gave the filmmakers on *Brave* additional time to keep reworking the story. Smith describes the specifics, "There were 160 scenes boarded for 36 scenes in the final movie, there were multiple iterations of all of them—multiple meaning in the tens and twenties, if not fifties."

Live-action editors understand this in terms of shooting ratios. A disciplined (or low-budget) director might have a ratio of eight hours of raw material for every hour finished. A lavish shoot or a

documentary might generate a 60:1 shooting ratio. On *Brave,* over 84,000 boards got delivered to editorial. In the end, the film had a typical number of shots, 1,596. That's a ratio of 53:1—but again, each shot is comprised of multiple boards, a single scene can have hundreds of boards, and every one of them demands an editorial decision. And story is only one department. At least as many versions spew from the successive departments of layout, animation, lighting, and effects, so that shooting ratio will more than quintuple over the life of a Pixar production. Once layout settles on each shot, each new delivery of that shot is a relatively clear replacement for a previous version. Still, the editor is responsible for the choice made at every iteration (are eyelines intact? did the frame range change? are important effects missing? what audience will see this, and will it serve that purpose?). Very few, if any, film-originated feature-length projects ever approached that enormity.

Although *Brave* had an unusually long production schedule, it differed little from other Pixar movies—especially as the increased flexibility of digital technology made it easier to generate multiple iterations. Even when a project is nowhere near the scale of a Pixar production, computer animation puts great demands on the editor's patience and ability to stay grounded in a Jell-O–like medium: endlessly shapeshifting, never truly solid.

The massive amount of editorial media, coming in from and going out to different departments, forms an import-export enterprise complete with manifests and customs checks on "shipments." The complex logistics of operating this hectic port fall to a supporting staff of assistant editors. The size of editorial crews in animation at their peak can baffle a live-action crew.

"For an assistant coming in, you have to stress to them that all of this media is going to be called upon at some point," explains Reimers. "It's a lot to know where that lives. Your organizational structure has to be extremely logical and easy for anyone to jump in and find, because scenes can change names, numbers. Boards can jump from one scene to the next. They can go to an entirely different scene because the director decides that this chunk of scene *A* now belongs in scene *Y*. As an assistant, you have to have the forethought to not only move it, but maybe keep it over here, too, because the editor remembers it as part of this scene. Maybe now it needs to live in two places."

All editors—and marathon runners—speak of the importance of mentally staying "in the zone." Assistant editors protect that bubble of concentration by tracking every bit of media. "Editors work so hard to find that space where you just…are going," Reimers says. "The train's moving down the tracks and if they hit a speed bump where they can't find something and they turn to their assistant and say, 'Hey, where's that thing? You know what I'm talking about?' 'No. What?' And then momentum comes crashing down. As an assistant, you're trying to support that creative process in a way that makes it quick and easy for the editors to access."

Shooting Ratios of Feature Films			
	Raw (hrs.)	Final Run Time (mins.)	Shooting Ratio
DEADPOOL	555	108	308 to 1
MAD MAX: FURY ROAD	480	120	240 to 1
GONE GIRL	500	149	201 to 1
THE TREE OF LIFE	370	139	160 to 1
THE MARTIAN	250	144	104 to 1
APOCALYPSE NOW	242	153	95 to 1
ARGO	175	120	87 to 1
FULL METAL JACKET	120	116	62 to 1
THE HATEFUL EIGHT	95	167	30 to 1
NO COUNTRY FOR OLD MEN	46	122	22 to 1
BAD DAY AT BLACK ROCK	16	82	12 to 1
TWIN FALLS IDAHO	18.5	111	10 to 1
INTO THE ABYSS	9	107	5 to 1
PRIMER	1.3	77	1.04 to 1

Figure 5.2 Live-action shooting ratios.

Courtesy Vashi Nedomansky, ACE.

Storyboards Delivered to Editorial	
THE INCREDIBLES	21,084
A BUG'S LIFE	27,565
TOY STORY 2	28, 244
FINDING NEMO	43,536
MONSTERS, INC.	46,024
CARS	46,389
TOY STORY 3	49,651
CARS 2	55,846
UP	62,976
RATATOUILLE	69,562
BRAVE	84,421
Boards Drawn ~ 112,000	
Shots Delivered 6,078	
Takes Delivered 23,908	
Shots in Final Film 1,596	
WALL•E	98,173

Figure 5.3 *Brave* had a shooting ratio of over 250:1.

© Disney/Pixar.

Editor Anna Wolitzky recognizes "a lot of different balls in the air. You have to make sure your editor has what they need. But another important quality is being able to anticipate what may be coming, before it's asked for." That is, to think like an editor because, "Being an assistant editor and being an editor are both creative in their own ways. But just because you're a great assistant doesn't necessarily mean you're going to be able to translate those skills directly into being an editor."

Assistants who successfully climb the career ladder to editor seem able to manage not only the technical and organizational apparatus, but to predict and adapt to the different creative problem-solving approaches of each editor. "It's interesting seeing other editors work, especially coming up as an assistant and training under these editors to become an editor yourself," explains Reimers. "You have to match your style to whatever they're doing. I started editing as a second assistant on *Brave* because we had a lot of work, and Nick Smith was a really great mentor who passed the work around to everyone to eliminate bottlenecks, and

keep everything flowing. He's helped me craft my work, just bringing my scenes in front of him, and getting the feedback from him, and also his style. Every editor has their own sort of style of how they like to see things done."

Inclusion in the Cutting Room

Like the film industry at large, Pixar—after decades of feature film releases—found itself awakening to the issue of diversity, both in the stories it tells and among its employees. One measure of their efforts is the range of characters seen in the films: work such as *Coco*, the 2017 Anderson-Unkrich effort, was heralded by critics as Pixar's "most culturally-diverse human family drama yet." In his acceptance speech for the film's Academy Award for Best Animated Feature, Unkrich articulates the studio's conscious move to enlarge its field of representation. "With *Coco*," he said, "we tried to take a step forward toward a world where nonwhite children can grow up seeing characters in movies that look and talk and live like they do. Representation matters. Marginalized people deserve to feel like they belong."

Inside the studio, the project of building a sense of belonging among diverse collaborators connects to all aspects of identity. Gender is only one such aspect, but the recent path toward parity for women may provide insight for improving other areas of systemic bias. Interestingly, the overall employee population at Pixar had become fairly balanced by the millennium; the area where women had higher numbers of representation, including positions of leadership, was on the production management side.

Wolitzky and Reimers both rose in their careers from assistant editors to editors, but after more than 20 Pixar films, there were still more male-identified editors than female at the studio. They have seen how a creative environment predominately led by men, for example (see credits for director, story, animation, layout) can limit stories and characters—and how that relates to the working environment. Reimers acknowledges, "If a group is weighted too heavily in any gender, thinking patterns can get stuck." This can limit the supply of receptiveness and empathy—attributes required to tell stories with deep emotion. While some progress can be measured in the abandonment of roles from a so-called Golden Age such as "storyman," there remain subtle forms of bias that demand greater inclusion to repair.

Editor Katherine Ringgold advocates for diversity in various ways, including casting discussions. "I am often the voice in a room that says, 'It seems like this character can be a girl. Couldn't it be a girl?' They just naturally go to a place where they make it a boy because they are boys."

Editor Edie Ichioka has found that challenge pervades the industry, well beyond Pixar. Having worked at numerous studios, she says, "I find myself in the unfortunate position quite regularly of saying, 'Well, why does the woman have to do that?' or, 'Why aren't there any people of color in here?'" She describes a feature film she edited where "there were no people of color at all, and I kept saying every day, put someone in the crowd. Make them from India. That would be culturally appropriate, you need that voice, you need more voices."

Reimers also talks about the challenge to communicate. "I was raised to speak up, so that women like me expect to be heard," she says. "Not everyone is built to have a strong voice at the table, and not every woman wants to jump in and do it. But all women want to feel included." Wolitzky confirms, "There are often a lot of men in the room who are very vocal and have a lot to say and want to get their point across. It's not always easy to interject in that, especially if you're one of the only women in the room."

To amplify women's voices, Reimers helped organize lunches and discussions with women in editorial. Her aim was to make "space to sit down and talk about creative issues so that you get the practice of speaking about things in a group setting, in a forum, at the conference table—so that it's not intimidating when the big group comes in, and you've got all genders, and big voices, and big personalities. You've got some practice in that space—and not only that, but you've developed a relationship with all of the other women, so you feel some support there. That can give people courage to speak up, when maybe they would've been a little hesitant before."

Wolitzky also found encouragement in a powerful role model at Pixar, producer Darla K. Anderson, with whom she worked on three features as "a terrific advocate and mentor. She was instrumental in my ability to transition from assisting to editing. She was very supportive."

Anderson's role as producer in these early days at Pixar was unique in a way she herself did not initially realize, "So after I worked really hard and didn't pay attention to male versus female, I looked around and went, 'Wow, I'm still the only girl in the room.'" Although being part of a male majority is not unique for women in the film industry, Anderson

tried to use the uniquely supportive environment at Pixar to bring about more fundamental changes. "I just wanted to take that Pixar attitude," she recalls, "and apply it to women's issues—which is a very complex social issue."

Many were excited to see Brenda Chapman as Pixar's first female director on *Brave*. When she was replaced by Mark Andrews, the editors who had been supporting a woman's vision for the mother-daughter story took it hard. "You have to grieve the film that you were making, because that film is not going to be made anymore," says Reimers. "You are moving on, and a different energy is coming in. Editorial really feels that. This was an adjustment period, where you felt the emphasis shift from a very soft, female, emotional energy to a raucous, loud, fast-paced, high-octane, macho man energy."

"I got along very well with Brenda. We were a good team," says Smith. "But I wanted Mark to do what he needed to do to get the film up the way he wanted it. I'm there to realize both of their visions." Comprehending the gravity of this potential conflict, Smith offered in his first meeting with Andrews that his attachment to the previous director's vision may disqualify him from the job. Bringing that existential outcome into the open created a field of trust and honesty in the new collaboration.

Reimers appreciated Smith's sensitive handling of the transition. "He was a study in graceful politics. What Mark was bringing to the table needed to be reflected in his editor and there had to be push back. Nick had to fight for the things in the film that we believed were important to Princess Merida and Queen Elinor's story that initially didn't resonate with Mark. But Nick made sure that that conversation stayed alive and was always in play." [See the evolution of the mother-daughter relationship in the three different openings created for *Brave* in Video 2.8.]

Showtime

Editors must be always open to input, particularly in the years-long production process at Pixar. "You don't stay objective for four years," says Ichioka. "That's why it's important to have other voices come in, and fresh eyes come in—that's what screenings are about. It's not only important to get different viewpoints, but it's important to get it all up on the screen, have the push and pull, and to keep being open-minded. As an editor you always say, 'Sure,' and do your best when you're asked to do something, because you'll be surprised by how many great things come

from that—even though instinctively, you may think, 'That's terrible, I really think we should stick with this.' Bad answer!"

For an editor struggling with their objectivity, sitting with a group that knows little about the story, let alone the problems the editor has been inspecting microscopically for weeks, lends instant perspective. For this reason, Pixar has always built work-in-progress ("WIP") screenings into its schedules. Live-action editors use this method, too—but the unfinished nature of an animation screening gives the effort a different, complex character for the editor, both in preparation and result.

The screenings serve a different function, too. For those concerned about spending time and money for the production, the screenings offer a milestone for review, where everyone can forecast whether, at the current pace, this project will finish in three years. In Pixar's early days, the screenings were mounted for the approval of executives at The Walt Disney Studios, who had authority to approve scenes to go into production. (In live-action of course, production is over.) With decisions like that at stake, pressure builds to make those screenings look as polished as possible: latest production dialog, cleaned-up storyboards, new animation takes—all of which flood into editorial at the 11th hour as every department aims to make their work shine. This squeezes the assistant editors tracking a media avalanche while supporting the editors who are burning the midnight oil in director sessions.

The editor's role as timekeeper also takes on a new focus. In animation, every frame of animation is so costly that if the running time grows an extra couple of minutes from the previous screening, there are serious budget implications. Editorial is on the spot for detailed monitoring of these durations—and if too long, responsible for somehow tightening up the whole. In this way, these WIP review screenings helped move the production forward toward the deadlines that were agreed upon with the production's co-financier.

As Pixar grew more autonomous, it moved the approval authority inside. Pixar had to create—and respect—its own deadlines in order to maintain its independence. For the editors in the hot seat, it didn't matter that it was now a Pixar "brain trust," or "executive team" or "creative leadership" group looking after the store.

Anderson explains, "Screening cycles are intense but necessary. A lot of weight is on the head of story and the lead editor to pick their battles, pace themselves. The editorial staff and story staff—they're the pressure points of the screening cycles, where it all lands and they make it all happen. So as a producer I'm trying to protect them."

"Darla would always say, 'We need to respect our deadlines,'" reflects Wolitzky. "She has very high expectations of deadlines and what comes out of editorial." The pressure leading up to each of these internal screenings is immense. "The energy ramps up and the hours ramp up," says Snyder. "You treat it like a release date you can't move, you've got to make that." Reimers confirms, "The deadlines for the writer and the story department tend to shift a little bit, but the screening date is the screening date, so editorial is up against it every time."

Snyder describes the screening cycle: "We'll put the whole film together, look at it with the executive leadership team. You show it as finished as it can be, as cinematic as possible, and we'll do that every twelve to sixteen weeks over a four-year period. Each time it's like giving birth to a new thing, and ideally it gets better and better. Sometimes it doesn't. Sometimes you'll make a version that wasn't as good as the last one. Story team and the editorial team work really closely together: what went wrong, how can we fix that. It's a very collaborative thing that's unique to animation. It gives us a lot of opportunities at making the film over again."

As Pixar grew in size, producers could recruit a different set of "fresh eyes" for a given problem they might be trying to solve. Early on, they might invite the story department from another project to help respond to problems in the second act. Reimers says, "They're pretty strategic about who they invite when because they know what notes they're looking for. After those, you get to a place where they want a fresh audience."

Schretzmann said that after these screenings, those who attend "are always invited to email notes to the producer. The director goes through all of them to see if there are any commonalities." Directors also have the opportunity to get input from other directors. Ringgold says, "I love that process of showing it internally to all the other directors, and for the director of the movie to get peers' notes."

After the screening, "They all go into a big conference room," Reimers explains. "The director, the producer, the head of story, the lead editor. If you've got layout and animation involved, they'll be there; usually the entire story department." Additionally, Anderson says, "There's the core Braintrust, but we add other people to that notes session, and customize it to what we're trying to accomplish. Maybe we need some notes from somebody whose strength has a lot to do with humor, or we're not getting the women's parts right. We try to put together these notes sessions that will bring out a healthy balance of what we think the film

might need, and decide: what part of this are we going to bite off for the next screening?"

Snyder confirms, "We dissect what's not working, create new stuff that's going to work better, or bolster what we have that's already working. It's also an opportunity to move things into production that are working really well—the green lights [i.e., approvals to go into production]. Each time we do that it's like making the film from scratch in a way." Reimers says, "We disperse and catch our breath because we've really been sprinting for the last two months. The tidal wave is about to hit again, and you start all over." Exhausting, yes, but seasoned animation editors like Wolitzky notice the positive side of this endurance trial: "Every few months, there are always people who haven't seen it, and it reminds us we're making a Pixar movie. This is very rich: there are a lot of things in here. There are a lot of gems. So we've got to keep going."

For editorial, these screening cycles are a double-edged sword. On one hand, the studio gets the movie up in front of an audience, the executive team, and colleagues. The project gets valuable creative feedback and, hopefully, approvals on scenes that can proceed into production. Depending on the outcome, the editorial team wonders whether it was the best use of their time to polish a version that gets thrown out based on a reaction to the screening: maybe if they had more time, they could have come away with something to hold on to, something that ultimately worked. But other times, they can come away from that screening and say the opposite: great to have put up that version because they were on the wrong track, and everyone needed to see it with an audience to get that information.

Previews

"Would you like to see a sneak preview of a major motion picture tonight?" With that appeal, aimed at a movie's intended demographic (e.g., families at the mall), most studio films have long made a recruited audience preview a key milestone where creative, business, and marketing interests come together to review the work. Computer-animated films pose unique challenges for the presentation. Anderson says, "Leading up to the preview is a big, big, big deal. We get everything we can in a film that's not finished yet. It's a collecting of all the assets. Trying to decide what tells the story best from layout pieces to animation pieces to lighting pieces and making all those artistic choices to stream together as

cohesive a piece, to represent your vision for an audience, to experience as much of your intention as possible."

Many frames are not finished at a first recruited audience preview—roughly one third of the film is in storyboards, another third is in some interim stage of animation, and the last third animation with lit renders (with color and detailed texture). Balancing these discontinuous elements drives a wedge down the middle of the editorial team's attention, between the film aiming to be finished in about a year and this temporary preview version, which is being made for appreciation next month by a civilian audience. The preview version of the film is the film that everyone has agreed to, just a work-in-progress going forth in front of audiences: a frozen moment in time that will be projected for one or two audiences before being shelved. The other, production version of the movie is not locked but rather is continuing to evolve in the cutting room and in other departments.

Building the preview version, Reimers explains, is kind of a backward process. "For assistants, this is a nightmare. This version goes over here, and did everything get where it needed to go?"

At an internal screening, things would be casual enough to explain what elements are missing without it sounding like an excuse: so much so that directors commonly present what has become known as a "cavalcade of caveats." The formal nature of a preview and the value of having input from an outside audience mean that the goal is to not interfere or distract with those creative caveats before the screening, while also making the audience as comfortable as possible.

Working against the advice to "never show a fool a half-baked cake," editors must make the judgment call on what is most legible to a lay audience; it is not necessarily the version closer to being finished. As part of the strategy to create legibility, editors order more storyboards, which, while visually more primitive, are emotionally clearer than the later, more robotic layout stage.

Different filmmakers make different decisions in terms of what they're going to put in front of an audience. Although layout tends to be difficult for an audience to decipher, the studio has diminished that issue by improving its finished appearance of layout over the years.

Steve Bloom confirms, "Previously layout was pretty painful to look at and not entirely convincing." But at the time he was editing *Coco*, "There were improvements in layout, with the characters moving in a more realistic way." Despite those advances, "In our audience previews we used very little layout, and most of it was action bits—running from one place

to another, and chases. Lee just didn't think it conveyed the emotion that you needed to get our story across as well as the boards did."

Not only do storyboards show more emotion, characters in layout can appear suddenly bald, or dressed in unitards. This throws the audience off, and an important emotional moment could be spoiled when that audience starts laughing for the wrong reasons.

Smith says, "It's hard for us to preview our movies in that the movie-going audience is not used to seeing what we work with. They have to be prepped. We show them an informational reel before the screening to prepare them for what they're going to see, so they won't giggle. But they invariably do giggle because it's kind of funny when someone's hair starts moving through cloth."

VIDEO 5.5 Preview Progression—*Brave* (1:35)

Director Mark Andrews presents the stages of a work-in-progress reel for a recruited audience screening of *Brave* (2012).

There are also good laughs. "It's fun the first time we get to show the film to an outside audience and see an audience just cracking up at stuff, and loving all the things that you liked about the scene when you first worked on it and that you've completely become immune to now, two years after the fact," explains Snyder. "My instinct is usually to trust that, even though we're not laughing at it anymore, the audience will."

Editors value the fresh eye and learn to read the audience, how they react. Boredom and confusion are the last signs anyone with the production wants to sense. Editors read these cues in the screen's reflected light, or simply sense them in the quiet intensity of a moment with 300 strangers in the dark. Insightful attention to audience reception in the moment is a daily-honed sensitivity for editors: they watch, they listen, they read the room. "Basically," Smith says, "I want to know if it's a good ride. Movies are about the ride, and if you do the ride well, then I feel we've been successful and engaged them, and made them feel, and made them emotional, and made them laugh."

Pixar aims for a wide audience of adults and kids alike. Because both the one-off version of the film and a cadre of high-powered executives are already on site, they often screen twice: first for young kids and their families, second for teens and young adults. The cues an editor has grown

to expect among their adult colleagues are suddenly pulled away by the younger audience. Kids usually signal their involvement in a film with complete devotion of their attention. While this is disconcerting to a film-maker hoping for laugh-out-loud boisterousness, kids who love a movie sit still and quietly. A "kiddie screening" has gone badly when the crowd squirms, asks questions, or worst of all, needs to use the bathroom.

The filmmakers decamp after each preview screening to compare interpretations. "The editor is with us in the nucleus of the talks we get into about everything: I depend on the editor for all of that," says pro-ducer Anderson. "Because the storytelling is enormously enhanced by the pacing, by the sound design, by the acting, by the music—all things the editor has an informed opinion on. They've been on this journey with us the entire time."

Honesty: Snarky Heroes

Editors have to maintain stamina, equilibrium, and patience along this arduous journey. But it can be a challenge, especially when honesty is the surest way to build creative trust.

"We have a reputation as editors for snarkiness because we are the end of the food chain," claims editor Axel Geddes. "There's a deadline that doesn't get moved, and we have all these other things coming in, and we have to deal with things in less and less time. So we get cranky and we overreact. But at the same time we also do have to be cheerleaders, and we have to remind people when the movie is working or what is working about it."

Some editors hold this reputation of being snarky fun-killers as part of the job description, or even a badge of pride. As Smith explains, "We're supposed to tell the truth. We're supposed to show the reality of what's up on the screen and hopefully give some solutions with the director to fixing it or to making it more entertaining, funnier, flow better. We tend to be cynical and critical because that's our job. We're not supposed to say, 'Yeah, it's great. Woo-woo. Yay team.' We're supposed to say, 'This is the tough stuff. This is what you've got to put up on the screen.' No director wants to go into an audience and be vulnerable. So you have to be brutal up front. It's the director being brutal on you and you brutal on the director."

Wolitzky knows. "Editors here have a reputation for being snarky and cynical sometimes. I don't know that I would say I embrace it, but I do

think part of the role is to be a logical, ground-in-reality sounding board, 'Is this working?'"

"Everything comes to light in editorial," says Reimers. "You can get really enthusiastic—and we make it our business to fix it and bring every-thing good to the fore. But when you come in here, if it doesn't work, we see directors' mistakes, story artists' mistakes, animators' mistakes, our own mistakes. We know everyone's human. I think that's where a lot of the snarkiness comes in. In editorial, the emperor wears no clothes."

Anderson sums it up. "Editorial needs to deliver when they need to deliver to get that film out. They know that they have to do everything as nimble and delicate as a performance of a tiny child's voice to pushing out the birth of this film at the end of it with one second to spare. They're going so fast and pushing so hard. And they have the brick wall. They take it on—the marathon. They are tough birds. I don't know what gives them the hero mindset, but they are my heroes, I can tell you that."

Note

1. Unkrich, L. 2022. *Stanley Kubrick's The Shining*. Taschen.

Out of the Galápagos **6**
Editors and Technology Adapt

All art is dependent on technology, because it is a human endeavor.
Everything involved in art—inventing oil paints, using charcoal on a
wall—you are dependent on technology. In film it is the same way.[1]
 —George Lucas, Director *(Star Wars, American Graffiti)*

Photo 6.1 Monsters, Inc. (2001).

© Disney/Pixar.

DOI: 10.4324/9781003167945-7

Editors have always been both technicians and artists, and so they embody a phrase heard often at Pixar: "The art challenges the technology, and the technology inspires the art." Editors landing in the studio's embryonic environment after *Toy Story* were among the first to experience many of the technical changes that began to affect nearly all films after that. Not all of these consequences were intended, or even imagined, at the time. But all of them highlight the direct impact of evolving digital technology on the expanding, creative role of the film editor—as well as Pixar's wider influence on the filmmaking process.

"All arts have length and measure," director Mark Andrews is fond of saying. For editors and their teams, the yardsticks—even the units of measure—underwent massive revision when computers at Pixar confronted analog movie making. "Ninety feet a minute," for example, had worked for generations when measuring celluloid running times. Now megabits per second demand calculation. Editors once drove the steel-geared, sprocket-toothed wheels of a Moviola, and now that loud tractor has evaporated into a stream of virtual symbols on a graphical user interface, set more and more in an abstract cloud.

The film editor has migrated, over three decades, from photochemical film to electronic videotape to data files, arriving at a completely "digital cinema." Editing systems and environs began their digital voyages with *Toy Story*. The force of these technical developments—in opportunities and limitations—bends the trail of resulting films in subtle ways. For when technology inspires art, it inevitably shapes it, too. The footprints on this path mark every page in this book: the freedom to experiment offered by nondestructive, digital film editing; the precise control of multitrack digital audio editing; the demand for additional and very different animation editor skills. The process of this change was no passive algorithm at play, but rather an entertaining and instructive series of very human ideas, ambitions, and luck.

GALLERY: A Darwinian Origin of Technologies.

Photo 6.2 Pixar's *Piper* comes to life on its digital shore (2016).

© Pixar.

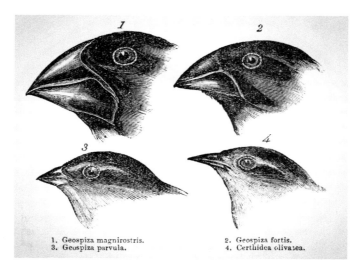

1. Geospiza magnirostris.
3. Geospiza parvula.

2. Geospiza fortis.
4. Certhidea olivaiea.

Figure 6.1 Darwin's finch.[2]

Figure 6.2 Leuresthes tenuis: Marvel of creative adaptation, the grunion leaves the water at night to spawn on beaches in the spring. Fish born out of water.

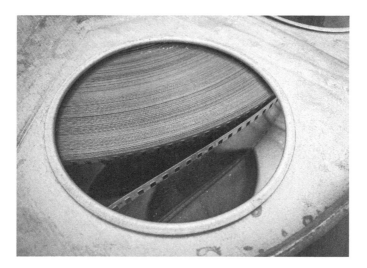

Photo 6.3 From the dinosaur…

Photo by Bill Kinder.

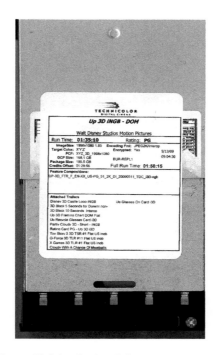

Photo 6.4 …to another odd fish: the hard drive, a surprising new species found its way into the projection booth.

Photo by Bill Kinder.

A Great Migration

If filmmaking technology were an animal kingdom and such tools as cameras and editing systems were species, one could tell a Darwinian story of evolution. *On the Origin of Technologies* would have the ecosystem of early Pixar correspond to the Galápagos Islands—and, in many of the same ways, would make an interesting environment for understanding how the forces of art, science, and commerce favored certain technical adaptations, commonly received as innovations.

Three obvious conditions supported rapid change as Pixar took on the challenge of a computer-animated feature film in the 1990s. The first was the studio's island-like isolation from the "mainland" of the film industry in Los Angeles. The second was the unique survival requirement that its fragile, intangible digital images make it "out to film"—as if a fish needed to grow legs to get on shore and reproduce. (Or if not grow legs, learn to flop really well, like a grunion.) Finally, a unique hereditary "gene pool" of computer scientists combined with film artists, leading to highly specialized, successful adaptations.

Isolation

As evolutionary biologists express it, adaptations within a species are more extreme when a small population develops in isolation. Industrialization depends, after all, on repeatability and systematic training to support efficient division of labor. From the guilds to the executive suites, people who have succeeded in the resource-constrained studios are not often motivated to change the system in which they have learned to perform.

With Pixar several hundred miles away in a "hidden city," the studio might as well have been an ocean apart from "the industry" in Southern California. The immature studio was therefore free to struggle and fail—and successfully adapt. It makes no sense that of all the places away from Hollywood there would be something special about Northern California for encouraging technological change. Yet why did moving image mavericks as disparate as Eadweard Muybridge (early motion picture pioneer), Philo T. Farnsworth (television pioneer), Francis Ford Coppola, George Lucas, and Ed Catmull emerge from the Bay Area?

Survival

The second parallel to the case of the Galápagos was the incipient digital film studio's harsh and unforgiving environment, forcing a "struggle for existence," as Darwin put it. On the equator, Darwin found finches and iguanas adapting to eat cactus; in 1990s Point Richmond, digital files clawed on to a celluloid shore, leading to all manner of quirky mutations in the then-time-honored processes of editing film.

It would be hard to picture that milieu from the 21st century, when everyone lives on their own digital island with a screen in their pocket holding keys to a vast library of "content," as well as the means to create and distribute it around the planet. But in the 1990s, 35mm film was the coin of the realm. There was no standard practice for putting pixels on film, yet it was essential to Pixar's ability to present itself as a "film studio," the then-secret wish of its founders. From their earliest days as Lucasfilm's "Computer Division," they hired alchemists who could transmute the ones and zeros into color and light on emulsion.

Heredity

In a modern "app" culture, digital-everything seems so obvious as to be uninteresting. But remember, one of the founders of Pixar also brought the iPhone to the world: Hollywood, meet Silicon Valley. This conscious hybridization of filmmaking with a "tech" strain made Pixar's characteristic adaptations unique compared to other animation studios at the time.

Film editors in a tech startup environment found themselves in the uncharted intersection of a developing art form and bleeding edge technology. As these cultures collided and struggled to hatch as a movie studio, Pixar focused an anomalous proportion of specialized knowledge and workforce on breaking through. It was often said with wonder, "More PhDs worked on *Toy Story* than any film in history." It was a great marketing line, but it was also true. The other go-to line on the studio tour was that the only place housing computer processing power greater than Pixar's render farm was NASA; it is unclear if this, or other claims comparing the system to the FBI's and the CIA's, were accurate. But massive computer rooms were largely unknown then, so the assertion was hardly, if ever, challenged.

By 2005, less than a decade after the release of *Toy Story* on film, 35mm projection was rapidly approaching extinction as a mass commercial format that had dominated for a century. Commercial animation's entire production and distribution chain, working all the way back to the storyboard artist's drawings, had also been completely subsumed by digital processes.

Editing's Family Tree: Scissors Begat Machines Begat Apps

Mechanical—>Electronic—>Digital

The tool most vital to the editor's role, the one touched every day, is where the various versions of a film "live" as a series of shots in a certain sequence, cut by the editor to a certain length. This tool, this technology, has actually taken many forms in cinema's short history, and as the nature of this "interface" has evolved, so has the editor's contribution been shaped.

Editing by Hand

Francis Ford Coppola recalls his editing mentor, Dorothy Arzner, describing how they used to cut film in the silent era. She called it cutting "in hand," meaning they would measure out lengths of film against their arm's length. "If you have a kiss, three arms is a very, very long kiss. But *four* arms is a *really* sexy kiss."[3] Original practitioners of the craft enacted a physical, private, nearly romantic dance with ribbons of imagery. They would commit to their decisions with scissors and cement, and move on. Like the cameras that captured the imagery, the projectors that played it back were cranked manually. Clockwork precision was simply unavailable; the pace and rhythm were subject to the projectionist's concentration, bicep conditioning, and safety sense (nitrate film, cranked too slowly, risked conflagration as the combustible stock had more time under the lamp's high heat). All of these factors influenced the spectators' experience in the cinema. Because silent animation was created to length, there was virtually nothing to edit but title cards and the excess leader on each camera roll.

GALLERY: Hand—Filmmakers Strike an Editing "Pose."

Figure 6.3 Sulley and Mike: all the great filmmakers measure cuts "in hand."

© Disney/Pixar.

Figure 6.4 Merida and Mum-Bear: all the great filmmakers measure cuts "in hand."

© Disney/Pixar.

Photo 6.5 Dorothy Arzner knew how to measure a kiss on film.

Courtesy Dorothy Arzner papers (Collection PASC 175). Library Special Collections, Charles E. Young Research Library, UCLA.

Editing by Machine

Not unlike the mechanization sewing machines brought to textiles, the Moviola brought to film editing in the 1920s. It sported a screen barely the size of an iPhone 6, with a viewing angle that required a straight-on look, for a maximum audience size of two (usually the director leaning in over the editor's shoulder). It was noisy and could mangle film and fingers like a hungry beast if not driven carefully. (Start and stop functions were operated by foot pedal, so "driving" the machine was the apt metaphor.) Its apparent violence intimidated many away from its sound and fury, affording editors

both a concentrated solitude and a deference to their skill that they eventually would come to miss.

Beyond understanding artistically where to make an edit, physically making a splice was a specialized craft that took patience and fine motor skill. There were many steps using a splicer, a scraper, water, a brush, felt, cloth, and film cement:

- Position the ends of the two pieces of film, emulsion side up, into a splicer
- Cut the ends at the desired frame squarely with the splicer (choose carefully, as each end will lose a frame in the destructive process; ordering reprints of the negative from the lab was expensive, time-consuming, and potentially embarrassing)
- Soften the emulsion with wet felt
- Scrape the emulsion with a scraper or emery board
- Brush the loose pieces of emulsion from the film
- Apply the cement to the film
- Close the splicer to join the pieces of film together
- Wait 10–15 seconds for the cement to chemically bond the two pieces of film
- Open the splicer, wipe off the excess cement
- Examine the splice for accuracy and strength

Until the 1950s, all sound was recorded on photographic film and had to be spliced this way, too. Not a process that invited experimentation, the steps entailed help to clarify why the Golden Age "cutter" was seen as a technician who would receive written notes from a director's assistant to execute carefully.

Few animation directors from the time used the Moviola for anything other than playing back work-in-progress reels; it was not seen as a tool for shaping performance; that had already been worked out on paper, with the beats-per-minute method expressed on bar sheets, dope sheets, and x-sheets.

One fascinating exception is Warner Brothers cartoon unit animator Bob Clampett, who experimented with the Moviola as a recording machine for an almost jazz-like performance:

On occasion, when he had a specific syncopated rhythm in mind that didn't adhere strictly to a regular beat, he would run blank film through a Moviola at full (normal) film speed, and tap on the film with a grease pencil the syncopated rhythm he had in mind, and then take the film off the Moviola and count the frames between the marks. He would time his actions to those numbers of frames, and then give that information to Carl Stalling, who would compose music to fit that timing.[4]

By the late 1960s, adhesive tape replaced cement, and undoing a poor choice was a little more forgiving. Also, the German-engineered KEM flatbed quieted the clatter and din, and from that point on, editors could sit while working. The interface offered a more sedentary interface for the practitioner: no more dancing or driving. The KEM (and also the Steenbeck) enlarged the screen, accommodating additional spectators who could now see a dim working copy of the film and hear two separate audio tracks in sync. Those tracks were by now recorded on magnetic stock, skipping the need for lab runs and destructive edits.

GALLERY: Mechanical Machines

Photo 6.6 Sam O'Steen keeps Mike Nichols in sync.

Courtesy Bobbie O'Steen.

Photo 6.7 Nicholas C. Smith started on a Moviola—assisting Sam O'Steen.
Used by permission of Pixar.

Photo 6.8 Wood-paneled early flatbed at the Frankfurt Film Museum.
Photo by Bill Kinder.

Electronic Machines

In possession of one of the first KEM machines imported to the U.S., self-described "boy scientist" Coppola built a bridge to the electronic shore, video. While the rest of the movie industry considered television a distinct species, Coppola said back in 1970, "I want to use a computer to push a button and instantaneously put together scenes in any combination."[5] He aimed a video camera at a KEM to liberate the material from the large apparatus. Copies could be reviewed portably. (The weight of that celluloid film reel shrank tenfold, onto videocassette.)

As these experiments of editorial hybrids evolved into his approach for *One from the Heart* (1981), Coppola coined the term "pre-visualization," using video recordings of storyboards to create what he would call a "score" of the film against "radio plays" with actors. This analog, electronic concept was a direct precursor to the layered digital storyboarding process later developed at Pixar. Editing videotape required a linear approach (working in order or redoing everything after a length change), but experimentation was invited. One could preview an idea without destroying anything. It was also another step removed from the physical undertaking. Cuts were made electronically, and there was no threading of multiple strands of sound and picture; it was all on cassettes concealed inside the machines.

Several businesses started on the concept of a computer-controlled video editing system for film. The Montage was an early one, literally bridging a computer to a rack of seventeen analog Betamax video decks. The Rube Goldberg contraption clacked away in Coppola's American Zoetrope in San Francisco, cuing and switching its analog tapes like an automaton, commanded by the editor pointing and clicking and "rolling" a KEM-like knob. The designers of these systems spent a great deal of effort to salvage what tactile sense of film editing they could: in addition to the knob controller, finely tuned to emulate the "ballistics," or mechanical feel, of the flatbed knob moving thousand-foot loads of 35mm, the Montage also had a digital version of the "grease pencil" editors could use for notes and signifying dissolves (a callback to the grease pencil's original use on film to mark a cut point or indicate an optical printing effect to the lab). It also featured an odd mutation that inverted the animation Story Reel editing process: its "print storyboard" function put the first frame of each shot on paper for consideration *after* it was edited.

Meanwhile, across the Golden Gate Bridge in Marin County, Coppola's former protégé George Lucas had charged his Computer Division with an editing project of its own. Ed Catmull had been brought in from the New York Institute of Technology (NYIT) to develop tools for editing picture and sound. "Editing was the craft closest to George Lucas' heart. After all, he had been an editor,"[6] recounts Lucasfilm Computer Division manager Bob Doris.

"There was no question that we were designing a system for the motion picture industry, and that almost any change beyond the flatbed editor would be rewarded as long as we could overcome the resistance to change,"[7] recalls Ralph Guggenheim, the head of the "CompEdit" project—once again illustrating the value of being away from the mainland of Hollywood, while also speaking to the difficulty of penetrating it. Here, too, a KEM controller was wired up so the "look and feel" of the system were comfortable for people used to editing film. Like progressively complex organisms adapting to their new environment, each technical leap in the editing world emulates traits of the most recent tools in order to assure reproduction to the next generation. It did not need to refer any further back—what was "intuitive" to the KEM generation would not have been to either Dorothy Arzner cutting "in hand" or to a Moviola-trained editor.

"All the time we were mimicking what we were replacing," notes Guggenheim. "We tried to lay out small filmstrips on the screen so it looked like what editors were used to seeing and we tried to hide from them all the video technology, so that it looked like film editing." Using a cutlist they called a "schedule," the Lucasfilm team devised a system of analog laserdiscs to present seamless (and less mechanical than videotape) random-access playback to the film editor.

As the CompEdit project lurched toward completion, it adopted a more marketable name: EditDroid. In the end, only twenty-four were sold. The other two branches of the Computer Division, digital sound editing and digital film recording, had also made pioneering efforts, but Lucas could not see a feasible path to commercializing any of it. He disbanded the Computer Division. In its wake, he sold digital editing patents to a tiny company back East called Avid, while Catmull convinced Steve Jobs there was a future in computer animation, despite that never having been Lucas' goal. Guggenheim would stay on at newly formed Pixar—eventually producing, with Bonnie Arnold, *Toy Story*.

Digital Machines

While it had made some headway in short-form television work and independent film, Avid was a rarity in the feature world—only one major studio release (Columbia Pictures' 1993 film, *Lost in Yonkers*, edited by Steven Cohen) had used the system at that point. It was practically unheard of in animation. Given Pixar's history with the CompEdit project, the new system would have seemed less risky in Point Richmond than just about anywhere else. Lee Unkrich remembers that *Toy Story*'s leadership "made a decision: since this was going to be the first computer animated film, to do everything on the film in a very technically innovative way." But it was not so easy. The technology was still new, and expensive, and not quite so capable in 1993.

Editor Tom Christopher, an early arrival on the film, helped set this course. He remembers, "There was at least a year of investigation into the editing platform before I got on board. I went with the group to look at the Lightworks machine in LA." Centered on that very tactile KEM-like shuttle controller, its metaphors were considered more "film-like" and "intuitive"—while also demanding a new breed of assistant editors well-versed in computer operating systems.

Avid was somewhat tainted as a video editor's system, premised on "source and record" windows like the linear videotape editing bay it first aimed to replace. It had an available Steenbeck-branded controller to help experienced film editors migrate, but that was an expensive add-on. So was the new "Film Composer" option, which unlocked the system's capability to publish cut lists at film's 24 frames per second (video ran at 30fps). Ultimately, Christopher's Avid recommendation made it through to producer Guggenheim. But budget challenges would strike both the controller and the Film Composer options. Instead, Pixar would deploy its own computer science might and some assistant editor brute force to solve the frame rate conversion problem. Nearly a full-time job, the tracking process echoed the old x-sheet from which the system was about to free the animation editor. Except it was backward from the traditional x-sheet: instead of giving a roadmap for the "cutter" to execute, the editor was issuing a roadmap for the film recorder to capture. The film would come back to editorial to resume its traditional role of conforming the work-in-progress reel. Editor Torbin Bullock started in *Toy Story*'s film room

and recalls how the whole experiment was quite tentative. "They didn't really know where to put us, so they stuck us in the photo science hallway, because photo science was in charge of pushing out film, and we were the ones that put it together. We were editing on the Avid, but they had to film it out onto 35mm film, so you could show it in theaters. It was such a laborious process, conforming 35mm print to the lists. There were a lot of late nights, but it was super interesting." The lines of communication between nominally traditional departments called Camera and Editorial were invented, reversed, and reinvented—because eventually, the movie would have to be projected on film for the filmmakers and the global marketing machine all geared to the century-old standard of 35mm.

Across the bay, Coppola was experimenting with digitizing his "electronic storyboard" process on *Pinocchio* for Columbia Pictures—for which he hired a crew of traditionally-trained story artists. Comparing notes on story process felt eerily similar for those on *Toy Story* and *Pinocchio* (which never was completed). Each project seemed so one-off and secret to those working on it, and yet similar due to shared frustrations with the limitations and "pain points" of these evolving digital tools. There was a common hunger to share adaptations, to cross-pollinate "tips and tricks." In fact, several of the people involved in that scrappy project brought their unique experience to Pixar a few years later (including editor Greg Snyder).

Troubleshooting took the form of a new ritual for film editing departments: phone support—in which the first question (after, "Did you try restarting?") was, "How many 'media objects' (i.e., 'takes') are in the system?" Pixar's answer, "hundreds of thousands," would draw a reaction of disbelief from the technicians accustomed to supporting television programming. Warnings followed that such quantities were far beyond the pale of tested or warranted practice.

GALLERY: Digital Machines

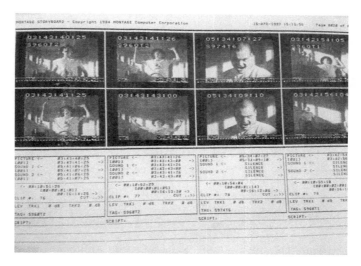

Figure 6.5 The Montage system featured an odd mutation, a total reversal of the animation Story Reel editing process: its "print storyboard" function put the first and last frame of each shot on paper for consideration *after* it was edited. While of dubious creative utility, it gave the film assistant editor visual confirmation when conforming film print.

Photo 6.9 EditDroid brought "cutting" a step closer to its digital abstraction. Developed by the CompEdit team, the transport controller felt like a KEM controller.

© & ™ Lucasfilm Ltd. All Rights Reserved. Courtesy of Lucasfilm Ltd.

Photo 6.10 A Bug's Life (1998) on a late-model KEM. Although edited digitally, a platoon of assistants manually matched celluloid to pixels and checked their work here.

A Bug's Life © Disney/Pixar. Used by permission of Pixar. Photo by Bill Kinder.

Photo 6.11 A typical videotape editing system in the 1980s. The left monitor showed the Source, the right Record.

Photo by Bill Kinder.

Photo 6.12 The Avid interface borrowed more from these tape-based interfaces. The left monitor showed the Source, the right Record. Interfaces, with Source and Record "windows."

Photo courtesy Tom Ohanian.

Photo 6.13 Early trials with Adobe Premiere software were relatively uncomplicated in 1993.

Photo by Bill Kinder.

Photo 6.14 The Touchvision system was one of several that faded away in the early 1990s. Like the Montage, it used multiple tape copies of the same material to create a "nonlinear" experience.

Courtesy Tom Ohanian.

Photo 6.15 For those accustomed to a Steenbeck flatbed...

Photo by Bill Kinder.

Photo 6.16 The Lightworks looked and felt familiar in 1993, with its digital lure: a tactile controller with "ballistics."

Photo from Lightworks marketing material.

Photo 6.17 American Zoetrope in San Francisco replaced its Montage with a Lightworks in 1994.

Photo courtesy Bill Kinder.

Photo 6.18 Avid was already making early waves in Burbank.

Photo courtesy Tom Ohanian.

Photo 6.19 Kenneth Guertin at work in 1990 on *Let's Kill all the Lawyers*, known as the first feature film edited on Avid, running beta software on an Apple II machine.

Photo courtesy Kenneth Guertin.

Photo 6.20 Erik C. Anderson cuts *Down with Love* (2003). By then Avid was on version 7 and was commonplace in Hollywood.

Photo courtesy Erik C. Anderson.

Figure 6.6 The production pipeline became a wheel (*A Bug's Life*, 1998), which later became…

© Pixar.

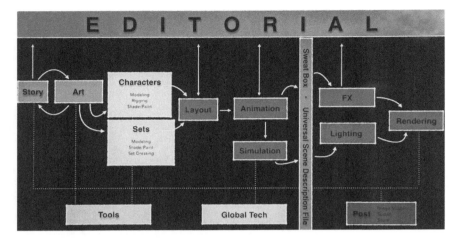

Figure 6.7 ...a cloud (*Piper* two decades later). The process, and metaphors to comprehend it, continue to evolve.

© Pixar.

Digital Editing: A Fledgling Migrates South

Pixar had become a harbinger of what was to come. No wonder the new tools boosted the creative input of the animation editor. "It's much more immediate," editor H. Lee Peterson says. "Whereas film tended to be, you did stuff and then the assistant had to do something and then you looked at it. So [digital editing] has to be totally innate, like film. I want to sit there with [Disney CEO] Michael Eisner behind me, and be editing. That would be the test, because then it's interactive. It's a pencil. It's a fancy pencil. I found that to be so powerful with getting to the essence of things." Editor Ellen Keneshea found that the new tools "did change your role as an editor. It was easier and more efficient to make changes, give input, and not paint by numbers" (literally, on x-sheets).

The perceived economic and creative advantages of digital editing moved from computer animation to the entire film industry over the next few years. Toward the end of the transition, Steven Spielberg and his editor Michael Kahn finally acquiesced. Spielberg has said of editing, "This is where filmmaking goes from a craft to an art."[8] He was one of the holdouts for the physical and mechanical editing

process that transformed the 35mm work picture. George Lucas had claimed, "Michael Kahn can cut faster on a Moviola than anybody can cut on an Avid."[9] Not coincidentally, the first film the director-editor duo edited digitally—in their fourth decade working together—was also their first animated film: *The Adventures of Tin Tin: The Secret of the Unicorn* (2011).

While recognizing that some positive aspects of KEM craft are lost, editor Kevin Nolting would not turn back: "I can't imagine working on film in animation. I just can't imagine doing these stories, just getting files, getting storyboards into a cut-able state. In animation, I think it's great." The point is not that films are better cut digitally. That would be absurd, unquestioning; some of the best films ever made were edited by hand, on Moviolas and on KEMs. The point is that the tools enabled a defining shift in the role of the editor.

GALLERY: Building the Bridge to Digital Cinema.

Photo 6.21 David DiFrancesco focused laser beams on the problem of migrating pixels to emulsion at Lucasfilm.

© Pixar.

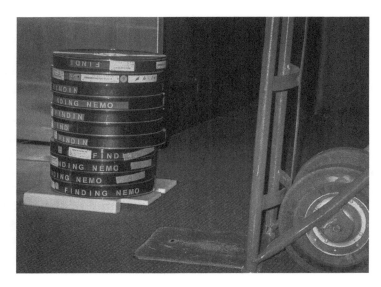

Photo 6.22 Twentieth-century manufacturing and distribution bled into 2003 (*Finding Nemo*).

Photo by Bill Kinder.

Photo 6.23 Setting up the world's record holder for largest film screening, with an audience of 30,000 for *Cars* (2005) at Charlotte Motor Speedway.

Photo by Bill Kinder.

Photo 6.24 Three digital projectors for each screen.

Photo by Bill Kinder.

Photo 6.25 The T-Rex of celluloid: 70mm and its guardian, David Keighly, after a
review of the IMAX version of *Toy Story 3* (2010).

Photo by Bill Kinder.

Photo 6.26 Projectionist's changeover marks (the circle in the upper right corner eight seconds before film reels had to be switched) were made superfluous by digital cinema. Pixar editors winked at film projectionists who would understand that the logo for *The Incredibles* (2004) was meant to signal a changeover cue for some of the last reels Pixar had distributed on film.

© Disney/Pixar.

Getting Pixels to Thrive in the Theatrical Wild

Catmull recognized that his studio's pixels needed to merge with that world standard distribution freeway, 35mm film. Computer chips were not fast enough, nor disks large enough, nor compression sophisticated enough to display even 30 minutes of standard definition motion pictures. It was axiomatic that for a filmgoing audience to be going to a film, it would be a…film. One of his first hires at Lucasfilm was his NYIT Computer Graphics Lab co-founder colleague David DiFrancesco, who would perform the alchemy binding pixel to emulsion. PixarVision, the first laser-based film recording system, was patented. Editors could make their decisions with video on a computer screen, but their crews would be responsible for conforming 35mm prints as they came from the lab.

Down the hall, away from the quiet Avid suites, was the raucous film room. It was pungent: a machine for stamping edge numbers on the film released a toxic vapor as it heated plastic to melt along the sprocket holes. "I love the smell of edge coding in the morning," wore itself out as film room banter. The platoon of specialized assistant editors was literate in the arcane cartography of "conform logs," and how to map them to a landscape of these stinking numbers. In the "real," live-action film world, this was standard operating procedure; but here, mounting these movies

on film was a strange process for editors because film was the last place these images would appear.

Laser film recording reached an important milestone when it was fast and reliable enough to record an entire distribution-size 2000' reel (about twenty minutes) overnight. At that point, editorial could afford to wait for a batch of shots to be recorded in continuous order: "Look ma, no hands." 3, 2, 1–obsolescence: "Look, Pa, no more film room in editorial." Gone was the kitchen-like sensory experience of all that heavy film and slamming mag: the aerobic effort, the thrum of rewinds, the counter-high bench, the thwack of a rewound reel, the stench of burning plastic. Soon, the entire industry followed Pixar's path straight past film to digital projection.

Enlarging the "Room Where It Happens"

For a few years it was not practical to have an editing screen larger than a CRT monitor; soon high-definition video would project directly from the editing system, leaping past the Moviola's tiny bombsight contraption to a cockpit full of copilots and navigators. This workspace evolution expanded the collaborative dynamic in the editing room: more voices, more opinions, more ideas.

"That was the first thing that was a big adjustment for me," remembers editor Ken Schretzmann. "I'm used to being in cutting rooms where it's you and the director, and you're working things out. The first review at Pixar there's about eight people sitting behind me, and people have laptops, and they're taking notes. You get no privacy in the cutting room, it's all public and being recorded. There's a whole culture of honesty. You learn not to take it personally."

Crawling on to Digital Shores

Toy Story's box office success afforded further technological progress: the 24fps Film Composer option; a Steenbeck-branded controller (it sat as a doorstop, announcing the new generation had arrived, and no longer expected the process to "feel" like it once did); that Unkrich wunderkind now on staff.

Looking past *A Bug's Life* to a multi-film slate, the Point Richmond studio hired a former Walt Disney Feature Animation production executive to lead the studio's production management. The Pixar approach was

so convoluted to this animation veteran, they engaged a consultant to illustrate and document the process—an expert in successfully mapping the manufacture of things, such as cat food, as if an ethno-biologist were summoned to identify this beast as fish or fowl. The illustrated documents captured the new species with some anatomical accuracy, but everything kept changing too quickly for a snapshot to stay relevant more than a few months. Something lasting did come of the seemingly futile exercise: the wheel-with-spokes paradigm, in the hub of which sits the editor.

Unintended Consequences—Future Generations

Orson Welles described film production as "the biggest electric train set any boy ever had."[10] As the medium dematerialized, the cutting room itself became virtual—accessible to anyone in the cloud with a login.

The language used to describe film editing had completed its move from solid ("train set") through liquid ("work flow") to gas ("cloud"). From materiality to abstraction, GUIs and symbols now reflect the progress of editors who, while in the eye of a creative hurricane, outwardly appear merely to be typing.

Most editors view the emergence of digital editing as progress, or the removal of barriers to creativity. If the abstract definition of editing is "manipulating images and sound in time," then it will always have a role, regardless of the tools used to effect that manipulation. But the various setbacks and unintended consequences of all this progress deserve to be cataloged before they are forgotten.

As steel transmogrified to vapor, editor Walter Murch noted the "loss of our old friends Clapstick, Sprocket, and Reel."[11] Scissors and blades are still common icons in graphical user interfaces for editing, but as new generations of filmmakers arrive with no direct exposure to those physical artifacts, what will their symbols mean anymore? The very question suggests those with the deepest insight into what changed are those who moved to digital editing only after extensively experiencing what came before.

For instance, editors after the Moviola were able to sit at their machines. But in push-button ease, compared to a cacophony of floor pedals and hand levers—they *lost* the ability to use their bodies to simulate the timing and rhythm of a cut. Murch, who started on the Moviola, continued to recreate that "dance" even when he moved to a KEM (by putting it on blocks) and then digital editing (by using a standing desk), to work "like a brain surgeon," and only committing to creative timing decisions made "in real time," "on the fly."

The largest—and possibly most damaging—impact of this editorial evolution has been around conveying skills and insights to the next generation. With film, assistant editors were physically present, to locate and serve the editors strips of film—new takes or camera angles—and observe the editors' strategies and problem-solving process. In the same room, the editors might even explain their choices or ask for the assistant's input. Observers of intention, actors in execution—assistants learned. As a result of digitization, even assistants working in the same room do not have access to the editor's decision-making. Often, in the heat of production, career advances appear in the form of "battlefield promotions" that can work—for assistants who have prepared and practiced for the new role along the way. Much better still to have had a generous editor who played a mentoring role.

Editor Nicholas C. Smith remembers a visiting film student unfamiliar with the digital editing systems in the early days, asking him what he was doing at the keyboard—was he word-processing? The lack of an apparent physical task can seem to lessen the weight of a decision. Back in the day, the ramifications of undoing a physical cut, a choice, meant a lot more than a command-Z keystroke for "undo." Although the editor may not be physically active as they cut, the mental job remains as challenging as ever.

These repercussions meant film editors preplanned and carefully considered every cut *before* they made it. Barney Jones, sound editor, relates this approach to his sound experience in the analog era: "You really had to commit to your idea, because you were actually cutting medium. Those were the days when you're really *performing* a cut, so you had to commit to your choices more." Many view digital editing technology's encouragement of multiple versions as a limitation, as encouragement to lack commitment. Digital editing has brought the freedom to experiment, and to control new levels of the sound and picture, yet that same ability to do unlimited changes and versions has also provided a good way to get lost, to lose sight of the story. Perhaps "undo" is, paradoxically, the aspiring assistant's solution: a no-cost opportunity to freely edit, learning from experiment and critique.

In principle, digital editing is faster with extreme computational power. But not so with the speed of thought, imagination, or quality of creation. For example, random access editing was a widely promoted "feature," but many film-trained editors saw it as a "bug," because it permitted, and even encouraged, less time simply viewing the footage, and the performances it held, in real time. Nolting observes, "Cutting on the Avid is so fast you don't really have time to think, and people expect you to move faster and faster. I even find myself getting impatient because the Avid is too slow,

which is ridiculous because we used to put a 1,000-foot roll up there and have to roll down to the last take—and remember things."

Editors were now fielding a new category of requests, all which start with the phrase, "Can't you just…?" Experienced producers found themselves in the mindset of, "If it's digital it's easier." Yet these same producers lost hold of their analog methods for taming deadlines. If a director saw room for improvement in a shot, or just wanted to defer a decision for another day, the producer could no longer hold overtime as a disciplinary stick, nor laboratory timelines. A new vocabulary of time management backstops arose: file transfer times, QC times, and the like. Editorial crews worked weeks of overtime while this new clarity emerged. Time was less saved than it was used differently. Nothing seemed to get faster or easier, breeding familiarity with the idea of "eating gains."

VIDEO 6.1 Born Digital in an Analog World (5:05)

What is gained, what is lost as pixels make it ashore? What fossils remain after a great migration?

Academy Awards® Clip © Academy of Motion Picture Arts and Sciences

Digital Nitrate

The ephemeral fragility of file-based filmmaking taunted early adopters as drives failed, files went corrupt, and vaulted backups were discovered to be incomplete. Given that Pixar was not just an early adopter, but the original adopter of the practice of making digital files into movies, editors there were among the first to suffer one rather tragic outcome of a digital ecosystem: the evaporating vault.

When DVD offered a new market in the late 1990s for *Toy Story* (it had only been on VHS and laserdisc), a commercially auspicious project was launched to master it directly from the digital source to this novel digital consumer format. The effort started with the film editors' cut list, the roadmap of the shots, their frame ranges, and sequence in the film. But not four years after the completion of the cinematic landmark, much of the landscape referenced by this cut list map was missing. Carefully handwritten logs rested with backup data tapes in a shoebox. But loading the Exabyte tapes revealed that some of them were incomplete, others damaged. Understandably, the focus had been making the world's first computer animated film, not future-proofing its files. Anyone who has

lost a day's work to a computer crash will recognize the existential night-mare of that much human effort lost. Resurrecting those missing original frames required a special team to revive old versions of software running on obsolete machines. Out of this hazing, Pixar editorial's backup efforts became considerably more robust. (Lesson #1: "It's not about the backup. It's about the restore.") This early lesson put Pixar ahead of the industry on this unglamorous aspect of digital filmmaking, the importance of which would remain underestimated.

This book is in part an artifact built on the digital archive. Hopefully, it makes evident the value of maintaining such an archive, through the effort of making it accessible and reviewable for discussion. But as the rest of the film industry began to experience data disasters, a multi-studio committee coined the term "Digital Nitrate,"[12] as if files were equivalent in longevity to the earliest silver nitrate film stock, which was prone to dissolving or bursting into flame. Less than ten percent of the film output from the silent era has been preserved, and nobody knows yet whether fate will be any kinder to digital movies.

Re-frame and Intra-frame

Editors also helped drive technological change in the form of a digital path to viewers at home: *A Bug's Life* was the first film to be reconstructed by editors in a digital video master for DVD (previously 35mm film copies were transferred to video by analog means). Audiences perceived a difference in the perfectly stable, grain-free, "clearer" image on the same, standard-definition displays they had for viewing VHS tapes. A new aesthetic in image perception was developing that would help spur the last mass, physical movie medium before streaming took over.

There was something else in that master which audiences may not have sensed as directly, though it surely affected their appreciation. "Pan and scan" was the process of cropping the left and right sides off the wide format film frame to fit on home televisions. Given the importance of eye-fixes across edits, let alone the careful staging and compositions of the director of photography, no wonder pan and scans were upsetting to filmmakers at Pixar: so much careful work was destroyed when the fundamental shape of the canvas was hacked.

A Bug's Life was a story meant for widescreen telling, and many sweeping panoramas were created in the theatrical version, filling the CinemaScope aspect ratio of 2.39:1 (width to height). The editorial and

layout teams were charged with working out a result that satisfied the commercial demand of 1.33:1 material *and* upheld the visual requirements of the composition. Inventing a process called re-framing allowed editors and directors of photography more choices in maintaining that eye fix. It was only possible because digital assets were more fluid and re-useable than live-action film frames. The unique process would be used on all subsequent 1.33:1 (aka "4 × 3") releases from Pixar. The hybridization of this broadcast television pan and scan with film process was a glorious freak of Point Richmond's isolated nature; no one else did this. Layout artist Craig Good presented a summary of the complex effort and the nature of the spotting session with editors to the 1999 National Association of Broadcasters—a perplexed audience who had never seen anything like it and could not imagine a case in which they could apply it themselves. Now audiences have tall screens, 9 × 16 in our pockets, and apps that make everything square (1:1). Progress?

VIDEO 6.2 Fluid Pixels—Beyond Pan and Scan (2:00)

Examples of the first effort to re-compose digital images for different formats for *A Bug's Life* (1998). (No sound.)

This editor-guided re-composition, or re-laying out of the film for a different screen, exemplified the expansion of the editor's role beyond the timeline and into the image itself—the so-called "intraframe" editing that was made possible by the new digital tools. The malleability has become commonplace. Says Nolting, "I use picture-in-picture a lot. If a character on the right side of the frame is doing something you don't want him to do yet, you can time all that out, and then give it to layout and say, 'Match this action.'"

This kind of editorial manipulation migrated from animation into live-action practice. Describing his work on *Nebraska* (2013), editor Kevin Tent said he "might do a simple split-screen between two characters in a shot so I can use different line readings for each of them. Or just do some very subtle timing changes. We would slow Bruce [Dern] down sometimes to just make him a tiny bit more off kilter. There are also a lot of driving montages and we did a fair amount of repositioning with the resizing tool to make sure that if we dissolve from one landscape shot to another, there would be something in the negative part of the

frame that could dissolve through." Kirk Baxter and Angus Wall, editors who frequently worked with live-action director David Fincher, also do this with long-take two-shots from a fixed camera, allowing an invisibly split screen in which one actor performs from one take, and the other actor from another take. The timing and pacing of the interaction can be manipulated by advancing or delaying one of the sides of the split. Editors have begun working with multiple takes and shots to seamlessly build performance—in pursuit of the exact same precision and manipulation animation editors have been enjoying for decades. This was always the dream of George Lucas, who said, "You can sort of direct the film in the editing room. Which is, growing up as an editor, what I've always wanted to do."[13]

GALLERY: The More Things Change

Photo 6.27 Rembrandt's *The Nightwatch* was cropped to fit in Amsterdam's Town Hall in 1715—just as widescreen films can be cropped to fit on television. Would Rembrandt have changed the shape of his canvas had he known it was going to be cropped? The Rijksmuseum tried in 2021 to restore the canvas "footage" (two on the left, one vertically) that was lost.[14]

A Bug's Life

Circus Examples with 1.33:1 Template

Photo 6.28 A Bug's Life (1998) would use the medium's elasticity to re-compose the images (seen here in layout).

© Disney/Pixar.

Photo 6.29 1.33:1 frame inside a 1.85:1 frame.

Photo 6.30 "Rat on a plane": the film might reduce to the seatback in front of you hurtling at an altitude of 30,000 feet.

Photo by Bill Kinder. *Ratatouille* (2007) © Disney/Pixar.

Photo 6.31 Or higher—how does the artist account for zero gravity?

Ratatouille (2007) © Disney/Pixar.

Photo 6.32 Bob Whitehill supports stories with the third dimension. So many
ways of seeing.

© Pixar. Photo: Deborah Coleman.

Photo 6.33 However many dimensions, the editor shapes the perspective.
Photo by Bill Kinder.

Photo 6.34 French film pioneer Alice Guy-Blaché with an immersive headset?

Case Study: How 3D Failed to Adapt

Of course, not all technical mutations will attract sustained commercial success, or even sustain more than a fad. One such failure was brought about by the arrival of digital cinema, which enabled a burst of 3D movies unseen since the 1950s. The brief 3D explosion illustrate what is missing when the commercial role of the technology drifts too far from the "art" of the story. The most successful 3D films used the technology as storytelling tool first. Naturally, Pixar's 3D team did their best to interpret and bolster the story with, literally, perspective; those films conceived as 3D stories fared best—Pixar's short film *Day & Night* (2010) being perhaps its most effective example.

Here in the 3D discussion is a clear example of the central role an editor plays in harnessing the new technology to effective storytelling. Ang Lee's *Life of Pi* (2012) is widely regarded as one of the most creatively successful stereoscopic 3D films. Not coincidentally, one of the main characters, the tiger, in the film was computer-animated. (And much of the set was rendered with Pixar's RenderMan software.) The stereo technique was carefully scripted. That script had a shepherd, in editor Tim Squyres. Just as surely as editors work a film's grammar toward clarity and comfort in two dimensions, so do they in three. Squyres worked behind a pair of 3D glasses to make sure depth cues supported the live-action story with an *animated* main character. When it did not work in the cutting room, Squyres suffered the headaches his audience would have (and went through a family-sized bottle of ibuprofen for his troubles on the project, in an honorable case of sacrifice to test the limits of technology for art). In 2010, the year *Toy Story 3* came out, there were close to 60 theatrical 3D releases. By the end of the decade, the count was nearly half that, running in fewer theaters. Perhaps if more editors had a guiding hand in the tuning of that extra dimension, 3D's commercial ascent would have lasted longer.

Projecting the Future:
Plot, Character, Visual Grammar Apply

New filmmaking technology becomes common practice only by proving its worth to the cause of drawing an audience, usually through strong storytelling. The progress of film technology from weighty 35mm cameras to lighter SteadiCams to ubiquitous smartphones would inevitably change the way films look and feel. With drone cameras already

cliché, animation's camera is no longer tethered, earthbound. When Unkrich talks about "restricting use of camera to what you could do with a camera on a live-action set" he is now looking at a host of options that didn't exist at the time of *Toy Story*. Gravity is changing.

New experiments in digital film production continue to mutate. Actors now perform on soundstages called "volumes," in front of rendered sets on massive LED screens. In an echo of Pixar's realigned production pipeline, editors are on set along with colorists and others formerly understood to be part of post-production. Integrating live-action with CGI is also forced by very external conditions: a pandemic pushed producers toward "virtual production" methods—where fantastic possibilities test filmmakers in search of believable stories and actors struggle to connect in a vacuum. Amid all the artifice, once again the editor will be trusted to pull out the emotional truth.

There is no turning back: the once-rarefied digital oasis is now the mainland continent, merely one human generation of filmmakers after those first digital files clawed on to the analog shore. Although some movies are still shot on film, virtually none of them are edited on film. The celluloid medium appears to be on the verge of extinction, remaining specimens of the celluloid beast trapped in the animal parks and zoos known as festivals and museums.

Meanwhile, fledgling technical variants such as virtual reality (VR) and augmented reality (AR) aim to be much more than evolutionary, promising fundamental rearrangements of the audience's relationship to the moving image. How different will these media be from film? Will these "advances" be met by the right editors on the right projects to assure their long-term survival? Many filmmakers (including numerous Pixar alumni) are grappling with these questions to understand what techniques of film craft apply to AR, VR, high frame rates, light field photography, and the rest. There will always be an endless din of promotion and marketing for the next medium: it has been roaring for decades already. Among the fever pitches to get "more eyeballs" and "more engagement," listen closely for the editor's voice—in a prominent, if not central role. It will tell how and which of these new species adapt, migrate, and survive.

Notes

1. Gurry, L. "Xbox's Don Mattrick Joins Steven Spielberg and George Lucas at USC Panel." https://news.xbox.com/en-us/2013/06/13/e3-usc-panel/. June 13, 2013.

2. Darwin, C. 1845. *Journal of Researches into the Natural History and Geology of the Countries Visited During the Voyage of H.M.S. Beagle Round the World*. John Murray.
3. Insdorf, A. *Francis Ford Coppola on the Future of Cinema, Marlon Brando and Regrets*. YouTube, July 27, 2015.
4. Gray, M. *Milt Gray on Cartoon Timing Past and Present*. johnkstuff.blogspot.com. August 5, 2006.
5. Kunkes, M. "Digital Dreamcatcher: 'Droidmaker' Chronicles the Early Years of Lucasfilm." *CineMontage*. January 1, 2006.
6. Buck, J. 2015. *Timeline Analog 3: A History of Editing*. Enriched Books and Tablo.
7. Buck, J. 2015. *Timeline Analog 3: A History of Editing*. Enriched Books and Tablo.
8. Spielberg, S. American Cinema Editors Career Achievement Award Presentation. 2011.
9. Desowitz, B. 2012. "Cinematic Siblings Still Thinking Analogue in a Digital World." *Editors Guild Magazine*. Motion Picture Editors Guild.
10. Leaming, B. 1985. *Orson Welles, A Biography*. Viking Press.
11. Murch, W. 2001. *The Blink of an Eye, 2nd Edition*. Silman-James Press.
12. Shefter, M. and A. Maltz, *The Digital Dilemma: Strategic Issues in Archiving and Accessing Digital Motion Picture Materials*. Academy of Motion Picture Arts and Sciences. 2007.
13. Apple, W. 2004. *The Cutting Edge: The Magic of Movie Editing*. BBC Four.
14. Siegal, N. "Rembrandt's Damaged Masterpiece Is Whole Again, With A.I.'s Help." *The New York Times*. June 23, 2021.

Afterword

7

Why Does It Matter?

> The very eloquence of cinema… is constructed in the editing room.
> — Orson Welles, Director *(Citizen Kane, Touch of Evil)*

Photo 7.1 No film comes to life until it is seen by an audience.

Photo by Bill Kinder.

DOI: 10.4324/9781003167945-8

You may have realized this is not so much a book as a klieg light aimed at film editors and their contribution to great animated films. With editors' central creative responsibility, and their methods—both art and craft—now adequately lit, and the "who, what, where, how and when" out from a longstanding shadow, our bright subject now deserves an answer to the question, *"Why* does this matter?"

Creating emotionally compelling cinema requires an advanced "literacy," an understanding of subtlety in tone, connotation, subtext, and pace: advanced literacy through editing. Maxims such as "Story is King" illuminate nothing compared to a detailed map of the editor's journey throughout a film's production—a journey challenging to track because of its "leave no trace" ethos (i.e., "if you notice the work, it isn't working"). The computer animation editor's contribution to the art of cinema has been particularly uncharted.

Of Consequence

"People have to be disabused of the notion that animation editing is not creative," insists editor David Ian Salter. "Not only are there creative decisions to be made in animation editing, but there are actually more creative decisions to be made than in live-action." It should be surprising that more attention is not paid to how these animated films, which hold such sway in the culture, work—and in so working, have had a major impact on the way all movies are made.

In the early 1990s Pixar (the image-computing company, pre-*Toy Story)* was contracted by Disney to help render a dollying camera simulation through a digital environment in the ballroom scene of *Beauty and the Beast*. Those techniques have since evolved so much that when a so-called "live-action" version of the same musical came out in 2017, filmgoers and -makers alike took that label at face value—even though the only "live-action" consists of heavily composited appearances by humans otherwise engulfed by animated sets and surrounded by animated characters.

Movies of global cultural gravity—from Marvel Studios' universe to *The Lord of the Rings* to *Star Wars* (and on and on)—may not be promoted as computer animation, but perceptive viewers and filmmakers alike had best understand: they are precisely that, they are animated. Many

other films show the increasing blur of animation with live-action technologies—the ones that are not big-budget VFX movies maybe most of all. It is rarely a point of conversation, because the CGI is applied in a way that does not intentionally undermine the classic storytelling unities.

Salter finds the growing awareness of animation's impact on the film editor's craft surprisingly incremental and reactive: "More and more live-action editors are having run-ins with animation in their work. A lot of live-action films now have a high percentage of computer animation in them, so the principles are not so unusual. I'm seeing a little bit of a change, too, in that a lot of live-action editors are actually expressing real interest in learning the techniques." Film or television projects, animated or not, can apply the methods discussed and lessons learned here without major studio budgets, years-long schedules, or giant credits lists.

As the editing craft begins to traverse these fluid borders, a wider group of film viewers, critics, and makers may eventually come to comprehend the creative command wielded by editors—on all films. Fortunately, there are already writers on film contemplative and probing enough to recognize *Toy Story* as more momentous than a "special achievement" and rather as a pivotal moment in the history of cinema itself. J. Hoberman writes, "With the advent of CGI, the history of motion pictures was now, in effect, the history of animation."[1]

The Best Animated Feature category arrived at the Oscars in 2002. Not that filmmakers should be pitied for winning a trophy in a "marginalized" category, but one can imagine this distinction collapsing in the next decade—a time when, over a generation after *Toy Story*, all filmmakers will have included animation techniques, especially those originated by editors, among their resources. The false boundary will have completely dissolved when an editor of an "animated" film wins for Best Editing, period.

GALLERY: Recognizing Editors.

Photo 7.2 Stephen Schaffer was the first editor of an animated film to win an American Cinema Editors award ("Eddie") for Best Edited Feature— Comedy or Musical. He was recognized for *WALL•E* in 2009.

Photo by Peter Zakhary/Tilt Photo.

Photo 7.3 Kevin Nolting won an Eddie for *Up* in 2010, the first year of the Best Edited Animated Feature category at the event, and again in 2021 for *Soul*.

Photo by Peter Zakhary/Tilt Photo.

Photo 7.4 Robert Grahamjones and Nicholas C. Smith share the prize for their work on *Brave* in 2013.

Photo by Peter Zakhary / Tilt Photo.

Photo 7.5 Axel Geddes received the nod for *Toy Story 4* in 2020.

Photo by Peter Zakhary / Tilt Photo.

Photo 7.6 Eddies (and editors Unkrich and Schretzmann) high-five for 2011's *Toy Story 3* win.

Courtesy Ken Schretzmann.

Cultural Impact

This influence of animation on live-action films is part of a longer history of give and take between the two. John Lasseter recalls, "We were so inspired by the revolution that was happening in the late 70s in filmmaking with the work of Francis Coppola and Steven Spielberg and George Lucas and Martin Scorsese, on and on. Amazing work that was going on, and how these films were so deeply entertaining audiences. We felt like, 'I would like to do this with animation. I know we can.'"[2]

Producer Darla K. Anderson remembers, "I wanted to be at Pixar, and I wanted to be a part of making these movies, because I wanted to be a part of changing the world. I believe that art can make a difference, and art can save people's lives, and move people, or just entertain them and let them escape into another realm."

No film better illustrates Anderson's timeless expression of the value in great art than a scene in Preston Sturges' Great Depression-set classic *Sullivan's Travels* (1941): prisoners in a chain gang are brought into a sacred chapel to see a movie. A Disney cartoon (*Playful Pluto*) flickers onto the screen to the delight and joyful laughter of this hardened group of convicts at the end of a day of forced labor—redemption and grace in a soulful, communal release.

Editor H. Lee Peterson had a *Sullivan's Travels* moment of his own with a young test audience. "I was doing *The Prince and the Pauper* with Mickey, Goofy, Donald, and Captain Pete," Peterson recalls. "Captain Pete is in a sword fight with Mickey, and Mickey slices his suspenders and his pants fall down—and he's got hearts on his underwear. The kids just erupted with laughter. Gigantic laugh. It was just so direct for them. I just thought, that's what I want to do. If this is just about making kids laugh, I'm all in on this. Captain Pete's underwear with hearts on them: it still gets a laugh."

This mission to appeal to young and old, local and global, can fulfill itself in surprising ways. A Pixar editorial employee, supporting screenings in Europe, is halted by a Heathrow customs agent. The stoic border patrolman decides to do some probing about this American's business in his country:

> He squints at the US Passport and turns slowly to the visitor. "Occupation: 'Filmmaker,' eh? What are you working on?"
> *"Finding Nemo."*
> "What's that?"
> "It's about a fish who gets separated from his father. It comes out next summer." It is not a winning pitch.
> "Mmm." Skeptically tilting his head back, the better to be looking down at his subject: "And what was the last film you worked on?"
> *"Monsters, Inc."*

The security official's stern expression melts into a broad, gap-toothed grin, and the turnstile clicks open. "Bloody hell, mate, my family love that film! Go on through!"

The real passport—the empathy, emotional connection, trust, and goodwill—appeared not in the government travel documents but in the incantation of that title, evoking the transformative power of its art felt by those who had seen it.

When a movie is seen by millions of people on the planet, anecdotes of human connection like this multiply, like ripples expanding across the water of culture. Like all such concentric waves, it begins with the pebble dropped. In this case, a collaborative team of artists in Northern California heaved the first stone. And in the center of that collaboration, in the middle of the first circle, lives the film editor.

Notes

1. Hoberman, J. 2012. *Film After Film: Or, What Became of 21st Century Cinema?* Verso. p. 5.
2. Cannes Film Festival Press Conference for *Inside Out*, 2015.

Sources and Resources

Unless otherwise noted, the quotations in this book derive from interviews conducted by Bobbie O'Steen and Bill Kinder between the spring 2014 and the summer of 2021. Interviews have been condensed and edited for clarity.

The video interviews were beautifully rendered by Directors of Photography Catherine Goldschmidt and John Baker.

Major thanks to Andrew Vernon for the clear production sound quality.

The scissor icon used in the video segments was designed by Susan Bradley.

Photo 1 Transcripts.

Photo by Bobbie O'Steen.

Interviewees

Darla K. Anderson
Robert Anderson
Catherine Apple
Steve Bloom
Torbin Bullock
Vince Caro
Ronnie del Carmen
Axel Geddes
Robert Grahamjones
Darren Holmes
Edie Ichioka
Andrew Jimenez
Barney Jones
Ellen Keneshea
Brian Larsen
Jeremy Lasky
Julie McDonald
Kevin Nolting
H. Lee Peterson
Sarah Reimers
Katherine Ringgold
David Ian Salter
Stephen Schaffer
Ken Schretzmann
Nicholas C. Smith
Greg Snyder
Jim Stewart
Lee Unkrich
Anna Wolitzky

Additional Sources

Tom Christopher
Nol Meyer
Kevin Reher
Tim Squyres

GALLERY: Editors of Pixar.

Photo 2 Catherine Apple (*Onward, Luca*).
© Pixar. Photo: Deborah Coleman.

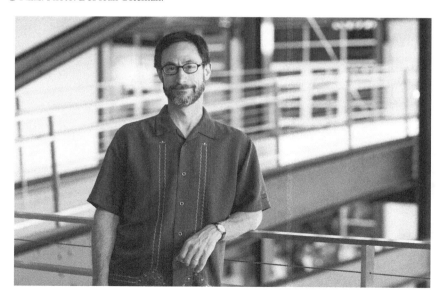

Photo 3 Steve Bloom (*Coco*).
© Pixar. Photo: Deborah Coleman.

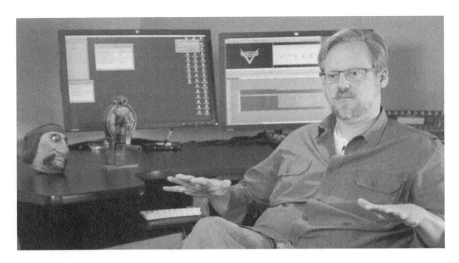

Photo 4 Torbin Bullock (*Toy Story, Toy Story 2, A Bug's Life, Monsters, Inc., Cars, Brave, Finding Dory, Cars 3, Toy Story 4*).

Photo by Bill Kinder. Used by permission of Pixar.

Photo 5 Axel Geddes (*Toy Story 2, Monsters, Inc., Finding Nemo, WALL•E, Toy Story 3, Finding Dory, Toy Story 4*).

Photo by Bill Kinder. Used by permission of Pixar.

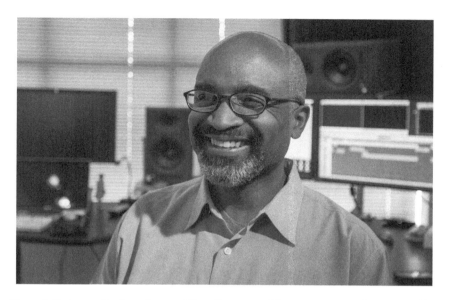

Photo 6 Robert Grahamjones *(Toy Story 2, Monsters, Inc., The Incredibles, Ratatouille, Up, Brave, Finding Dory, Cars 3, Soul).*

Photo by Bill Kinder. Used by permission of Pixar.

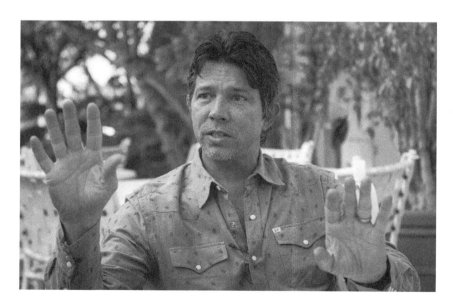

Photo 7 Darren Holmes *(Ratatouille).*

Photo by Bill Kinder.

Photo 8 Edie Ichioka (*Toy Story 2*).

Photo by Bill Kinder.

Photo 9 Ellen Keneshea (*A Bug's Life*).

Courtesy Ellen Keneshea.

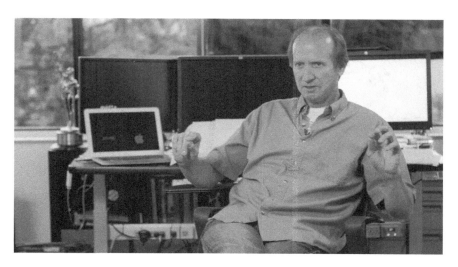

Photo 10 Kevin Nolting (*Finding Nemo, Cars, WALL•E, Up, Monsters University, Inside Out, Toy Story 4, Soul*).

Photo by Bill Kinder. Used by permission of Pixar.

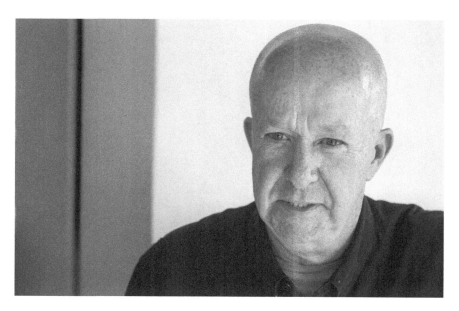

Photo 11 H. Lee Peterson (*Monsters University*).

Photo by Bill Kinder.

Photo 12 Sarah Reimers (*Brave, Finding Dory, Coco*).

Photo by Bill Kinder. Used by permission of Pixar.

Photo 13 Katherine Ringgold (*A Bug's Life, Toy Story 2, Monsters, Inc., Finding Nemo, Ratatouille, Up, Cars 2*).

Photo by Bill Kinder. Used by permission of Pixar.

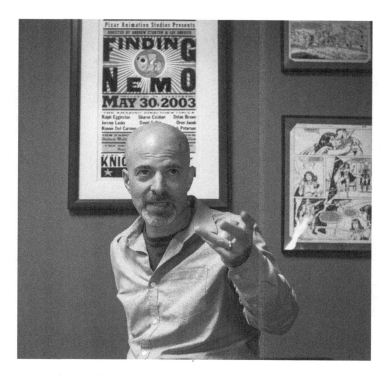

Photo 14 David Ian Salter (*A Bug's Life, Toy Story 2, Finding Nemo*).

Photo by Bill Kinder.

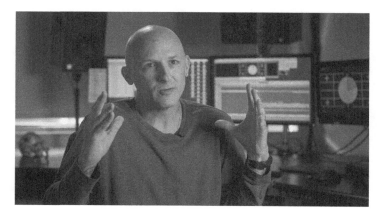

Photo 15 Stephen Schaffer (*WALL•E, The Incredibles, The Good Dinosaur, Incredibles 2*).

Photo by Bill Kinder. Used by permission of Pixar.

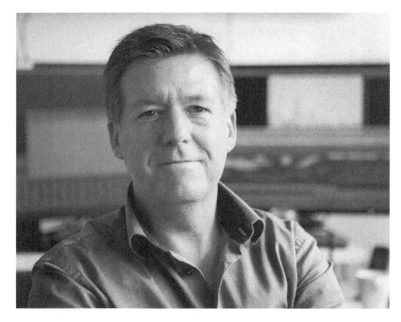

Photo 16 Ken Schretzmann (*Toy Story 2, Monsters, Inc., Cars, Monsters University, Toy Story 3*).

© Pixar. Photo: Deborah Coleman.

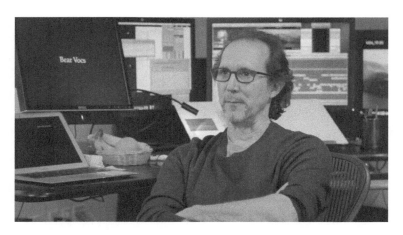

Photo 17 Nicholas C. Smith (*Cars, Finding Nemo, Ratatouille, WALL•E, Brave, Inside Out, Luca*).

Photo by Bill Kinder. Used by permission of Pixar.

Photo 18 Greg Snyder (*Monsters, Inc, Ratatouille, Toy Story 3, Monsters University, Coco, Toy Story 4*).

Photo by Bill Kinder. Used by permission of Pixar.

Photo 19 Jim Stewart (*Toy Story 2, Monsters, Inc.*).

Photo by Bill Kinder.

Photo 20 Lee Unkrich (*Toy Story, A Bug's Life, Toy Story 2, Monsters, Inc., Finding Nemo, Cars, Coco, Toy Story 4, Onward*).

Photo by Bill Kinder. Used by permission of Pixar.

Photo 21 Anna Wolitzky (*Toy Story 2, Monsters, Inc., Cars, Toy Story 3, Monster University, The Good Dinosaur, Coco, Onward*).

Photo by Bill Kinder. Used by permission of Pixar.

GALLERY: Sound Editors of Pixar

Photo 22 E.J. Holowicki (*Finding Nemo, The Incredibles, WALL•E, Up, Brave*).
Courtesy E.J. Holowicki.

Photo 23 David Slusser (*Red's Dream, A Bug's Life, Toy Story 2, Finding Nemo, Cars,*
Ratatouille, The Incredibles, Up, Toy Story 3, Brave, Monsters University).
Courtesy David Slusser. Used by permission of Pixar.

Photo 24 Barney Jones (*Toy Story 2, Toy Story 3, Brave, Monsters University, Coco, Onward, Luca*).

Photo by Maurice Ramirez.

Photo 25 Andrew Vernon (*Toy Story 3, Cars 2, Brave, Monsters University, Cars 3*).

Photo by Bill Kinder. Used by permission of Pixar.

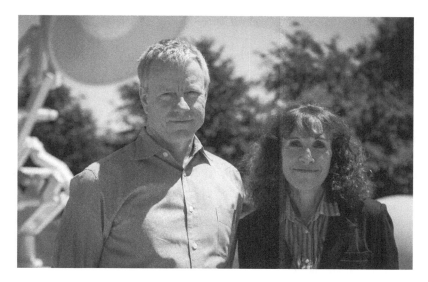

Photo 26 Making the Cut is co-written by Bill Kinder (left) and Bobbie O'Steen (right).

Photo by John Baker.

Co-authors Bill Kinder and Bobbie O'Steen are experts in the field. Kinder was the founding director of Editorial and Post Production at Pixar from 1996–2014. O'Steen is a film historian and educator specializing in editing, and the author of *The Invisible Cut* and *Cut to the Chase*.

Suggested Further Readings

Chapter 1

ANIMATION HISTORY

Cartoons: One hundred years of cinema animation by Giannalberto Bendazzi. Indiana University Press. 1994.

The Nine Old Men: Lesson, Techniques, and Inspiration from Disney's Great Animators by Alexandre Deja. Taylor & Francis. 2015.

Of Mice and Magic: A History of American Animated Cartoons by Leonard Maltin. Plume. 1987.

The American Animated Cartoon: A Critical Anthology edited by Danny Peary & Gerald Peary. Theme Park Press. 2017.

The History of Animation: Enchanted Drawings by Charles Solomon. Random House. 1994.

Disney's Art of Animation by Bob Thomas. Disney Editions. 1991.

The Illusion of Life by Frank Thomas and Ollie Johnston. Walt Disney Productions. 1981.

EDITING

The Technique of Film and Video Editing: History, Theory, and Practice by Ken Dancyger. Focal Press. 2011.

On Film Editing by Edward Dmytryk. Focal Press. 1984.

The Conversations: Walter Murch and the Art of Editing Film by Michael Ondaatje. Alfred A. Knopf. 2002.

The Invisible Cut: How Editors Make Movie Magic by Bobbie O'Steen. Michael Wiese Productions. 2009.

Cut to the Chase: Forty-Five Years of Editing America's Favorite Movies as told to Bobbie O'Steen by Sam O'Steen. Michael Wiese Productions. 2001.

The Technique of Film Editing by Karel Reisz. Focal Press. 2010.

PIXAR HISTORY

Creativity, Inc. by Edwin Catmull. Random House. 2014.

Insanely Great: The Life and Times of Macintosh, the Computer That Changed Everything by Steven Levy. Viking Penguin. 1994.

To Infinity and Beyond! The Story of Pixar Animation Studios by Karen Paik. Chronicle Books. 2007.

The Pixar Touch by David A. Price. Alfred A. Knopf. 2008.

Chapter 2

STORY

Professional Storyboarding: Rules of Thumb by Sergio Paez and Anson Jew. Focal Press. 2013.

Storyboarding: A Critical History by Chris Pallant and Steven Price. Palgrave Macmillan. 2015.

Chapter 3

SOUND

Designing Sound for Animation by Robin Beauchamp. Focal Press. 2013.
Film Rhythm after Sound: Technology, Music, and Performance by Lea Jacobs. University of California Press. 2015.

Chapter 4

CINEMATOGRAPHY

Composing Pictures by Donald Graham. Van Nostrand Reinhold Co. 1970.
Master Shots by Christopher Kenworthy. Michael Wiese Productions. 2011.
Setting the Scene: The Art and Evolution of Animation Layout by Fraser MacLean. Chronicle Books. 2011.
The Five C's of Cinematography by Joseph V. Mascelli. Silman-James Press. 2005.

Chapter 6

TECHNOLOGY

Timeline Analog 1–6 by John Buck. Enriched Books and Tablo. 2015.
Live Cinema and Its Techniques by Francis Ford Coppola. Liveright Publishing Corporation. 2017.
Film After Film by Jay Hoberman. Verso. 2012.
In the Blink of an Eye (2nd Edition) by Walter Murch. Silman-James Press. 2001.
Digital Nonlinear Editing: New Approaches to Editing Film and Video by Thomas A. Ohanian. Focal Press. 1993.
Droidmaker: George Lucas and the Digital Revolution by Michael Rubin. Triad Publishing Company. 2006.
Understanding Digital Cinema: A Professional Handbook edited by Charles S. Swartz. Focal Press. 2005.

Index

Italicized pages refer to figures, photos, and video descriptions. **Bolded** pages refer to videos.

9780367766146